my kitchen table

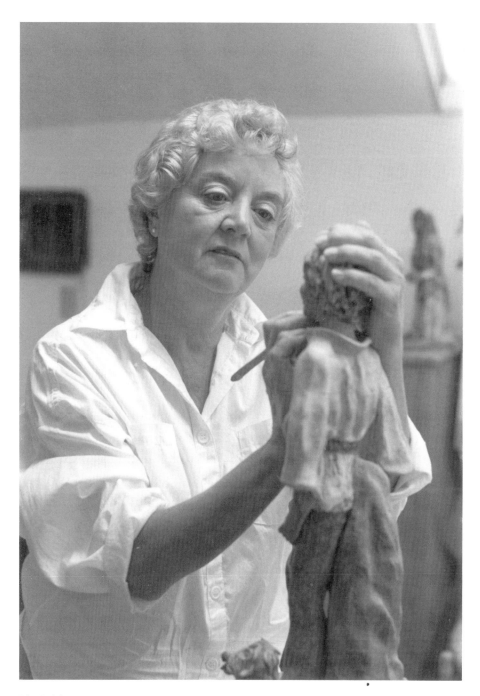

Pilar Pobil.

my kitchen table

SKETCHES FROM MY LIFE

PILAR · POBIL

Foreword by
Robert D. Newman

THE UNIVERSITY OF UTAH PRESS
Salt Lake City

 The Defiance House Man colophon is a registered trademark of the University of Utah Press. It is based upon a four-foot-tall, Ancient Puebloan pictograph (late PIII) near Glen Canyon, Utah.

11 10 09 08 07 1 2 3 4 5

LIBRARY OF CONGRESS CATALOGING-IN-PUBLICATION DATA

Pobil, Pilar, 1926–
 My kitchen table : sketches from my life / by Pilar Pobil ; foreword by Robert D. Newman.
 p. cm.
 ISBN 978-0-87480-896-4 (pbk. : alk. paper) 1. Pobil, Pilar, 1926–
2. Painters—United States—Biography. I. Title.
 ND237.P723A2 2007
 759.13—dc22
 [B] 2007003916

To Mallorca,
the island of my past
and of my dreams,
and to Utah,
the beautiful land
of my reality

The Struggling Artist Views Pilar Pobil's
La Candelaria, oil on canvas, 30" × 40"

by Maurine Haltiner

Amid blazing candlelight
old pains
of childbirth
flame above the heads
of women
in Pilar's *La Candelaria.*
Under the shadow
of ancient law, they gather
in a knot of faith
and fear, participate
in the Purification
of Mary.

If I remove
the varnish, let garden
wind snuff the candles,
drop scarlet blisters
of wax onto the palms
of my extended hands,
will she forgive my sin?
Will she heal my wounds
with bold ointments – orange,
sap green, purple, turquoise, lemon
yellow, and vermillion? Will she confer
upon me the blessing
of pigment?

contents

illustrations

color plates

author's note

THE STORIES IN THIS BOOK are realistic portraits of people I knew in the past combined with the tales I heard when I was very young. I recognize that the people and events have been subject to my own interpretations, and like any storyteller I have likely taken some liberties when shaping the stories. So, while true, it may be that some details are open to dispute. These are the stories as I know them. Some names have been changed.

foreword

PILAR POBIL'S PAINTINGS, with their vibrant colors and movement, are set in the El Greco and Joan Miró physical and mental landscapes of Spain, the Frida Kahlo passion of Mexico, and the Maynard Dixon deserts of Utah. They shift from the bustling gathering of swirling dresses and beckoning eyes to the noble drudgery of the olive harvest strewn beneath bursting trees to the pure pastels of Mediterranean houses etched against a foaming blanket of sky. Everywhere, there is a story, narratives that casually meander and those stopped teasingly brief. The paintings do not end and are never demure. They spill over onto frames that extend rather than contain them and possess their surrounding spaces. They overwhelm with a synesthesia that blends outside and inside, waves of pigments spilling over their beached canvases to then retreat and reveal. Beneath every scene, and every scene within a scene, looms some autobiographical fragment, some fleshy whisper of joy or sorrow within the visual breeze.

My Kitchen Table gives us these stories and weaves the autobiographical threads in the rich tapestry of a life full of remarkable events and people, as colorful and dynamic as the paintings that emerge from it. The appetizer is Pilar's Spanish childhood, populated by eccentric relatives and a hero-father torn from her life by Franco's brutal regime. The wonders of age and the mischievous discoveries of youth are the spices that infuse the multiple courses that follow, each further flavored with sly insights and sharp humor, her seasonings of recollection through experience. Pilar guides us through Spain, Mallorca, Mexico, and

Salt Lake City with the brushstrokes of her memories, painted thick with surprises, always noting the sights and the tastes that have served her late-blooming artistic prominence.

My Kitchen Table is a gathering of the phases of Pilar's life that flow and flower like the best conversations among interesting friends enjoying delicious meals, the kinds of meals and conversations that burrow deep into your taste buds and memories, making subsequent experiences duller by comparison and calling your imagination back to dwell and embellish. It is a celebration of the palate and the palette, of the feelings that cause us to sing while walking and of the sensuality of moments dredged in the honey of laughter and love.

Like her paintings, Pilar's stories overflow their pages. They fold us into their embrace, so we feel and see her dancing in and out of our minds, a curious and mischievous child, a young woman in love coming to a foreign land with a foreign culture and tongue, experiencing the heartbreak of her losses and the continual renewals that have ripened her art. Pilar's book, like her house, is a magic kingdom, and she is the fairy princess who presides. She paints her shoes for social engagements. The seats of her chairs beam faces. Her electrical wiring metamorphoses into fantastic snakes. The garden that leads to her studio is Salt Lake City's Giverny. Paintings are everywhere and talk to each other with glittering non sequiturs. At the center of it all is her kitchen table, the place from which she serves the voices and visions of her life. The subtleties of her telling, like the bold clarity of her judgments, are those of an artist whose inspiration is a feast she graciously invites us to share.

<div align="right">

Robert Newman
Dean, College of Humanities
University of Utah

</div>

✏ *the kitchen table*

W HEN MY CHILDREN WERE GROWING UP, our family was a kitchen family. We had a lovely old house with many pleasant rooms to sit and visit in, but for everyday meals or even on formal occasions, we would end up congregating around the kitchen table. For us, dinners, especially Sunday dinners, were a very important time to get together and enjoy each other's company. I would spend hours preparing the food, which always had a definite Spanish influence.

I grew up on a Mediterranean island, Mallorca, and was a member of an extended, large, diverse, and colorful family that had seen better days. I am a cook who likes to improvise, and often I cook up old memories: I start thinking about somebody I knew, a place I visited years ago, or a time long gone, and pretty soon I am cooking my interpretation of a certain dish typical of that part of the country, or I cook the way a friend did, or I create what was served on some memorable occasion. Perhaps I use extra garlic or let my imagination incorporate a few more herbs, but the results are always close to my memory. My family thinks it is delicious. There is nothing better to bring out conviviality on a winter day than a good meal served at a generously large kitchen table with the steam from the pots still clouding the windowpanes, through which you can see the snow hanging from the bare tree branches.

We would linger at the table after dinner, and one or another of the children would say, "Mom, tell us one of your stories!" "What stories?" I would reply, "I don't have more stories to tell, you know them all!" But then I would have another glass of wine and start think-

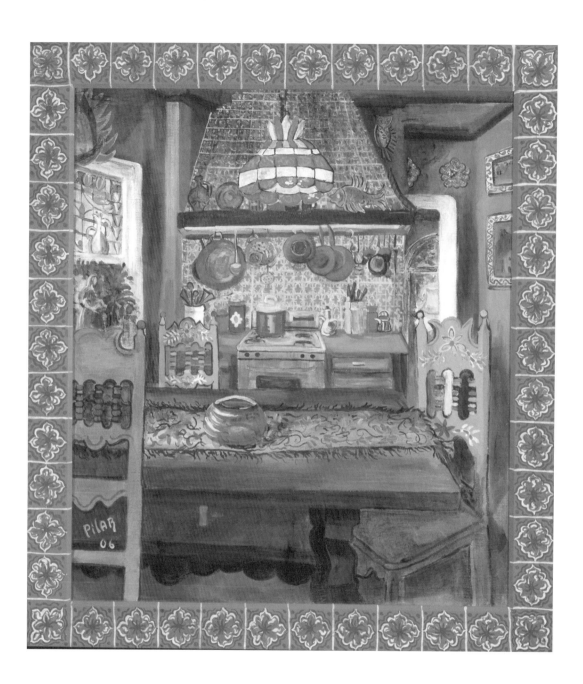

My Kitchen Table, 2006.

ing about times past. When you leave your native land for good, your life is cut in two. The first part retreats inside to allow the second part to develop without hindrance. It becomes a hidden part of yourself that not many people see. In my case, it started showing itself in my creative process. It showed in whatever I did: decorating the house, landscaping my garden, sewing my daughters' dresses, and cooking our meals, and later, of course, it manifested in my art. It appeared in my sculptures and in my paintings. To this day, in all the diverse work of my second life, you can see the definite influence of my first life.

It is not the same for everyone. Some immigrants will come here, and a few years later they will be totally integrated and might even be offended if other people, hearing a slight difference of accent or form of speech, ask them where they are from. This is not the case with me; I have been here many years and my second life is much longer than the first was, but I still value my past experiences very much and believe I have been enriched by them. This hidden life has been so strong that even though I like my new country very much —I am perfectly adapted to it and don't pine to go back except to visit—my old life is still a very important part of me and has the greatest influence on what I do. Not a single day goes by without my remembering some event from my past.

I love people and have many friends, but inside I have the feeling I am not entirely like them. And now, when I return to Spain, the same feelings come when I am with my friends there. Because of my life here, I am not like them either. I guess this is how life takes over and shapes you in different ways, according to your surroundings and your experiences. The feeling of separation is not as strong now as it was when I first came to America. At that time, the distance was enormous. The world I knew was gone and I had to face a new one, and I did. Even ordinary things were different: I confused cabbage with iceberg lettuce, I had never eaten corn on the cob or avocados, I had never seen television. I had to learn new ways of expression, not just with language but with perceptions. My husband sometimes teased me and said I had the soul of a Mallorcan peasant because I still do things my own way, sometimes rejecting the tools the modern world provides. I use modern things when they serve my purpose, but many times doing things the old way serves to preserve my hidden identity, a certain self-expression.

So, even if most of my stories happened a long time ago, when we were sitting at the kitchen table having a little more red wine than we should have, the stories came out alive because they were still alive inside me. I did not feel as if so many years had gone by. I could then, and still can, see my country the way it was when I left it, populated with the people I knew and loved. I would talk about Catalina, our cook, who spent more than forty years with my family and was loved by all; Pepa "La Carpintera," our dressmaker whose father was a carpenter; and Tonina, my dear friend, the daughter of my mother's wet nurse. Uncles, cousins, and friends all became as familiar to my children as if they had known them personally. Later, when my children were grown, they asked me to put the stories in writing. I always said I would and, although I started many times, they were never completed. I thought the manuscripts were lost. Not long ago, I found them and decided it was time for me to complete them.

My children are off in different directions, my husband has gone to the great beyond, making more fragments of my life. Our kitchen table, where I am writing now, does not come alive with their conversations as once it did; I hope that writing will bring the separate pieces together and make them whole again. Even though I am getting old in years, I don't feel old in my mind. My life is still developing and the future is as interesting as the past, perhaps more so because it is more challenging and I can shape it with my work and with my effort. The world is always changing, and because I have lived in different times and cultures, I might be able to project a view of places and characters that don't exist anymore. Some of the people I knew were quaint even then, and I think now it would be difficult to find the kind of innocence and naïveté that developed those personalities. I introduce them here, and I hope my readers will find them interesting. I know my children will enjoy meeting them again. ❧

mallorcan tales

growing up

✂ my early life

ONE OF THE FIRST VISUAL MEMORIES I CAN RECALL is the proclamation of the Republic in Spain, when King Alfonso XIII, the grandfather of the present king, Juan Carlos I, was deposed from the throne and went into exile. Of course, at the time, I did not understand the meaning of what I had witnessed; it wasn't until much later that I figured it out.

My family and I were living in a large house on La Calle de Santa Clara, on the *piso principal* (main floor, which in Spain is actually the second floor, above *la planta baja*, or street level). There were several shops on the street: a barbershop on the north side, very colorful with its striped post and leather chairs in green; a beautiful old pharmacy on the corner, with mellow polished wood cabinets displaying gorgeous ceramic covered jars, overseen by the imposing *farmaceutico* (pharmacist), with his immaculate white starched robe and a bald head as polished as the wood. Around the corner was a shoe repair shop run by a couple and their three daughters. I remember them well because the four women had extraordinarily thick necks—likely due to extended thyroid problems. There was an old carpentry shop that went deep and dark into its building. I think the carpenter must have died when I was young, because I don't remember him well. But I do remember his wife, Catalina la Carpintera, their son Jaime el Carpintero, and their daughter Pepa la Carpintera, a dressmaker who came to our house to sew our nightgowns and underwear, as well as the uniforms and aprons of our maids.

Above the shops came *el entresuelo* (the mezzanine), almost as large as our floor, but with lower ceilings. The pharmacist and his elderly mother lived there. Our floor had very large rooms with high ceilings and beautiful mosaic floors that extended all the way to the back of the house, to the patio and the garden that connected to the neighbors' gardens.

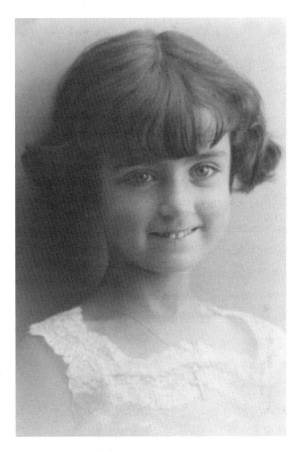

Pilar Pasqual del Pobil y Truyols, August 1935.

There were pantries and cool rooms downstairs and several more floors upstairs, including the schoolroom, the sewing room, the maids' rooms, the chauffeur Miguel's room, the laundry and storage rooms, and finally *el porche* (the porch), a large empty space at the top, where our laundry was hung out to dry if it was raining. At the very top of the house were the terraces, from which you could see the roofs of the other houses, the cathedral's spires, and the steeples of all the other churches and convents of Palma. Farther away, but still not far, was the wide blue bay of Palma, la Bahia.

On the terraces we had chicken coops and pigeon cages and large earthenware pots where our cook, Catalina la Cocinera (not to be confused with Catalina la Carpintera), planted herbs and tomatoes. There were also blooming plants, including many geraniums, and all the other flowers we admired. Many of the other rooftops also had pigeon cages and, in the early evenings, before sundown, some of the pigeons were let out for exercise. Their keepers would guide them from their terraces with long flexible canes with white cloths attached, and the whole flock would fly back and forth in the sky, obediently following their owners' commands. Since nobody in our house knew how to do that, or had the inclination to learn, our pigeons were sadly deprived. As I recall, our pigeon population wasn't exactly planned but was the inevitable result of the mating of a pair that had been given to one of my older sisters for Easter many years before.

The porch and the terraces were my real play area. I could ride my tricycle, jump rope, build make-believe houses, and produce original theatricals with my cousins. Most important of all, when my father was due to arrive on the island, from the highest terrace I could spy his ship on the horizon. Then I would go wild with excitement and joy. My father

was an officer in the Spanish navy and, in my early childhood, he was commander of one of the three navy *cruceros,* the *Míguel de Cervantes.* I adored him.

On the day of that great historic event, the proclamation of the Spanish Republic, which was set in my memory with such vivid clarity, I was not playing. I was sitting on my little stool, my very own *taburete,* which I carried around with me for years. I was sitting at the lookout, a glass-enclosed balcony in the corner of the house that had a view of several streets, La Calle de Montesion, La Calle del Call, La Calle de San Francisco, and La Calle del Sol, all intersecting our own street, La Calle de Santa Clara. It was one of my favorite spots. On winter evenings, I would watch the light man come along the streets with his long torch, making the street lamps come to life, one after another, as he walked from one far corner to the next.

But on this particular day, evening had not yet come. The day was still bright with sunlight, and I was just sitting there daydreaming when I heard the sound of drums coming down the street. Pretty soon, three men appeared around the corner, dressed in the ceremonial costumes of the town hall. They were the town criers, and their medieval uniforms were tunics of brilliant red, blue, and gold velvet emblazoned with the coat of arms of the city of Palma. Beneath the tunics, their legs were covered with white stockings, and on their heads they wore velvet caps with a long tassel hanging down the side.

Standing directly on the corner in front of our house, right across from my perch, the drummers played a climactic finale as I watched and listened. The man in the center unfurled a parchment and read the proclamation to the few people who had gathered around him, and to me, transfixed on the balcony. When he finished, they hung a poster on the corner wall for everyone to see and then continued across town, repeating the reading of the edict over and over again as they went.

Though I didn't understand it then, what I witnessed was the end of the Spanish monarchy. For the first time in their history, the people of Spain had voted in a democratic republic. Unfortunately, it was a troubled government destined from the beginning to collapse. But that was something I didn't understand then or for many years to come. I only half knew of the sad events that were disturbing our peaceful lives—the strikes, the protests,

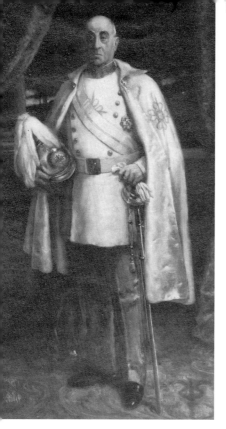

Left: Full-length portrait of maternal grandfather, Fernando Truyols y Despuigch, Marques de la Torre.

Right: Maternal grandmother, María Magdalena Villalonga y Zaforteza, Marquesa de la Torre.

the assassinations of politicians and officials that were undermining the power of the government. At first it happened slowly, sporadically, but then it accelerated until, in 1936, it culminated in the rebellion of part of the Spanish army in the colonies of North Africa. Instigated by, and under the command of, General Francisco Franco, the army crossed the Straits of Gibraltar intent on starting what would become one of the bloodiest events in the history of Spain, the Spanish Civil War.

But at the beginning of the Republic, my life continued relatively undisturbed. Thinking back now, I don't remember things from that time sequentially but more as a collage of impressions of people and events, some of which stood out more than others.

My mother's family was one of the oldest families on the island. Our ancestors had arrived with the army of Jaime I, El Conquistador, to reclaim the land from the Arab invaders who had occupied parts of Spain for eight centuries. It was after a victorious battle that the king famously sat down to rest and sustain himself with a hearty meal of bread, olive oil, and garlic. Feeling satisfied, he declared, "*Ben dínat*" (literally, "I have eaten well"). In that same spot, a castle was erected by one of my relatives, and it was called Castillo de Ben Dinat. And there it stands, almost seven hundred years later, still with that name.

My father's ancestors also came to re-conquer, but after they succeeded, they went back to the city of Valencia on the Peninsula.

MALLORCAN TALES: GROWING UP

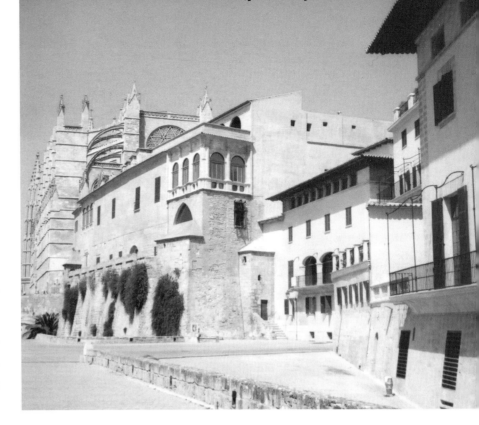

Se Murada, grandparents' house in Mallorca, and neighboring buildings: the Bishop's Palace, the cathedral, and the old Moorish fortress, the Almudaina Palace.

My mother's parents had been very wealthy. My grandfather Fernando not only had his own fortune but inherited an even larger one from a childless aunt. In addition to many beautiful houses and properties across the island and in Cataluña, they had the Castle de Requesens in the Pyrenees Mountains near the French border and the Castillor de Peralada farther south. They were one of the original seven noble families on the island of Mallorca, their title Marques and Marquesa de la Torre. (On the island of Mallorca, there was much intermarriage among the seven noble families, which is probably the reason quite a few of the descendants weren't very bright. Thank goodness my father came from the Peninsula—I like to think that helped me out!)

My mother's oldest brother was the family heir, and he was allowed to seek pleasure any way he wanted. He was a heavy gambler who used to spend his nights at the fancy local casino, Las Minas, surrounded by his administrators, who were always ready and willing to provide him with instant cash in exchange for his signature. By the time I was born he had managed to greatly diminish the family's fortune.

But my grandmother, María Magdalena, still lived in a beautiful palace within the ancient walls that had been built in years past to defend Palma from marauders, pirates, and invaders from North Africa and the eastern Mediterranean countries. The wall separated the house from the Bay of Palma. Next to grandmother's home, on a higher parapet, were

the bishop's palace, the cathedral, and the fortress of the Moorish kings that now housed the governor of the Balearic Islands. From my parents' house to grandmother's house was a very short distance but one I was never allowed to walk alone. If I wanted to visit her, I had to wait until it was convenient for an obliging adult to take me.

When I knew my grandmother, she was already very old, but she was wonderful and very relaxed, so different from my neurotic mother, her sixteenth child. When I was very young, I loved to visit her, and I have great memories of that time.

Under the far end of her sitting room was a gate and a passage that connected the street going uptown with the little plaza on the other side. Two short entrances and a gate led to the beach on the Bay of Palma.

The sitting room had two balconies on one end, one looking up the street toward town, and the other, more or less at the same level as the wall, looking over it and out to the sea.

My grandmother couldn't walk much by that time, so she would sit all day in the space between the two balconies, watching people come down the hill from town to pass below her and then reappear as they continued up the paseo. It was a great observation point, one from which she could inspect all the ladies with their children and nannies, or the priests from the nearby churches. And it was very entertaining for her to peer out as she knitted booties for her great-grandchildren. She had given birth to seventeen children, and twelve had reached adulthood. I was one of her youngest grandchildren—she had seventy-nine of them. Many of my older cousins were already married and enthusiastically contributing to the island's growing population.

At that time, my grandmother was very large and shaped like a pear. She wore long dresses, always black, and when she got up from her chair she swayed from side to side like a large ship heading out to sea. She was loved and very popular, so every evening her living room was filled with local society. People came to chat, to pass the time, and to comment on the day's happenings in town. But during the day she was mostly alone, and everyone else in the house was otherwise occupied. Because I lived nearby and I loved her so much, I often went to be with her. She told me stories and taught me how to knit and how to hem hand-

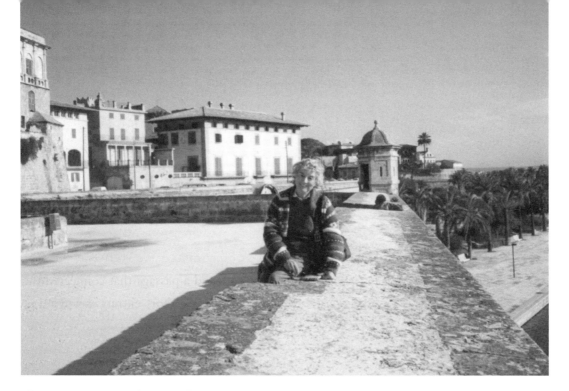

Pilar sitting on a parapet of the old wall, 1987. Grandparents' house in the center background.

kerchiefs and put lace around the edges. If other cousins were there, we would all play out on the wall, La Murada. Along the wall is the paseo, where people would walk, talking and taking in the sun and the fresh sea air. The wall is very long and has little stone garrets with gun windows where, in the old times, the sentinels would keep vigil, protecting the city from invaders. In certain places, the wall widens and there are shade trees and benches and ponds with swans and ducks, protected during my childhood by an old policeman who was always kind to children, nannies, and old ladies, while keeping his eye on the young couples.

La Murada was a very interesting place. In our area, you could look down through the window of an adjacent building where glass blowers using long tubes and a fire pit would turn fireballs into beautiful bottles and vases. In another area, close to the governor's palace, there were barracks, and you could look at the soldiers doing their exercises as they moved in time with the drums. And there was the grand staircase leading to a higher level and another wall called the lookout, and to the entrance of Almudaina Palace, the cathedral, and the bishop's palace. And all this opened to a grand view of the Bay of Palma, the harbor,

La Muralla. 2002, oil on canvas, 29" × 40".

and the windmills of the Molinar. Higher up the pine-covered hill was Bellver Castle, the ancient summer residence of the Moorish kings.

There were many people around at that time I remember now with love and gratitude. One of them is Catalina the Cook, who lived with our family for more than fifty years. She never married because she didn't want to obey a man. She was a very accepting person, undemanding and patient and very intelligent, and in my house she was always treated with total respect. Every morning she went to the market to get what she needed for the day. We had pantries, where we kept the durable supplies, but no refrigerator, so anything that could spoil had to be purchased the day it was needed. Besides being a wonderful cook, Catalina was a great music lover. Her favorite piece of music was Ravel's *Bolero*. She had first heard it when she was younger, listening through a door during a party at my grandparents' house. Every time it played on the radio, she got tears in her eyes. I spent many hours in the

kitchen with Catalina, standing on a chair by the counter watching her chop, trim, and sauté. Though I didn't realize it at the time, she was teaching me how to cook.

After the main meal, which in Spain is served at about two in the afternoon, and after she had washed the dishes and tidied up the kitchen, she and the two younger maids would go to the little parlor next to their bedrooms, where they would mend clothes as they gossiped or told stories. After I learned to read, I would read them the *Lives of the Saints*. Catalina's favorite was the story of Saint Juan Bosco, a terrifying tale of satanic apparitions and horrible temptations that would make it hard for me to fall asleep at night.

There was also Miguel, our chauffeur. If my father was going to arrive very early in the morning when everybody was still asleep, Miguel would come to my room and gather me up all wrapped in a blanket to take me in the car to greet him. I would be the first to see my daddy, because I just couldn't wait. It was still dark in the harbor, with the ship's lights reflecting in the water, and he would arrive and take me in his arms. Much later, after my father's death, Miguel got our maid Rosario pregnant, and my mother fired both of them. They got married, but I don't think they lived happily ever after.

Then there was Catalina la Carpintera. La Carpintera and her daughter Pepa were also my friends. Pepa used to come to my house two days a week to sew our nightgowns and our underwear. She was a very good seamstress and an outstanding gossip, though never malicious. She went to sew in many people's houses, so of course she had endless subjects to discuss. She was attractive and very clever, but never married. I remember one time a man followed her across town, taunting and bothering her until she got really annoyed. Just before she got home, she started to smile and entice him. When she got to her house, she signaled for him to wait, which he did, and she opened a window and threw a bucket of cold soapy water all over him. Served him right!

Pepa's brother, Jaime el Carpintero, was not so great. Once, he came to our house to repair some windows, and as a joke, he grabbed me, carried me up a ladder, and left me on a windowsill, where I clung to the iron grill two stories above the patio. There was a well in the center of the patio, and I thought I was going to fall into the dark still water. That little prank didn't go very well for Jaime in the end.

My father was very often away, either at sea or at other naval bases. The navy also sent him to France, Switzerland, or Germany, and because he was an expert with radio and communications, he was also sent on submarines. I missed him terribly, and when he was home I followed him everywhere, like a puppy, but it didn't bother him. He loved me so much and would take me places. He'd show me the stars at night, and he always gave me books. One day I was sitting next to him on my little stool and, as was my custom, I was reading a book out loud. At first he wasn't paying attention, but after a little while he put me on his knee to see if I was just making up a story and turning the pages. He soon realized that I really was reading. My older sisters had a teacher who used to come to the house. I would follow them to the schoolroom and always ask her questions. Since I wasn't yet four years old, my early reading became a bit of family history. After that I used to read to the maids, and over the years I taught several of them how to read and write. At that time it was not yet the law that all children had to go to school and in some villages many of them didn't.

In the summertime, I went to Son Vida with my grandmother, before the rest of the family. I was always happier when my mother wasn't there. My mother was extremely fearful of everything and overly strict with us. I used to love climbing trees and running with my cousins. Sometimes we would go to the fields with the farm workers, and my grandmother always let me play as I wished.

Son Vida was a wonderful old house, a castle really. It had a tower and crenellations, many rooms with swords and shields hanging from the walls, and armor standing at attention in the hallways. There were twenty-two bedrooms and only two bathrooms, in addition to my grandmother's, which was strictly off-limits. In our bedrooms we had wooden stands with porcelain basins, which were filled with hot water from metal jars. On Saturdays all the children would have a bath in the laundry room. A fire would be made under a huge *cosio* to heat the water, and then one by one we would all get a good scrubbing in an old lead bathtub.

Those summers were filled with interesting things and people and more freedom than I ever knew at home or at school. We played croquet in a large area in front of the main entrance, sometimes even at night under a bright moon. Jorge, one of my older cousins, used to organize theater performances, and we children were the actors, dressed in old

Son Vida, view from a watercolor painted in 2006.

clothing from the attic and smudged with burnt corks to make mustaches and beards. We would go to the hills to hunt for mushrooms, asparagus, capers, and, after a rain, snails. We cooked small meals in a playhouse equipped with a working stove. Sometimes our grandmother would hire us to take turkeys to the pasture, paying us with real money! We loved to play tricks on the grown-ups, including Don Rafael, the priest who also spent the summer at Son Vida, holding Mass daily for grandmother in the little church in the courtyard.

Son Vida was exciting and sometimes scary. There was a dungeon under the tower, and ghosts would show up unexpectedly in the dark corners of the parlors or in the long corridors of the second floor, where our bedrooms were. Sometimes you would turn a corner and see a white figure slowly fading into the dark. At night unexplained murmurs and dragging noises came from the attic, but we got used to it and accepted it because, after all, there was nothing we could do about it. Sometimes, though, if we children had to go to bed a lot

earlier than the adults, a maid would sit at the top of the stairs knitting, in case some of us got overly upset. There was one scary tale about an old *contrabandista,* a smuggler who had lived in the attic for a long time without anybody knowing about him—until one day he was found dead on an old mattress. By all appearances, he had lived a peaceful life among the discards of many generations.

Son Vida's dining room was a huge room with a long table that could seat a hundred people. French doors led to the courtyard on one side and a long balcony on the other that looked over the wooded hills and mountains. We had supper at about nine in the evening and, since it was usually very warm, all the windows were open to the nighttime breeze. Occasionally, a couple of bats would fly in and all the ladies would put white napkins over their heads so that the bats wouldn't get their claws into their hair and hold on. During the summers at Son Vida we children felt equal to the adults. We were even allowed a little bit of red wine mixed with water at the dinner table because grandmother thought it was healthy (as evidenced by our rosy cheeks after we drank it).

These days Son Vida is a luxury hotel. Even the farmhouse where the workers lived has been converted to make space for more bedrooms, and each bedroom now has a modern bathroom attached. But the gardens we played in have all been replaced by bars and swimming pools, the fields of almond and olive trees have been turned into golf courses, and the ghosts of the past have finally vanished. Son Vida is just another resort where people from all over come together to talk of nothing much.

When I was about six years old my father was promoted to the position of admiral of the Spanish navy, and he was given command of the Mediterranean base on the Balearic Islands. We had to move from Mallorca to a neighboring island in the Mahon Harbor, Menorca, where the base was located. At that time, my father was the youngest admiral in the navy, and he had been promoted on the basis of merit, not seniority.

Before we moved, he had to go to Barcelona to be outfitted with his new uniforms and I don't know what else. My godmother (my mother's older sister Dolores) had become a nun after being widowed without children, which was a very typical thing to do at that

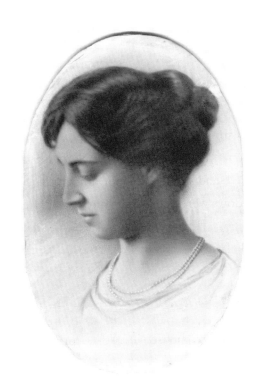

Mother, Concepción Truyols y Villalonga.

Father, Luis Pasqual del Pobil y Chicheri.

time in Spain—as opposed to a woman's traveling and enjoying the rest of her life with all the money she had. She lived in a convent in Barcelona, so my mother gave me permission to go with my father to visit her.

That was the highlight of my life to that point. To take a trip with my father on a ship from Mallorca to the mainland; to board with the rest of the passengers and stand on the deck in the cold night watching the island disappear in the dark; to go to the dining room to have supper with my daddy; and then, finally, to sleep on a real bunk bed in a real ship's cabin—I was completely ecstatic. When we got to Barcelona we stayed at the beautiful

Hotel Majestic, and my daddy took me everywhere: the zoo, the grand park, the Tibidabo, the movies, and, of course, to see my godmother, a meek lady dressed in a white wool habit, in the convent. I never forgot that trip.

Soon after that we moved to Mahon, Menorca, to the naval base. I vaguely remember the trip, but recall very few details. I do remember the house, though. It was white stucco with blue shutters, and it was perched on a high promontory overlooking the base, the harbor, and the white town of Mahon. In front of us, across the water and to our left, was the open sea. I remember my sense of freedom because I was allowed to wander all over the hills of the naval compound where the officers and their families lived. I soon made friends with other children, and I was treated with great deference because I was the daughter of the admiral. I loved that! Catalina la Cocinera and one of our maids had come along with us, but the admiral's house was already fully staffed. I remember only the majordomo, Odon, who made the most heavenly pastries, and the laundress, but that's because I got to know both of them later and under very different circumstances.

I remember those days in Mahon as a blur of brilliant sun and blue skies and the shimmering sea, with me roaming the rosemary- and oregano-covered dry hills in the company of children who spoke Castilian instead of my native Majorcan. We would stop by their houses for treats—cookies and milk, or fruit. There was no fear; we all knew we were safe. From morning until sunset, we would wander all over the place, waiting until that very last moment when we finally had to go home for supper. Sometimes the whole family would take trips around the island, visiting the faraway beaches of white sand and pretty shells; or our relatives in Ciudadela, another town on the island, for the Fiesta de San Juan. The main square would be closed so that young men could perform on their horses, all dressed up in their ancestral costumes. I hold the memories of those days on Menorca very close to my heart.

Then came the war. I don't remember when I first heard about it or understood it, but I do remember certain events. I remember when I heard the shouting of angry voices down at the base in front of my father's offices. Our garden reached as far as the very edge of the cliff, where there was a security fence. I lay on the grass looking down. In front of my father's building, there was a crowd of sailors screaming and protesting and raising their

arms, hands closed into fists in the communist salute. I saw my father appear at the top of the steps, and although I could see his mouth moving, I couldn't understand his words. Eventually, the sailors stopped yelling and listened to him, and then the mood changed and they were cheering him and shouting "*Viva el Admirante, Viva el Admirante!*"

I will never forget the last time I saw my father. The house had a glassed-in veranda that overlooked the harbor. I was outside, looking in at my father, who was sitting in a wicker chair with a book he wasn't reading lying on his lap. In front of him on a tripod was a machine gun, pointed at him, and a man dressed in black with a red scarf, not a sailor. I wanted to go to him, but the door was locked and the man would not let me in. I waved to my father and he waved back. I stayed there for a long time, and I don't know what happened after.

The next memory is of my mother and my sisters and Catalina and Francesca and me all crowded in a little room in Majordomo Odon's house in Mahon. My mother was drinking tea. We had been evicted from the Admiral's House and had nowhere to go. We had no money and we had to hide. I didn't understand any of it at the time. Odon and the laundress (I can't remember her name) took us to an attic that was used as storage for old furniture. They were taking a great risk, I am sure. They were good people. We spent a long time in that place, making our way among the discarded furniture. There were windows, but we weren't allowed to open them because we might be discovered by the snipers that were shooting from the streets at almost anything that moved. I remember looking through the shutters—we were on a small square with a church—at the people who were taking things from the church—images, confessionals, benches, anything they could find, and throwing them in a big fire in the center of the plaza while singing "La Marseillaise," the hymn of the French Revolution, and shouting with their fists raised.

Although my mother and my older sisters were not allowed to leave our hiding place (for they would certainly be recognized), my younger sister and I could go out in the evenings with Catalina for a little walk in order to relax us. I always wanted to pass in front of the hospital where they had told me my father was staying because he was very sick. I hoped that by some chance he might look out of a window just as we passed so that I could wave at him. Of course, I later found out that my father had never been in the hospital. My father

and all his officers had been taken to the Castillo de la Mola and were being held prisoner there. Many years later, Catalina told me that every time I asked her to take me by the hospital I was breaking her heart.

It was during just such an evening walk that one of the strongest impressions of the war embedded itself forever into my memory. We had gone to the wharf, the natural direction for a walk if you live in a harbor town. We were resting on an old stone bench by a landing when a derelict cargo ship came to dock by the steps right next to us. It was an old wreck that had been brought out of retirement during the war, and the scene that followed will remain with me until the day I die.

A group of people disembarked, both men and women. They were dressed in black with red bandanas and kerchiefs. The women were wearing pants, which was extremely strange at that time in Spain. But even more shocking to me was that they wore nothing on top other than a red banner diagonally across their torsos. Bare-breasted, they came running off the ship shouting profanities and shooting their rifles into the air, the women just as violent as the men. It was very frightening. Much later I found out that this group, who called themselves anarchists, was one of many marauding through the towns and the countryside, victimizing and killing, seemingly at random and without mercy.

The same group whose arrival I witnessed made their way up to the Castillo de la Mola the next day and opened the door to the room where my father and his fellow officers were drinking their morning coffee. Raising their machine guns, in a matter of seconds they killed all the forty or more prisoners whom they had never before laid eyes on. Father and his officers were buried in a single common grave and, just like that, all of my little friends and I who had roamed the hills together that golden summer were suddenly and forever without fathers. But nobody dared tell me the truth then, so every day I continued to drag Catalina past the hospital, looking up at the windows, hoping I might see my father looking out, and breaking poor Catalina's heart.

A short time later, my mother was able to secure a small apartment that belonged to a young relative who was away. She pawned some of her jewelry, which she had managed to sneak out when we had been evicted, so we were able to hide there and at least survive.

Catalina and Francesca would go out to find food, which was very scarce and expensive at that time and available only through the black market. There was very little to begin with and, on top of that, the militia, perhaps even the same men who had killed my father, would from time to time come by to confiscate in the name of the cause whatever we had and we were all left to starve.

The apartment above ours was used as the headquarters of one of the political parties that were sprouting up all around us. We had to be extremely careful and silent in order not to disturb them, because any small thing could be used as grounds for summary executions. I remember many nights when my mother could not sleep. I had never been her favorite daughter and never would be in the future (I was too independent, too stubborn), but I felt so sorry for her and I would try to keep her company. At that time, life was so disordered that it didn't matter if it was time to sleep, or eat, or wake. Routines and obligations were suspended, and we simply passed the time in our small rooms—sometimes staying up all night, sometimes spending the whole day in whatever passed for our beds. I would try to talk to mother in whispers, and we would watch the armed men and women as they emerged from the building or returned to go upstairs to their headquarters.

Somehow my mother managed to communicate with another woman, the widow of one of my father's officers. She had a house in Barcelona. We could not cross the sea to go back home to Mallorca, which was so very close, or to our grandmother and relatives, because Mallorca had been captured by the other side in this crazy war. So my mother decided we would go with her to Barcelona and then continue the trip to Alicante to the home of my father's brother and sister, Uncle Emilio and Aunt Luisa. We didn't even know if they were still there because there was no way to communicate—telephone and mail service had ceased to function. But what had become very clear was that no matter what, we had to escape from Mahon if we wanted to live. The situation was daily becoming more perilous.

I remember the day we were getting ready to leave. My favorite older sister, Fernanda, had washed my hair and was combing it. She told me we were going to Barcelona to have more freedom and to be safe. I exploded, "What do you mean? We can't escape and

leave our father sick in the hospital! I'm not going anywhere until he gets better and can go with us." It was then that she told me our father was dead. She did not tell me he had been killed. She said he had been very sick and had died in the hospital. I was devastated. I thought it was the end of my life. Since then, I've never had anything affect me with such horrible force. I could not accept it, and at seven years old, I thought my life was over.

We got our meager belongings together and walked the streets before the sun came up so that nobody would see us. We boarded a ship that was in such ruins that nobody had even bothered to confiscate it. Stretching sheets and blankets out on the deck, we sat down and waited for its departure. What happened next is another one of the vivid scenes I carry with me from that time.

We had been waiting for hours—our family, the maids, and the lady from Barcelona. The sun was becoming very hot. Suddenly, a group of militiamen, dressed as usual in black, with red kerchiefs and with guns pointed, boarded the ship. Grabbing the lady from Barcelona, they opened her suitcase, searched her, and then claimed they had found some papers hidden in her corset. Everybody was forced to disembark, and right before our eyes the widow was gunned down in front of a nearby low cliff. They left her body draped over the rocks—I'll never know how long she was left there.

I suppose we went back to the apartment, but I don't remember that, or how long we stayed there. But we eventually found another boat, and this time we did make it to Barcelona. We didn't know if we would find our father's family in Alicante, or even if they were still alive, but there was nothing else we could count on. After we got off the boat, we went directly to the train station and caught the next train to Alicante.

Another officer's widow and her son, Toni, a boy who was about my age, were traveling on the same train. We had some crayons and a small tablet of paper. I was painting a picture and writing something about the images in very bad writing. The train was very slow, so some people even had time to jump out, pick some fruit from a tree, and climb back into another cabin, which was a good idea since food was so scarce. There were guards walking along the corridors of the train, looking into the compartments. Once, one of them put a pistol to my head. When I looked at him, terrified, he responded with a crazy grin and

then said he was just kidding. The train stopped in every station, and we all had to get out and be searched before we were allowed to climb back in. If you had anything of value, it would be taken from you. We weren't allowed to wear our earrings for fear they would be torn out of our ears. But in one of the stations, a militiaman got hold of the papers Toni had in his pocket, and because the soldier couldn't read, he was convinced it was some kind of code. He wasn't going to let the boy back on the train. All of us were already on the train, and Toni's mother, too, and the train was starting to move. All of a sudden, a man who was on the train reached down, grabbed Toni, and pulled him up onto the moving train. It was such a relief, because if someone was separated from you that might be the last time you ever saw them.

We made it to Alicante and found that my uncle and aunt were still there, though they were planning to escape as soon as possible. My uncle's house was situated on a beautiful square called La Plaza de Ramiro, which was almost at the waterfront. It had very tall palm trees in front, and the militiamen said they were going to hang a Pasqual del Pobil from every tree. I guess it was convenient for them that we had just provided them with a much larger supply, since there were so many trees. As far as I know, my family hadn't done anything to deserve that treatment, other than being of the privileged class. My uncle had four maids and a chauffeur working for him. The maids were all very loyal, especially Concha, who had been with the family for many years, but the chauffeur had joined one of the many parties that had recently sprung up all over Spain. He assumed charge of the house, making a few rules for us to live by, including that we keep the upstairs balconies open and the lights on so that we could be easily observed in the evenings as we sat in the dining room or living room.

Again, I don't know how, but we managed to escape. My uncle had a lot of money and knew many people. We were all given fake passports. My mother and sisters and I all became Argentines, while another aunt and her children became French. Under that guise we were able to pass through customs fairly easily. But Uncle Emilio, Aunt Luisa, and our cousin were too well known in town, so they dressed as French naval officers and a wife and passed through customs also. We all met in an oil tanker in the harbor and waited there for

several days for a large German transatlantic ship that was due to arrive. When it did, it wasn't allowed to come into harbor, and so we had to go out to sea to meet it.

It was very dark, and we had no lights on our small boat. As soon as we left the shelter of the harbor, the sea became very rough. The boat would rise high atop a big wave and then quickly drop down hard. The water was washing over us, leaving us soaking wet and shaking with cold. My mother was becoming more and more hysterical, and soon she was screaming every time a wave hit. Every time she screamed, I would join in, too, screaming as loudly as I could.

When we finally arrived at the side of the large ship, it loomed over us like a huge black cliff. Hanging down its side was a rope ladder we were supposed to climb. There were three sailors standing in our small boat and more up along the ladder. The first sailor would grab one of us children then, swinging us back and forth, toss us to the next sailor, and in this manner we made our way, flying from arms to arms up the ladder and onto the deck, where we landed soaking wet and terrified almost to the point of shock. But at last we were safe.

It was not a luxury liner, by any means; it was a boat used for transporting troops, so there were no staterooms. Down in the hull there were bunks, three or four high, so once again we had to climb ladders, this time just to go to bed.

Our original plan had been to go to the Netherlands, but when we got to Lisbon my cousin Isabel and her husband (they had also escaped, on foot and by way of the Pyrenees Mountains) somehow managed to radio to the ship, so we disembarked and joined them. First we went to a cheap hotel in Lisbon; later we moved to a house. We stayed there until we were able to cross the border into Spain again.

My most vivid memory of Lisbon from that time is of the huge rats that ran through our rooms at night. Every night when we went to bed we had to pull our blankets and sheets well off the floor so the rats wouldn't grab them and then climb up on the bed to walk on us—though sometimes they did anyway. I also remember walking in the Plaza de Rocio and seeing the beautiful colors of the buildings—light pink, blue, green, or cream, glowing in the sun. After we had spent some time in Lisbon, our family rented cars and we drove to Bada-

jor, Spain. My cousin Isabel's husband was Nicolas Franco, General Franco's brother. (I am not proud of this connection, but that was the situation, an immutable fact.) I never met the Generalíssimo, but I liked Nicolas, and years later, when I was a young girl and visited them in Lisbon, he was a very good friend to me, and his son Niki was then and still is a very dear friend, whom I still sometimes visit when I go back to Spain. Nicolas was the Spanish ambassador to Portugal, and I visited them there several times, sometimes spending the summer.

But that was much later. At this time, we crossed the border into Spain and went to Badajor and again stayed in a hotel for quite some time. I don't remember much, except that I made friends with two little girls who always dressed in black. One time I overheard my cousin Isabel speaking to their mother, explaining that my father had been shot just as her husband, their father, had. It was thus that I learned the truth of my father's death. That brought on another crisis for me, which led to many years of nightmares. I would scream in the middle of the night, unable to wake up. My sisters found these episodes so terrifying that none of them wanted to sleep in the same room with me.

Fortunately, our trip to Mallorca was somehow arranged. I vaguely remember a train crossing a bridge with a wide river below, and I remember the Rock of Gibraltar, El Peñon. That was where we embarked on the British boat that took us to Mallorca and home, at last, to our old house. About a week after our return, my beloved grandmother had a heart attack and died. The rest of the family blamed us because they said her death was brought on by all her suffering over our fate. I could never figure out exactly why that was our fault.

Spain was still at war. Nearly every day, airplanes flew over to bomb and terrorize us. In Palma the authorities had opened big holes in the streets with steps leading to the tunnel used by cargo trains transporting goods to the rest of the island. When the sirens started wailing, usually in the middle of the night, we would all come out of our houses and take shelter in the tunnels. They were cold and humid, with water dripping down the walls. We would sit for hours, until we were completely sure the attack was over. When we emerged onto the streets it was funny to see the outfits people had hurriedly thrown on while fleeing. My mother had Pepa make pajamas from a wool blanket for my little sister and me to

sleep in so that we would always be prepared to make a quick exit. They were really uncomfortable and itchy, but they probably did keep us a little warmer on those cold nights in the tunnel. When you came out of the tunnel, you never knew if your house would still be standing. Ours, luckily, was never hit.

After several months of this routine, my mother decided to go to Son Vida, where she hoped we would be safer and also find more to eat. Food was very scarce, and we were almost constantly hungry in Palma.

When the war finally came to an end and Franco proclaimed himself Generalíssimo, the supreme power, I was much too young to understand. Since both my mother's and my father's families were from the privileged class, I assume most of them were behind Franco. Later, I came to realize that the Right, the conservative party in Spain, had, from the beginning, undermined the elected president of the Republic because they didn't want to lose the privileges that came with their station. They justified this by claiming that, in Spain, the common man and the public in general were too ignorant to know how to govern themselves in a democracy. They needed a so-called strong hand, a paternalistic rule, and Franco was the self-chosen father of this dictatorship.

Most of my relatives were for Franco, but I am happy to remember that many of them resented my immediate family, my mother and sisters and myself, saying my mother didn't deserve the pension she received from the government for being an admiral's widow. You see, my father had remained in the navy after the Republic had been declared, refusing to resign in protest when the king had been deposed, unlike many other officers, generals, and admirals. I was too young to know, but some of my older cousins, who later stood against the loss of freedoms and against the controlled press, told me they had always admired my father for his stand. He did not hate the king, but he knew that Spain needed a new form of government, progressive and democratic. He was a good man who died unjustly in a time of insane chaos, confusion, and violence. The war resulted in the long domination of my country by a conceited, cruel, and ridiculous little man with a mustache, who pulled Spain forty years behind the rest of Europe. ❧

✒ my grandfather's cook

Y MATERNAL GRANDFATHER, Fernando, was born in Mallorca a long time ago. In fact, he died before I was born, and I have been living for a long time. He was a nobleman, and his title was Marques de la Torre. He and my grandmother, María Magdalena, lived in an old palace over the city's medieval wall next to La Almudaina, the ancient fortress of the Mallorcan Moorish kings that is now the residence of the governor of the Balearic Islands. They also had a country estate called Son Vida.

My grandfather and King Edward VIII of Great Britain had one thing in common: they both had a French chef, and both chefs had been trained at the same culinary school in Paris. The two men had became good friends and kept in touch long after they graduated. On one occasion, the king's yacht moored in Palma's harbor while my grandfather's household was in Son Vida for the summer. The king's cook made his way to the country to visit his old friend Bernardo, my grandfather's cook.

Son Vida was a beautiful country house on the outskirts of Palma, up in the hills covered by pine, oak, and *esparragueras* (asparagus bushes). Son Vida was beyond the small village of Son Rapiña, a pretty place with stone houses; crooked, cobbled streets; and an old church with a stone tower. In my youth, I spent the summers in Son Vida with my grandmother. Every Saturday, we would walk to the village to buy *alpargatas* (espadrilles) that we would demolish on our jaunts over the hills, dirt roads, and fields the following week. It was about three kilometers from Son Rapiña to Son Vida, mostly uphill. Walking from the village to the palace, we would pass the lower fields and the *era*. The era is a large stone circle where, during the harvest, the cut wheat is piled in heaps. It has a center pole that holds a long bar with a rectangular metal plate. On windy days, a horse is harnessed to the end of the bar, blindfolded, and pulls the bar around and around, lifting the wheat up into the

air so the wind can separate the grain from the chaff. The result is two big mounds: one of grain, and the other of straw. We children would jump on the straw as on a trampoline.

Continuing our walk, we would pass the house of Jordi the woodskeeper and his wife, Margalida, a potter who made *ollas* and *graxoneras* from the nearby red clay. The hill became steeper as we passed the entrance to the lower gardens. After crossing a small wood of pine trees, we arrived at the main gate of Son Vida, which was made of stone and built like a fortress. It resembled a short tunnel, and on both sides there were shelters for the dogs to sleep. The main gardens started just past the gate, and a long, curved drive led to a wide esplanade in front of the entrance to the house.

The main part of Son Vida was built in the late thirteenth century, when our ancestors came to the island from Cataluna with the armies of Jaime I El Conquistador, King of Aragon, to reconquer Mallorca from the Moors who had invaded Spain seven hundred years earlier. My ancestors evidently had good taste, for they stayed on the island after the victorious king returned to the Peninsula. They could not have found a better place.

Much later, when my grandfather inherited a very large fortune from a spinster aunt, he enlarged Son Vida by building a tower, a spectacular main entrance, and by making the entire house a real showplace.

My grandfather's hobby was carpentry, and he had a magnificent shop in a stone wing on one side of the house. He made wonderful furniture. Son Vida was a beautifully appointed place. The walls in the *salas* were hung with silk damask in red, green, or gold, and the ceilings were *artesonados*, carved wood in dark tones. There were many paintings, some by old Spanish masters and others by Mallorcan painters who have became famous, too. (Mallorca has very good artists; the beauty of the island has inspired many, including poets and composers.) The walls of the dining room, which had a refectory table that could seat a hundred, had murals depicting ladies and gentlemen in hunting clothes with their horses and hounds. Son Vida also had a central patio, or *clastra*, with a fountain and rubber trees and flowers. On one side of the patio, stone steps led to a charming little church; my grandmother had a priest, Don Rafael, who would spend the summer, so she could attend Mass every day and he could hear our confessions.

There was a long stone terrace on the east side of the house that ran the entire length of the building; it was the place to sit in the afternoon, with coffee, after the main dinner, which is usually served at 2 P.M. From this terrace you could look down at several levels of gardens with palm trees and *pitas*, beyond those to the fields of almond and olive trees, and beyond those to the church steeples of small villages. In the distance you could see Palma, with the *campanarios* (cupolas) of the cathedral and the towers of the Bellver Castle, standing on its own pine-covered hill. Beyond it all, shimmering blue in the glorious sun, the Bay of Palma.

But, back to the story. The two cooks, grandfather's Bernardo and the king's chef, got together and had a great time reminiscing about their experiences. Bernardo showed off the estate of his employer, the house and the gardens. The king's cook was very impressed. There were many flowers, so he asked Bernardo if it would be possible to get a bouquet to adorn the king's table that evening. Bernardo asked grandmother's permission, and she obviously felt honored by the request. My mother and her sister Mercedes, both very young girls, were put in charge of the project. They got overly enthusiastic, and the result was several magnificent baskets of artistically arranged flowers that were delivered by carriage to the king's yacht in time for dinner that night. The flowers were so spectacular that King Edward was apparently astonished and asked his servants where in the world they had come from. The cook was called into the royal presence and his explanations were so expressive that the king sent an emissary to my grandfather, asking his permission to visit the estate.

My grandfather was thoroughly confused by the story of the cooks, the flowers, the yacht, and the British royal family. Nevertheless, in the island tradition of hospitality, a formal invitation was sent to the king and a great dinner was (of course) prepared by Bernardo. It was served in Son Vida's vast dining room, with many of the island's important residents in attendance.

During the course of that dinner, my grandmother had occasion to correct the table manners of one of her daughters, Mercedes. For years it had been her habit to rest her elbow on the table while eating, and no amount of scolding had been effective in correcting her lack of manners. That very day, amid all the pomp and ceremony, while Mercedes

was engrossed in the conversation (French was spoken) and many savory dishes were being eaten, Mercedes, according to her natural inclination, put her elbow on the table. Instantly, a footman in *líbrea* (full dress, for special occasions) approached her and, with the most delicate touch, lifted her arm and slid a red velvet pillow under it so she could rest more comfortably. The family story recalls that Mercedes never had to be reminded again of good table manners.

There is a sequel to this story. In 1989, Queen Elizabeth II of England visited Mallorca. Naturally, there was a great to-do and a lot of publicity in the local papers and on television. It was reported that Elizabeth was the first reigning British monarch to visit the island. "Not so," said my mother, who was ninety-eight years old and the last surviving member of her family's generation. She proceeded to tell the story of King Edward VIII visiting Son Vida when she was a young girl. One of my cousins called the press, and a reporter was sent to interview my mother. She told him the story in detail and with such clarity that the reporter went back and looked in the archives of the old newspaper *Diario de Mallorca*. He found the story to be true, so they published a retraction with an apology to my mother and said that Elizabeth actually was the second reigning British monarch to visit Mallorca. ❧

❧ la difunta (the deceased)

IT WAS LATE IN THE YEAR, and the weather had turned wintry. A cold wind from the sea was blowing up the crooked streets and playing havoc with the dry leaves of the sycamores. It was very dark; the few gas *faroles* on the corners splashed patches of light on the wet cobblestones. The lady was shivering, her flowing robe and her veil trailing behind her as she walked quickly, anxious to reach the home she had left earlier in the day under such unusual circumstances.

The lady was my great-grandmother and the time was the 1800s. The place was in Alicante, a town on the eastern coast of the Iberian Peninsula, where my father's ancestors had made their home for the past several centuries. Alicante is a beautiful Mediterranean town. It does not have mountains or forests, but it has long beaches of white sand that stretch nearly forever, until they end at some rocky point tumbling into the sea to continue on the other side until another obstacle interrupts their path, and so on again and again. It has a harbor that now provides a shelter for yachts and recreational boats but in the old times was used only by fishermen. Later it was a port for a few ferries taking passengers from the Balearic Islands to the mainland and back, and perhaps to Africa. Along the waterfront is a *paseo* with tall, slender palms. It is usually a nice, friendly place, with restaurants and cafés inviting people to sit and enjoy the pleasures of the cool breezes and the mostly blue skies. Farther into town, one finds older streets; narrow streets leave the main road at various angles and, from time to time, open up into small plazas with an old church or a convent presiding in their center—San Nicolas, Santa Maria, San Pedro, and even the cathedral, in a larger square. If you go farther, you will find a hill, not very high, but high for Alicante. On the summit, there stands a medieval castle, El Castillo de Santa Barbara, a fortress built in early times to defend the coast from invaders and pirates who, during Spain's long history,

would make their way to the Iberian Peninsula from Africa and the eastern Mediterranean countries.

My great-grandmother's name was Beatriz. She had been born in a northern Spanish town, Leon, and, according to family records, she was a noble and beautiful lady, one of the ladies-in-waiting to the Spanish queen Doña Juana La Loca. This queen was indeed *loca* ("disturbed, crazy"); when her adored husband died in her arms, she refused to allow his burial. Instead, she embarked on a long, aimless trip, a pilgrimage to nowhere, taking his coffin in a wooden carriage pulled by members of her court. Each night they stopped in the countryside, where her servants would build an altar and the coffin would be opened so she could kneel by it in her *reclinatorio* holding the decaying hand of her deceased husband, and ordering everyone in her entourage to kneel and pray with her. There is a painting in the Museo del Prado in Madrid depicting this scene.

At some point, to her credit, my great-grandmother managed to get away from the procession—I don't know how, but she did, and good for her! She met my great-grandfather, and they fell in love. They were married and went to live in Alicante, his ancestral home, where she became well loved for her charity and admired for her beauty.

The family owned lands, orchards, and fruit trees, but their house was in the city, an old Spanish house that still exists, stern and unforgiving from the outside, with barred windows and *rejas* and the big *portalon* with the heavy doors and brass *aldabas* (door knockers) always shut tight against unwelcome intruders. By contrast, as often happens in Spain, the interior had sunny rooms and a central patio, with a fountain and flowers and happy children. One day, her happy life took a sad turn: she became ill with an undetermined malady. Doctors were called, they had consultations, and everything possible was done, but her mysterious illness prevailed. She lost the will to fight and, one morning in early fall, she did not wake up to the new day. She was dead. Her husband was devastated, her children inconsolable, the whole town in mourning. They washed her and combed her beautiful hair; they dressed her in her wedding dress and pinned the white veil to her curly locks. They put her coffin in a horse-drawn carriage for her last trip to the Church of Santa Maria, where the funeral was to be held in the morning. They left her there, in the care of her Savior, among

the images of saints she had revered during her lifetime, and the family went home with their sorrow. The church was lonely and empty. It was night, and no light came through the stained-glass windows. Only a few candles burned around the coffin, and two or three silver lamps hung over the altar of Mary and in the sanctuary, the *sagrario*. It was silent with the silence of death and eternity.

But sometime soon after midnight, the sacristy door slowly opened with a little squeak of its unoiled hinges. A dark figure slid stealthily into the nave, walking quietly and carefully. It approached the coffin and opened the lid. There was Beatriz, lying peacefully in her eternal dream. Her skin was transparent and very white, her eyelids closed so that her long lashes touched her delicate cheeks, and her slender hands with their long fingers were crossed over her chest. On her left middle finger she wore her wedding ring, the large diamond that her loving husband had wanted her to take to her grave. It caught the light of the candles in the church's penumbra, and the stealthy figure put his hand on it. The ring was tight, and it would not come off. His other hand took hold of Beatriz's wrist while he gave a mighty pull. At that moment, Beatriz sat up, like a puppet tugged by a string, and opened her eyes. The sacristan nearly fainted with fright, and it is a wonder Beatriz did not herself faint, waking up in a coffin in the solitude of a church, with a dark figure leaning over her. Instead, she climbed out of the coffin, gathered her skirts, and ran to the door, where, fortunately, the key was in the lock. And that is how she came to be in the lonely, rainy, cold streets of Alicante one night in early winter, running for her life to her safe place—her home, her husband, and her family. When she arrived, she got hold of the *aldaba*, and started frantically knocking at the door with all her strength, the noise sounding loud in the silent house. A maid looked down from an upstairs window and started screaming hysterically, "The Lady is here! The Lady is here!" The family woke up, the husband came down, and there was Beatriz, back home, returned to her health, her life, by the grace of God! In the morning, Beatriz sent her diamond ring by special courier to the sacristan.

uncle julian, aunt marita

MY UNCLE JULIAN WAS A WOMANIZER, and he came from a long line of aristocratic womanizers. The legend said that one of his ancestors, the Count of Esparraguera, was one of the last landowners on the island to exercise on his subjects the ancient right to deflower every virgin in his domain on the night of her wedding, before the girl was given to her lawful husband. Another of the count's charming habits was to spend Sunday mornings in his townhouse in the village square, in front of the parochial church, "playfully" shooting the backsides of the peasants with a BB gun as they exited the church after Sunday Mass.

It was said that he had a pact with the devil, and that, on the night before his burial, when his coffin, covered in the black velvet of mourning and surrounded by candles, was resting in state in the salon of his palace, his body disappeared and was replaced with the trunk of an old dead tree.

In spite of his dreadful ancestor, my uncle Julian was a handsome, charming, and debonair man, a favorite among the ladies. Though his family had lost a good part of their ancient wealth, he still retained his palatial home and the prestige of his name and his title. He had traveled extensively throughout Europe and the Orient and had as much culture as could be reasonably expected in a man as fond of leisure and pleasure as he was. He really liked to have fun, and he remained a bachelor until his late thirties, when he married my aunt Marita, then barely sixteen.

I understand that Marita fell head-over-heels in love with him, and of course she was very flattered that a man of the world such as Julian had chosen to marry her among all the other women who would have given anything to have him. They took a honeymoon trip unlike that of any other couple on the island, touring France, Italy, and the Greek Islands. It was a dream!

for a minute and then I said, "Well, not very often. But once in a while, if I am really, really bored and I am alone and I don't know what else to do, I'll grab my Parcheesi and I'll play both sides of the game." I could see Don Rafael's face through the screen of the confessional, and I'll never forget his dirty little smile. I immediately knew I had said some really stupid, idiotic thing, but it was a long time before I knew what he had had in his corrupted little mind.

I was just a child. 🐦

❧ carlitos

WHEN I WAS A CHILD, I LIVED ON AN ISLAND. It was a different world. On this island, we had a different language, society, and culture from the rest of the country. My mother belonged to one of the seven aristocratic families on the island, and my grandmother was the Marquesa Viuda de la Torre. The other six families were also titled. All of them had intermarried for generations, and their descendants formed the upper echelons of the society. The professional class—attorneys, doctors, the military, and so on—came second, and last came the working people and the peasants. In general, the men of the top class did not have careers or formal work, except for those few who joined the national armed forces, where they held the top posts. The men of this class typically had the usual country-gentleman activities, such as riding horses, racing hounds, gambling, chasing women, and sometimes administering their vast estates. It was through gambling that my uncle Pedro, my mother's oldest brother and heir to the title and the fortune, lost most of the family lands.

My father was from the mainland—the Peninsula. His family was from Alicante and was also an old family with a title, but their values were different. To begin with, they had not been so wealthy. As a tradition, the men belonged to the Royal Navy, and my paternal grandmother, María Luisa, was Italian. She was probably one of the first emancipated women in the country. She was a writer and poet and did not take any nonsense from her four sons and one daughter. María Luisa prepared her sons for the Academy of the Navy, and my father, Luis, was on his way there when he was only about fourteen years old. He was the youngest of his family. By the time he went, his older brothers were already there, and all but one became naval officers. One of them, Ricardo, was too much even for his stern mother and never made it because he was a rebel and wanted only fun.

When my father was a young officer, he came to the island in his ship for war maneuvers. There was a grand ball in the casino in the officers' honor, and that is where my

Paternal grandmother, María Luisa Chicheri de Bellinzona, Marquesa de San Felipe.

Paternal grandfather, Eusebio Emilio Pasqual del Pobil y Guzmán, Barón de Finestrá.

mother and father met. He was very handsome in his uniform, and my mother was a beauty. My father fell in love right away. They were married soon afterward—hardly knowing each other and not even speaking the same language—as my mother did not speak Spanish. It was a matter of pride on the island to ignore the official language of the country. She spoke Mallorcan and French because she and her sisters had a French governess. When they married, they had never been alone together in the same room, and it was not until later that my father insisted she learn Castilian. Castilian was spoken in our house and with our family ever after.

We lived on the island because my mother never wanted to leave. Two or three times, she followed my father to different posts, and once they were in Madrid for three years when he was in the Ministerio de Marina. That is where I was born, the only member

of the family to be born outside the island, and also the only one of my grandmother's seventy-nine grandchildren who was born on the Peninsula. As a result, I was always called *La Forastera* ("The Foreigner"), which set me apart forever, for good and for bad. Following the years in Madrid, we lived in Palma, since my mother always complained and felt sorry for herself when she was away. After the war, and my father's death, we settled there permanently. My mother never left the island again. She died at age ninety-nine.

As a child, I was very imaginative and I learned to read on my own before I was four. I adored my father, and the fact that he was away so much made me quite obsessive about him. When he was to arrive home, it was an established fact that I would go to meet him at the harbor. He arrived very early in the morning on the *Correo de Mallorca*, the overnight boat that went between the mainland and the island. Our chauffeur, Miguel, would come into my room before sunrise, wrap me in a blanket in my nightshirt, and take me in the car to the dock. I can still recall the bliss I felt then when my father came to the car and took me in his arms. He had a unique smell—the sea, cigarettes, his wool uniform, and shaving soap. It was a smell I never forgot, even when I was left without him forever in a family of only women—my mother and older sisters.

I remember the day it was discovered that I could read. My father had just arrived, and I had been following him around, as usual, carrying my little stool so I could sit as close to him as possible. I had a book of *Grimm's Fairy Tales*, and I was sitting reading aloud (I always read aloud). At first, my father thought I was making the story up, but slowly he realized I wasn't. He took me on his knee and made me read for him. I did, without hesitation. That became one of the family legends—I was a true wonder. It was determined that because I always went into the schoolroom where my older sisters had their daily lessons with their teacher, and because I was always asking questions, I had been able to learn on my own.

From that time on, I was always a good reader; it became one of the reasons I was often ridiculed by my cousins. They thought reading was boring and a waste of time. They also ridiculed me because I spoke Castilian, had some peculiar manners, and was born in Madrid. I was a *forastera*.

Our house was in the old part of the city, the Calle de Santa Clara, a short distance up the hill from my grandmother's house. Today, only fragments of the wall remain intact. Her house was a grand place that sat on the old defense wall, La Muralla, by the sea. Part of her living room straddled one of the old city gates, La Portella. That part of the room had two balconies, one of them looking up the street, La Calle de la Portella, and the other, facing directly opposite, looking over the wall and to the sea, the Bay of Palma. My grandmother had a choice observation point. She could watch people coming down the street until they went through the gate over which she was sitting and came out the other side, and she could see up to the Muralla. Over the years, the Muralla, which in older times had once surrounded the city, became a gathering point for people taking the sun, children playing, nannies gossiping, and lovers holding hands. She spent her life sitting there, when she was in town, knitting booties for her many grandchildren and great-grandchildren. She was a wonderful lady.

I remember one day when I was out with my younger sister and our nanny. Because we lived in a townhouse, she took us to play at the old wall every sunny day. The wall was, and is, quite extensive—like a long park. In one area it is very wide, with trees, benches, and duck ponds. There was also a grand staircase that led to the Plaza de la Cathedral, the Palace of the Bishop, and the Moorish fortress, La Almudaina, where the Captain General had his residence. All these beautiful buildings loomed high over the wall, which, on sunny winter mornings, filled with pigeons, children, nannies, and an old policeman keeping order and taking care of everything. In the *fosos* (moats), soldiers of the nearby barracks did exercises. It was a very colorful place—full of life.

On this particular day, the three of us were just coming back, hot and tired, right at the two o'clock dinnertime. When we got to the house, there was a big, black, shining car stopped at our door. Because this did not happen very often, it was very exciting, especially when my father was away. There were few cars on the island that we could not recognize. Besides, we did not have many visitors who came from so far away that they needed a car. Most people liked to walk and were never in such a hurry that they needed to ride. So I knew that something unexpected was going on and, full of curiosity, I ran upstairs ahead of

the others. Of course, I was right—something was different. For the first time since I could remember, a member of my father's family had come to visit us. Because we were across the sea, it was a very unusual occurrence.

It turned out to be Carlos, a second cousin of my father's. Although I don't know how old he was, because I was a child he seemed pretty old. He was perhaps only in his late thirties. He had just married and was on his honeymoon. His wife, Rosario, was even older than he, and she wore thick glasses and was pretty overweight. They were not a glamorous pair, but they were very nice, and my mother had already invited them to stay for dinner. There had been no time to prepare anything special, but our cook, Catalina, was good, and there was never a need to be embarrassed by unexpected guests. Carlos and Rosario visited for a while and talked a lot, especially Carlos. After they left, I never saw them again. But I never forgot about them because they were *forasteros*, like my father and me.

Many times after that day, when we were coming home from playing at the wall, I wondered if there would be another black shining car parked in front of my house with exotic people visiting us. It never happened again. Nevertheless, we kept getting letters from our cousin Carlos. He was a euphoric, talkative type, and like me he wrote more quickly than he thought. He wrote about the research he was doing on our ancestors in the Basque country, as far back as the ninth century. He wrote about his older brother, who held a high office in the Generalitat, the regional government in Barcelona. He wrote about what was wrong in our country and what should be done about it, and about his career in the aviation corps. Mainly, he wrote about his young son, Carlitos.

We knew everything about Carlitos. We got a baby picture of him lying on his tummy naked, with a cute smile. In another picture we saw his first tooth and his early steps. We knew where he went to school, we saw him playing on the beach with his little shovel and bucket, and we saw him sailing his boat off the shore. We were sent a formal photograph of his first communion; he dressed in a sailor suit, with a white bow on his arm and a candle in his hand. We also read how smart, clever, and handsome he was.

This went on for years, even after my father's death and the end of the war. Carlos never came back for a visit, but he liked to write and, obviously, he liked to talk about his son. When Carlitos was a teenager, the letters came less often, and when they did, they

talked of other things. Carlitos had become a sort of good-natured joke with my sisters and me, because he had been so cute and perfect and his daddy had bragged so much about him. Sometime later, when we had almost forgotten him, a sad letter came. Carlos said he was very unhappy with his son, and, if by chance he came to the island and asked to borrow money, we were not to give it to him. This advice was unnecessary because after my father died and the civil war ended, the country was poor and we had hit hard times. Every penny counted. Nevertheless, it was significant and very sad that he felt he had to warn us, when he and Rosario had loved that boy so much.

Sometime after that, I married and came to the United States with my American husband. After the birth of my first son, named Luis, in my father's memory, I had to travel out of the country to get a permanent resident card. I went back to my island. In the process of arranging my papers, I had to go to Barcelona to the American consulate. While I was there, I visited some school friends, and the mother of one of them said to me, "I was sorry to hear about your cousin's son." I did not know what she was talking about and told her so. With some reluctance, she told me the story.

My cousin Carlos and his wife, Rosario, lived in an apartment building not too far from this lady's house. They were very friendly with another couple in the same building and often got together to play bridge on Saturday night. One night, they were playing in Carlos's apartment, and the other couple's children, a boy eleven and a girl eight, were left alone. In the middle of the game the young boy telephoned. He was frantic because they had a robber in their place. A masked man had entered the apartment, gotten hold of the little girl, and demanded money or jewels. He threatened to kill her if the boy didn't comply. Terrified, the boy went into his parents' bedroom under the pretense of getting the goods and got a gun from the dresser drawer and shot the bandit.

The two couples rushed to help the children and found them in their nightclothes, hysterical, the boy holding the gun and the bandit lying on the wooden floor in a pool of blood. They took the gun, called the police, and tried to comfort the children. When they took off the bandit's mask they discovered that the young man behind it was my cousin's son, Carlitos.

❧ *the arrival*

N THE YEARS OF MY YOUTH IN MALLORCA, according to my personal observation, whether partial or impartial, the character of the Mallorcan aristocrat was a curious blend of true noblesse, ignorance (except in elective subjects), generosity, friendliness, snobbery, stubbornness, humor, recklessness, and who knows how many other traits.

Uncle Pedro had them all. As a child, I saw him as an imposing figure: tall, very handsome, with a thick batch of white hair and the ruddy complexion of an outdoorsman. To a little girl like me, orphan of the war, he was either casually kind or casually dismissive. Fond of horses, dog racing, hunting, and carpentry, Uncle Pedro was also a scholar of Spanish history who was proud of his long ancestral lineage. He thought his home, his family, and his island were the center of the universe. His sense of entitlement had no limits. He had been born *el heredero*, the heir, the eldest son, with all the undisputed rights to indulge his tastes and desires. Whether those were right or wrong, reasonable or unreasonable, wise, stupid, affordable, or otherwise was of no consequence.

After my grandfather died and before I was even born, he had become the head of the family. According to the ancient laws of the Kingdom of Mallorca, the heir could do as he pleased until the time when the estate would finally be divided into two parts, one half for the heir and the other half to be divided among all the other children and the heir himself. This was called *la legítima* and it could never lawfully be denied to any child. The final arrangement could take a long time to complete, and until that time the first-born son had unlimited access to the family treasure to do with as he pleased.

Uncle Pedro was a reckless gambler. He would go to the fashionable local club, Las Minas, and gamble the night away. The administrators of his estate, who willingly provided

him with instant cash in exchange for signatures, always surrounded him. Many of the family lands and properties were disposed of in that way.

His wife had died very young giving birth to his ninth child, named Pilar, like me. She was much older than I, about the same age as my mother, who was Pedro's younger sister.

Because he was the heir, he and his family lived with my grandmother, María Magdalena, in her very old house, a seaside palace over the ancient wall of the city. He was also in charge of Son Vida, a country estate some kilometers from Palma.

In addition to gambling, Pedro had another passion—carpentry. He had learned it from his father, my grandfather, Fernando, who had built a wonderful carpentry shop at Son Vida, where a whole wing of the house was dedicated to his work. Every tool that could be obtained at that time was at Pedro's disposal. There was a full-time carpenter, who would do the basic cutting and building, then my uncle and his oldest daughter, Maria, whom he had trained to share his passion, did the fine artistic work. They made beautiful chairs, cabinets, tables, and more using rare imported woods and decorating them with inlays of ivory, mother-of-pearl, and tarnished gold leaf. They created real masterpieces that can still be found in many of the old family homes.

Of all his children, Pedro was closest to Maria and found her to be his greatest companion. That was rather unusual at that time, as girls were considered insignificant human beings, unworthy of attention and certainly not in the same league as their brothers, who could go hunting or race horses and dogs.

By the time I knew Maria she was not young. She was a plain, no-nonsense person. She was also a talented artist who would occasionally condescend to teach us children something or other. Though she was always kind, she generally didn't want to waste her time with us.

I know of one occasion when Maria went to Barcelona by ship with her father, though I don't know why. On their return trip they had separate cabins—estate rooms—as was proper at the time. The daily boat, called the *Correo* (mail boat) *de Mallorca*, left Barcelona

at nine in the evening and arrived at Palma's harbor at dawn the following day. Two boats would do the crossing each night—one from Palma to Barcelona, the other from Barcelona to Palma, and they would pass each other on the high seas. This is how our island maintained regular communication with the mainland. At that time, airplanes and airports did not exist, not even in the realms of our imaginations.

As is the custom in seaports, the people of Palma would go to the harbor to watch the mail boat's departure. It was fun to watch the passengers say their goodbyes and board the boat with all their paraphernalia. We'd listen to the sirens sound three times before the crew pulled up the gangways and the boat started its journey, slow and majestic at first, making its way among the other ships until it reached deeper water. Then the engines would power up, and away it would go toward the dark, high sea and the distant land of new adventures that those of us left behind could only imagine, which we did, longingly.

But the return trip is a different story. We Mallorcans share a very strong feeling for our island. We have great fondness for Se Roquete, our "Little Rock," as we call it in our native language, a pet name for our lovely Mediterranean pearl. It really is a jewel rising from the blue, with its granite mountains, terraces of olive and almond trees, green meadows, and ancient windmills. It is a little land of white sand beaches and small coves with pine trees mirrored in the transparent blue-green water. "La Isla de la Calma" is its given name. It is idyllic; it is our love. And no matter how many times we leave the island and how many times we come back, the "arrival" is always an event. For us, the islanders, it is almost a religious experience.

While other passengers were still asleep in their cabins, we, the natives, would congregate on deck to watch the arrival. The sea breezes may be brisk and the humidity high, and in the winter, the cold penetrates right to the very bones. But we would be there with our heavy coats and scarves, our eyes peering into the early morning mists, anxiously waiting for that magical moment when the shadow of the island, like Venus on a half shell, emerges from the dark sea and slowly begins to take shape. The morning light turns violet first, and then gradually the sky is transformed to pink and gold.

We spy the first landmark, the highest point on the island, El Puig Mayor, after the Cabo Blanco, the long cape stretching out into the blue, which marks the entrance to the Bay of Palma. As the sun rises, we watch the city appear before us like a magic land of dreams, glowing in the light. The Bellver Castle stands alone at the top of its own hill, surrounded by pine trees. There are the gothic towers of the cathedral, the Almudaina, the fortress of the Moorish kings. It is a view you would not want to miss because, for the Mallorcan people, no matter how long or how short the absence, that arrival is the sweetest of pleasures.

But back to the trip of Uncle Pedro and Maria. On that particular morning, when the time was getting close, my Uncle Pedro went to Maria's cabin to wake her so she could enjoy the arrival. Not wanting her to miss it, he opened her door and walked in. The first thing he saw was a big white behind sticking out high from beneath the blankets. Not able to resist, he walked straight over and gave it a good, hard smack, and cried out, "Maria, wake up!" Maria turned around startled; Uncle Pedro was startled, too. Maria was another lady. ❧

✒ *tonina*

TONINA WAS A VERY SMART WOMAN. In fact, I think she was the first "liberated woman" on the island of Mallorca. But she would not have known the meaning of the word, and would not have been able to analyze the motivation for her actions.

She was the youngest daughter of my mother's wet nurse (or dída). In the olden times on the island, when a noble lady had a child, a country woman was hired to come to the house and nurse the baby. She left her own newborn in the village with another woman, perhaps a neighbor who had had a child at about the same time and could take care of both, and came to live in the big house for a year or two. Although now no one would approve of such a practice, at that time that was the custom, and many wonderful relationships developed that way. Usually, a very strong tie would unite forever the nurse to the family, and especially to the child in her charge.

My grandmother had seventeen live children (and two stillborn), and I suppose each of them would always remember and love his or her *dída*, just as my mother did.

Her home was an old hill town toward the center of the island—Montuiri—a village the color of sand and dry, beautiful stones bleached by the sun. Dusty and calm, its hilly streets were so steep that the winter rains would run like streams, carrying loose stones down into the valley. At the very top of the hill is an old church dedicated to San Bartolomeu, the patron saint of the village, and in the evenings, old women in black would silently enter in its shadows and sit on the corners of the wooden benches to pray the Rosary. I have been there countless times. You could walk in the streets and see only an occasional furtive figure turning around a corner, or partially opening a house door to observe as you pass by, only the eyes of the looker shining in the dark. In the evenings, after sunset, the peasants would return from the fields, some carrying their tools and baskets on their backs, others, more

fortunate, guiding their carts and donkeys up the hill.

My mother's nurse, Margalida, lived in a neat stone house on a street behind the church, nearly at the top of the town, La calle de la Posada. The first room in the house had a cobbled floor and a cistern filled with rainwater funneling in from the roof. That was the room used to receive the visitors and socialize with neighbors; a door to the left went to Margalida's bedroom, small and modest, with an antique wooden bed that must have been in her family many generations and a washing stand of about the same age, perhaps a gift from my mother's family. The bedroom had a window that looked out to the street and was very pleasant and clean, with a spotless white *pique* bedspread. There was also the kitchen, with a large fireplace for cooking and heating the house in the winter, and a pine-wood table and chairs. The walls were white-

Se Dída. Sculpture of Margalida, my mother's wet nurse.

washed and always sparkling clean, pleasantly contrasting with the dark ceiling beams. The house had two more bedrooms, and in the back a sort of courtyard that they called the *corral*; it was not large but had space for a washing tub, some chicken coops, potted plants, and, of course, the privy. That was a rather horrible place, no more than a hole in the ground, with a little skimpy roof and a curtain, supposedly for privacy. For me, when I went to visit, it was a real nightmare; I'll speak of that later.

Margalida's husband had been a poor peasant who would hire himself out to the landowners. He had only two or three small plots of land just outside the village, where he grew some vegetables and wheat and kept a few chickens and a pig to feed his family. They had four children, two boys and two girls, and Tonina was the youngest.

They all worked hard in the fields with the father—all except Tonina. By the time she was fourteen or fifteen, she could already see the ravages their hard life had brought to her family: her father died young, her brothers looked older than their years, and her beautiful sister was burdened with several children and also working in the fields.

Tonina made her choices. She decided she would not marry ("Why would I want to be a man's slave?" she told me much later) and she would not work in the fields. Instead, she would live with her mother, take care of her, and became a dressmaker.

And this is how she became my dearest friend; until the end of her life perhaps the best, most loyal and dedicated friend I have ever had. She must have been in her early twenties when her mother asked mine if Tonina could come to the city and live with us so that she could attend an academy and perfect her trade. We lived in a large townhouse with many floors, so space was not a problem, and my mother was very happy to do something nice for her *dída*. So Tonina came and lived with us for several years. I was a little girl, and she loved me.

She took me for walks to la Murada in her free time, and she taught me all sorts of things. I have always been pretty good at sewing, and I give her the credit for that. There was a small room above the kitchen, where the cook and maids would congregate in the evenings to do the mending and some sewing or knitting, and they would tell stories. I would join them and read to them, a chapter or two every evening.

Those were the years of the civil war and immediately after, and because of coal shortages the lights in our houses dimmed with distressing frequency, coloring everything with a sickening greenish-yellow tone. It sometimes felt as if Satan were about to show up, so I was always trying to get Tonina to go with me and tuck me in, which she did. But mostly, I remember those evenings with warm feelings, because both Tonina and Catalina loved me so much, and I felt closer to them than to my own mother.

After Tonina moved back to Montuiri, I used to go to visit her and her family and stay in their house. Tonina's mother had became an invalid and was always sitting in a chair in their front room, or sunning in the street, next to her doorsteps. Her friends and neighbors came to visit her, and she was always cheerful and happy. She was a very pretty old lady, and her daughter took very good care of her. She dressed in the old way, with a full, striped skirt, a black bodice, and her *rebosillo*, a lace headdress, always crisp and white. She had learned to maneuver her chair, which was not a wheelchair, and was able to move a little around the house; she was always in a good mood.

Tonina and her niece, Maria, who followed Tonina's example, becoming a dressmaker and remaining single, worked in the back room. When I went to visit, it was often for a holiday—Easter, or San Bartolomeu Day—and both Tonina and Maria were usually very busy finishing the dresses for the young girls going to parties. I would help with casting the seams or hemming the skirts, because everything had to be hand finished, and so I learned to sew that way.

The fiestas would last about a week, and there were all kinds of celebrations. Groups of men would walk in the streets in their traditional costumes, dancing and playing the *chirimias*, the bagpipes. Among them, making mischief, was *el Dimoni*, the devil. He wore a grotesque mask and torn clothes smeared with red and black and spent his time bumping into people, especially girls. He also had a *latigo*, a whip with a leather thong, and he used it to hit people as hard as he could whenever he had a chance. He must have been the local sadist coming out of the closet for the occasion. I remember once—I must have been about fifteen or sixteen—when I was watching the street performances and he singled me out from among the crowd. He probably saw that I was a city kid and came after me. I started to run and the people were laughing and making room for him to chase me. I ran up the street and into the house of Tonina's brother, Damian, who was sitting at the table eating soup. I got behind him, trying to avoid the *latigo*, but still he would not give up, not until Damian stood up and told him to get out of his house. Now it would be considered sexual harassment, but at that time in Montuiri people thought it was just good-natured fun—never mind a few red welts on your arms, or even your face and neck.

Tonina was a wonderful and amusing person, with lots of good sense and good humor. Everyone liked her, and even though she was single she was not considered an old maid, because it was her choice. Any man in the village would have thought himself lucky to marry her, even when she was older. She was always very neat and crisp, smart and efficient, and would not tolerate abuse or nonsense from anyone. Every Sunday after church, she went to the tavern across the street to have a glass of wine, a little bowl of olives, and a dish of calamari. This was at a time when women in a village would not go to such a place unaccompanied by a man. And men usually did not take them, preferring to have a drink alone with their buddies. For Tonina, Sunday was a day of relaxation and enjoyment after a week of hard work, and no one was going to tell her what she could or could not do. Even when I was really young I went with her to the tavern and had a little wine too. If I got a little tipsy, it was OK, just fun, with no malice intended. That was the way Tonina looked at the world. I wish there were more people like her!

When I was a teenager, I was very popular in the village; they did not dare talk to me very much, because I was not one of them, but they would follow me and shout *piropos*, compliments about my blue eyes, or my long curly hair, or the way I walked. This is an old Spanish custom and is in no way offensive, unless it gets out of hand—which it sometimes does, but never to me in Montuiri. The most dramatic thing I remember from any of my admirers occurred one night after I was already sleep in my upstairs room. (By then Tonina's house had expanded, with a second floor where she had her *taller* [workroom] with Maria and two other women assistants, and two other bedrooms.) I was awakened by the sound of something hitting the windowpane: it was a paper bag containing two large empanadas. Empanadas are typical fare for Easter celebrations in Mallorca, and people take great pride producing "the best." I had just been presented with this "gift" from the sacristan of the Church of San Bartolomeu and a group of his friends, who then proceeded to serenade me by singing and playing guitars. It was all very lovely and thoughtful, though, unfortunately, the empanadas were reduced to crumbs. We ate them for breakfast anyway.

As a result of my visits to Tonina's, I had a rather embarrassing experience. It happened in Palma. One day a friend introduced me to a young man, Pepito Senna, who

wanted to meet me. We started to talk, and he told me that for a long time he had "known me by sight"—a common Spanish expression meant to indicate he had been aware of me and wanted to meet me personally. He explained that he had an aunt living in Montuiri and that her house was right on top of Tonina's. In fact, the view over their garden wall was of Tonina's backyard.

I was horrified. Immediately, I thought of the awful "privy" I hated so much, and I became convinced that he had seen me going to the bathroom. I escaped from him as soon as I could, and after that, if I saw him coming up the street toward me, I would go the other way. The next time I saw Tonina, I told her about it and she had a great laugh about the whole thing. She assured me that he could not have seen me, but I never entirely believed her and never was comfortable with the poor guy.

When I was older, and dating my future husband, Walter, *un Americano*, I went to visit her, and Walter came to visit me. Very properly, she found a room for him in a *posada*, an inn, though he dined with us at her house. We went on a *romería*, a pilgrimage, to the sanctuary on the Puigch ("Mountain") of San Miquell, a yearly celebration on a mountaintop. We had a cart and a donkey, but Walter and I walked, because we did not want to burden the animal. Tonina cooked *arroz con caracoles*, rice with snails, in an open fire. Walter loved the dish, but I ate the rice without the snails. We drank lots of red wine and sang and danced, and Walter fell in love with Tonina, forever.

Later, after I'd joined Walter in America, we made regular visits to Mallorca to see my mother. But we always went to see Tonina, too, and our children loved her. When my mother died, she was buried in the Montuiri cemetery, next to her old nurse; later Tonina was buried there, too. These are all beautiful memories of a dear friend. ❧

❧ stories of pigs

FOR MORE THAN A DECADE after the Spanish Civil War, food was scarce in Mallorca. In my family, we were often hungry—not seriously starving, but we had many deprivations. We never had enough olive oil—a very important item in the Mediterranean diet—or rice, or sugar, or coffee; in fact, we did not have enough of anything, even bread. Sometimes, the only available food would be beans, and we ate beans for weeks, disguised in every possible way: *potage*, casseroles, even bread and cake. People passed along recipes meant to disguise the flavor, but it didn't work; you could always taste them. I got so sick of beans that it was years before I liked them again.

Of course, you could buy many things on the black market (*estraperlo*), but it was very expensive and there were many abuses. I remember an extremely "creative" example of how far and how low some individuals will go to make money. There was a man named Negrete; he had a big operation and was making millions smuggling staples and selling them at exorbitant prices. He was pretty famous, and the law was after him, but they could not catch him *con las manos en la masa* (with his hands in the dough). One time, to improve his reputation with a well-publicized good deed, he donated three live fat pigs to an orphanage run by Las Hermanas de la Caridad, the Sisters of Charity. It was all over the papers, and people said, "Well, for once he has done a decent thing!"

The sisters butchered the pigs, with help from some good souls in the community. It is a lot of work, and they spent days and days curing the hams, making *salsichas* and *botifarrones*, and *sobrasadas* and what not. They did a beautiful job, and when everything was hanging from the rafters in their *despensas* (pantries), they gave a sigh of relief, because now they could face the coming winter with extra supplies to feed their charges.

Well, they should have known better. Very soon after that, their pantries were raided during the night, and the main suspect was Negrete. Everything was stolen. He had had the sisters do the work for him, free of charge, while he benefited from the positive public relations he got at their expense. He got away with every last item, and even though everyone knew it was he, it could not be proven. He should burn in hell just for that single "accomplishment" in his dark career.

Well, anyway, most of the time we got up from the dinner table still feeling hungry. I had dreams of good, savory food; for some reason, one of my obsessions was a baked red pepper stuffed with seafood and rice. I still adore that.

My mother and our cook, Catalina, were always hoarding whatever they could lay their hands on, so once in a while we could have a treat. One harvest season my mother decided to go all the way: she went to Montuiri, a village in the interior of the island, to visit her *Dída*, her old wet nurse. My mother's nurse and her children were like family to us and even now, when I go to Mallorca, I visit her descendants, who are still my friends.

Anyway, my mother asked *Dída's* son, Sebastian, to buy a pig for her and have it butchered and prepared in the Mallorcan way, which is very good, including as it does *sobrasadas, longanizas, salsichones, butifarra, jamon Serrano*, and so on. Everything was brought to the house, and it looked great, expensive, but great. It was hung from the rafters in the pantry in the back of the house, by the garden, and we thought about that bounty all the time. My mother wanted to start eating it, but our cook, Catalina, would say, "Señora, we must wait a little; it will be better if it hangs a little longer, and winter is coming. It will be a long, hard time." And my mother took her advice, and we kept away from the pantry shelves, though we could hardly stand it.

In the meantime, my sister Fernanda, who wanted to be a nun and was always involved in charities, had taken under her wing a family of gypsies who lived in a cave in the mountains behind our house. (By that time, my mother had sold the townhouse in Palma and bought another one on the outskirts of town, by the Bellver Castle, where she lived until she died at ninety-nine, and where my older sisters still live now.) Fernanda wanted to

convert the gypsies—an impossible task that had been tried before by stronger people than she—and bring them into the fold of the Mother Church. She was visiting them, preaching to them, and trying to find them jobs, even though they were perfectly happy with their lot, looking picturesque and authentic and begging from the British tourists.

She was most dedicated to the youngest members of the family, two girls of about twelve and thirteen; she wanted to teach them good manners and cleanliness so that she could find a family that would hire them as maids. To accomplish this, she brought them to our garden and gave them a bath in the laundry room, washed their hair, and deloused them. Afterward, she dressed them with our old but clean clothes.

One night soon after that, I was going to a party without my mother's permission. Mother was convinced that anything fun was sinful, so my aunt Fernanda had invited me to spend the night at her home. I was to go to the party with her daughters. This was something we frequently arranged, as my aunt knew how unreasonable my mother was and was always helping me.

The next morning, while I was still in bed, the maid came to wake me to take a telephone call. It was my sister Carmen, and she was very agitated. "Pilar," she said, "You had better come home. We have been robbed, everything is gone, we have been cleaned out!"

"Oh, my God," I thought. I had visions of an empty house—my mother's silver collection, her jewelry, the paintings, everything gone!

Then my sister said, "Not a single longaniza, not a ham, not even a sobrasada has been left—the pantry is empty!"

Poor Catalina was heartbroken. "Oh, Señora, if only I had let you taste that ham, and that sobrasada! It was so good, the best I had ever seen. Not an ounce of fat!"

The gypsy family left our neighborhood soon after that, and my sister Fernanda did not have a chance to see if her teachings had done any good. But I have a feeling that they prospered, and the two young girls must have done well in life. They were very smart! ❧

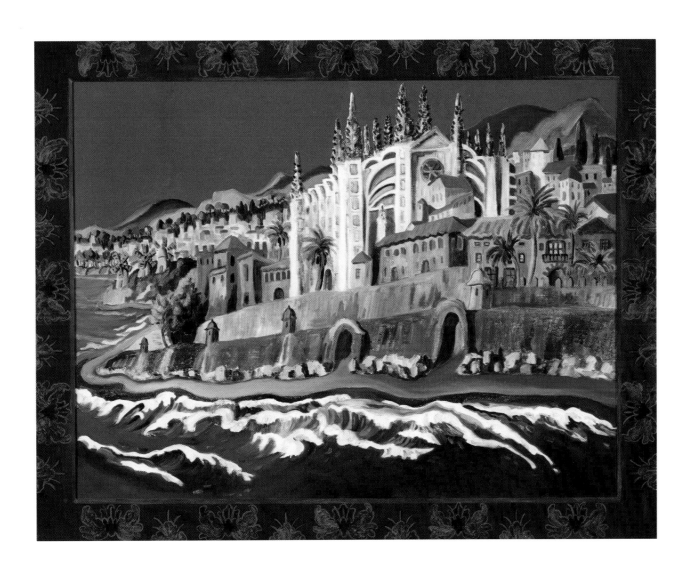

1. *View of Palma.* 2002, oil on canvas, 35½" x 45". Unless otherwise noted, paintings are from the collection of the artist.

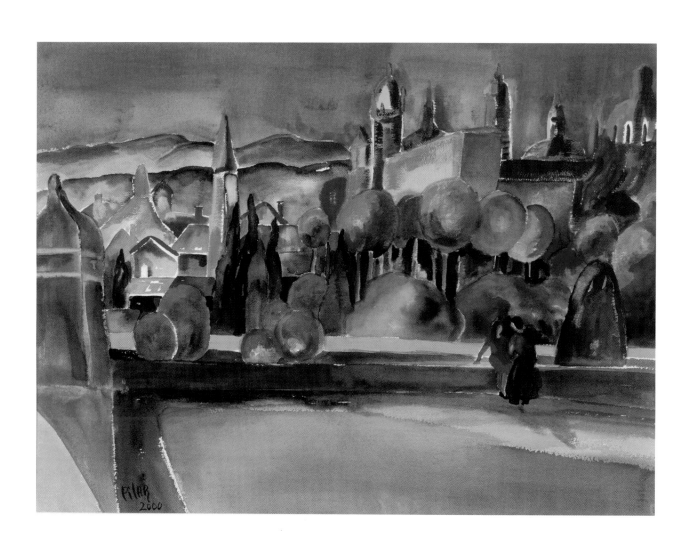

2. *La Murada.* 2000, watercolor, 16" x 22".
Private collection.

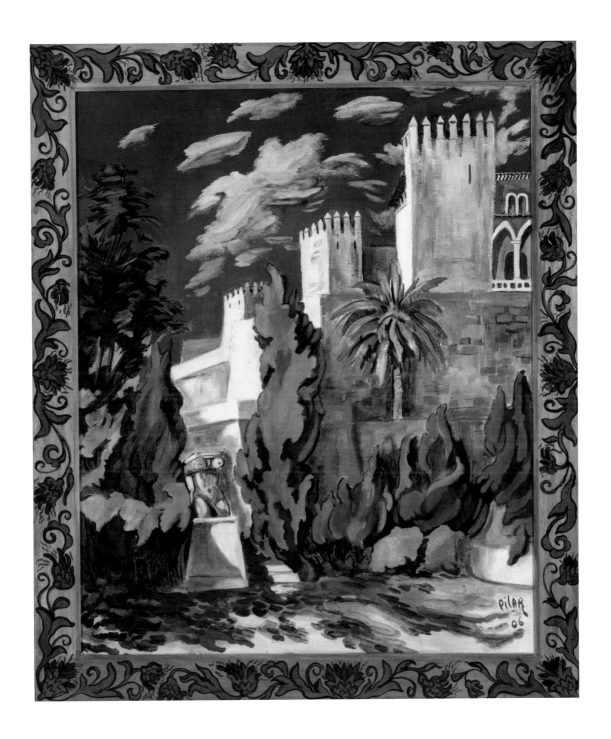

3. *Palacio de la Almudaina.* 2006, acrylic on canvas, 45" x 35½".

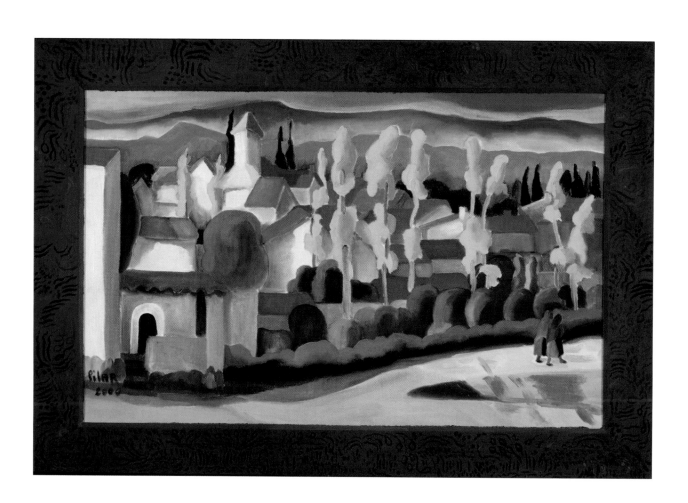

4. *Otoño en Mallorca*. 2000, oil on canvas, 24" x 30".
Private collection.

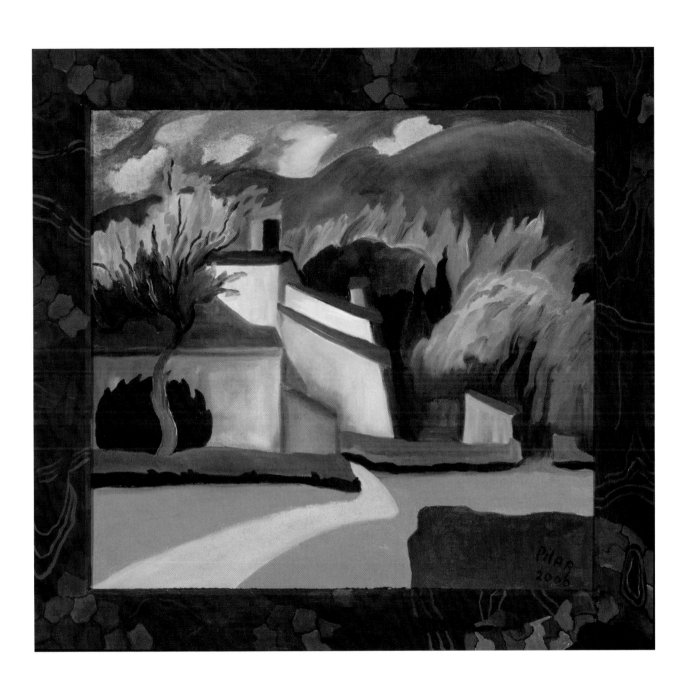

5. *Casa de Payés*. 2000, oil on canvas, 24" x 23".
Private collection.

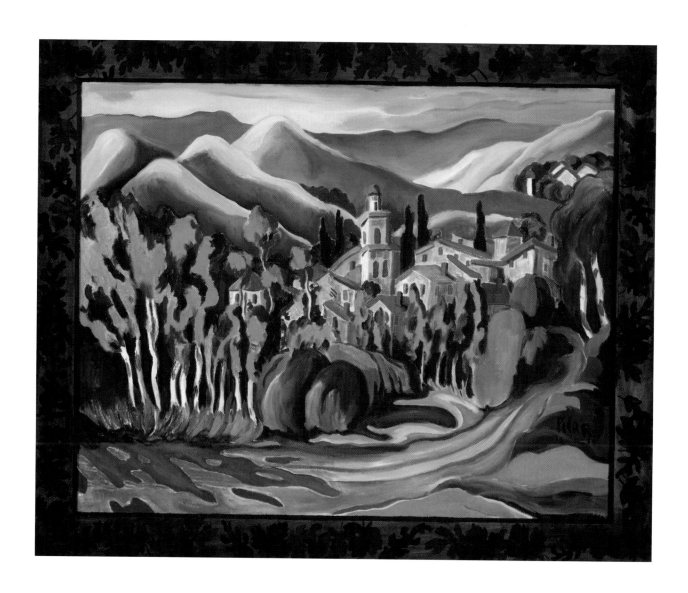

6. *In the Morning Light*. 2001, oil on canvas, 37" x 47".
 Utah Arts Council Permanent Collection.

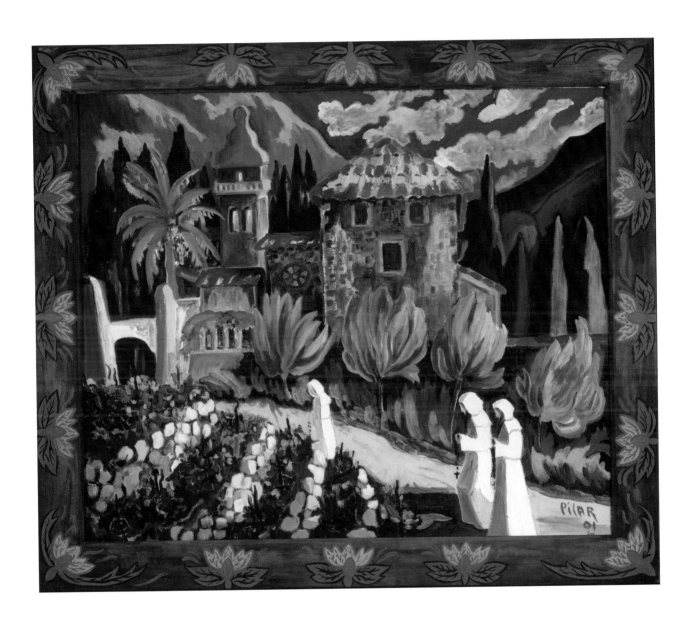

7. *La Cartuja de Valldemosa*. 2001, oil on canvas, 38" x 45".
Private collection.

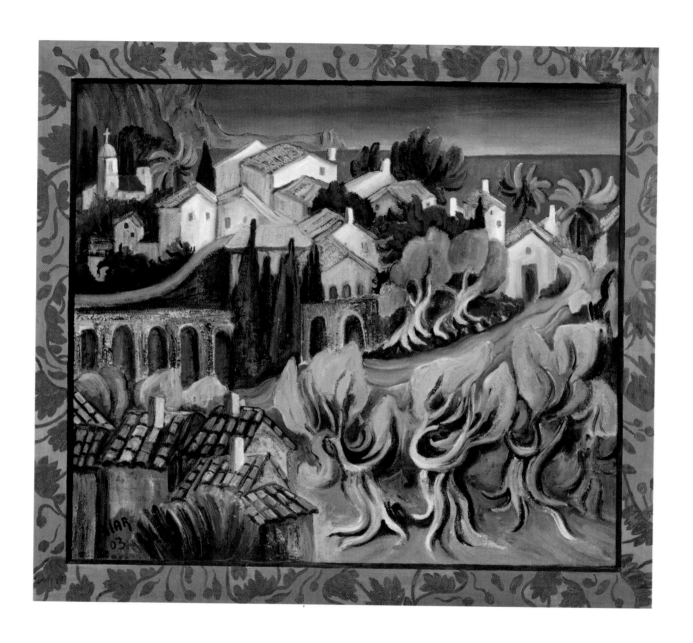

8. *Olivos Milenarios, Mallorca.* 2003, oil on canvas, 35" x 40".
Private collection.

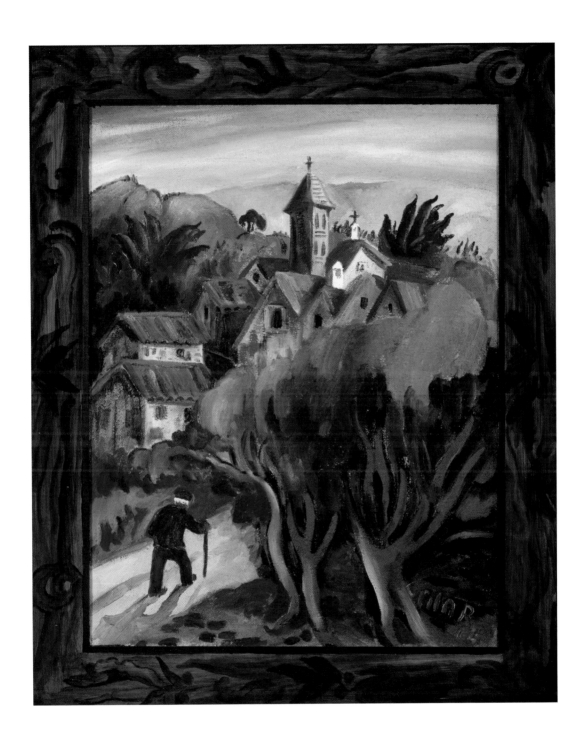

9. *A Moment in Time.* 2004, oil on canvas, 35" x 25".
Private collection.

10. *Se Dída*. 1979, stoneware, 15½" x 12" x 9".

11. *Evening Prayer (Domínguez-Escalante Expedition)*. 1976, stoneware, 23" x 20" x 16".

12. *Mediodía.* 1994, oil on canvas, 35" x 20".

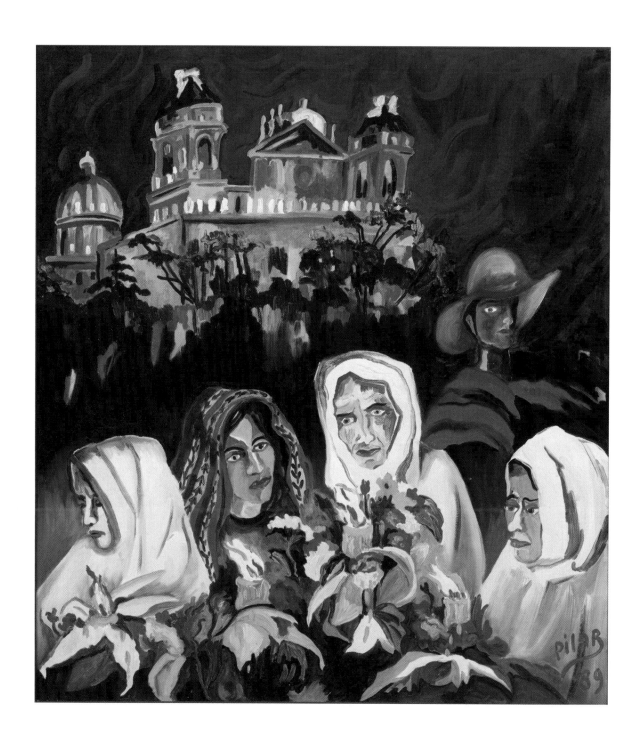

13. *Fiesta de Mayas.* 1989, oil on canvas, 43" x 39".
Salt Lake County Permanent Collection.

14. *Café Río*. 1994, oil on canvas, 44½" x 39½".

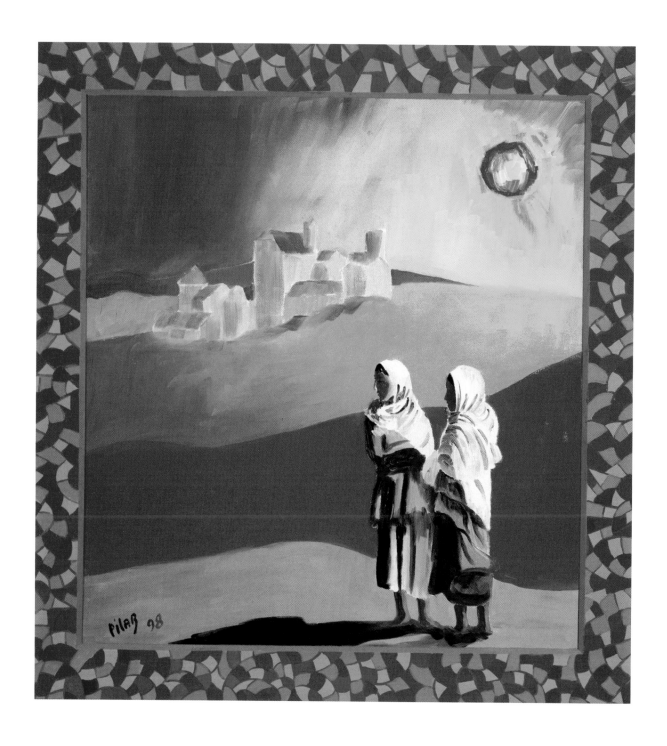

15. *El Sol Ardiente*. 1998, oil on canvas, 26" x 24".
Collection of Marcia and John Price.

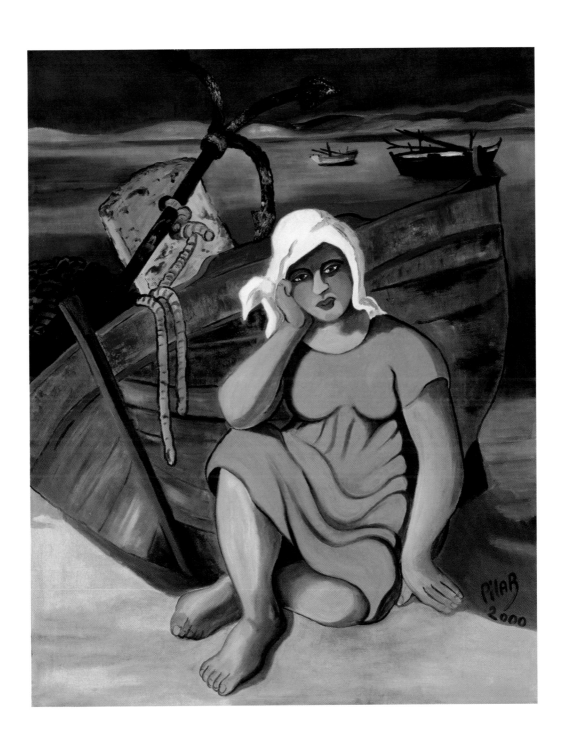

16. *Mar de Verano*. 2000, oil on canvas, 45" x 35".
From the series Costa Cantabrica, in the collection
of the College of Humanities, University of Utah.

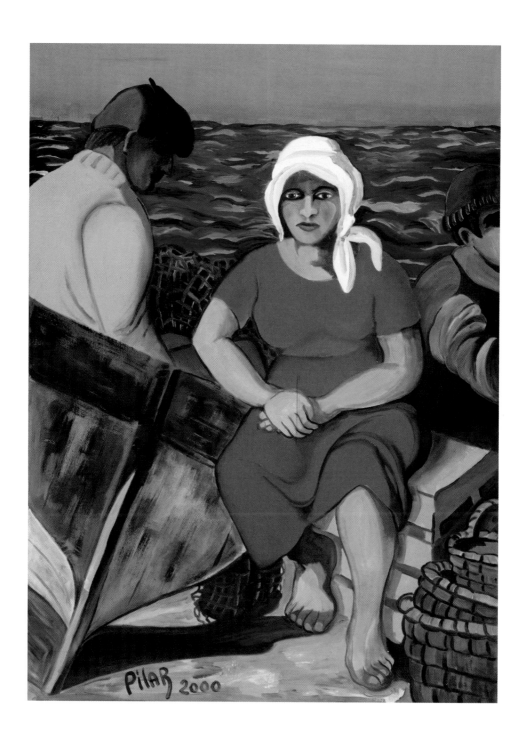

17. *En la Mañana.* 2000, oil on canvas, 46" x 34".
From the series Costa Cantabrica, in the collection
of the College of Humanities, University of Utah.

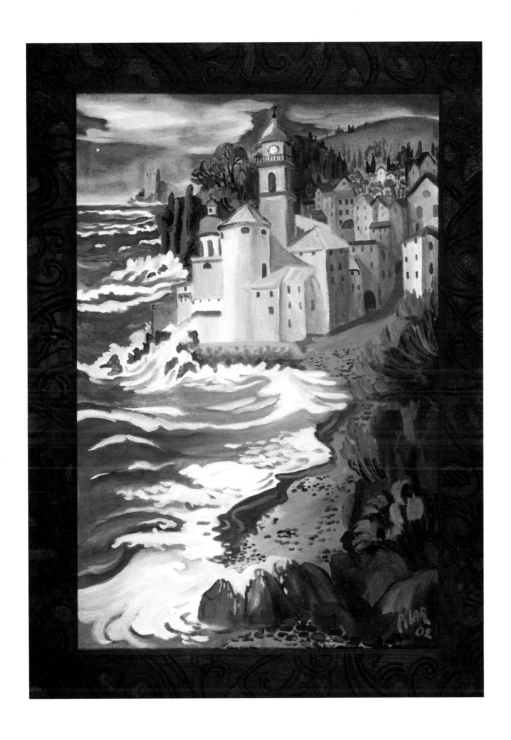

18. *The Yellow Church*. 2002, oil on canvas, 32" x 24".
Private collection.

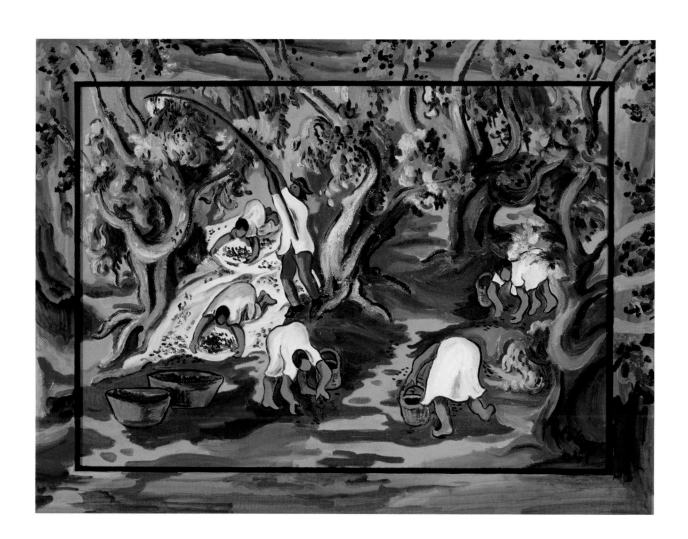

19. *The Olive Pickers*. 2004, oil on canvas, 34" x 38".
Private collection.

20. *Las Musas Junto Al Mar.* 2005, oil on canvas, 68" x 38".

21. *"Mujeres de Luto," Guatemala.* 2006, oil on canvas, 55" x 45".

22. *Pueblo Escondido*. 2003, oil on canvas, 30" x 40".
Private collection.

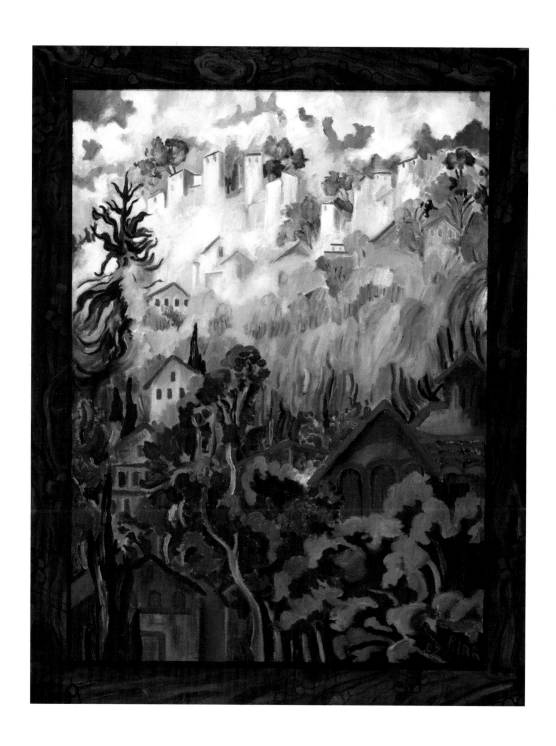

23. *En las Nubes*. 2002, oil on canvas, 35" x 47".

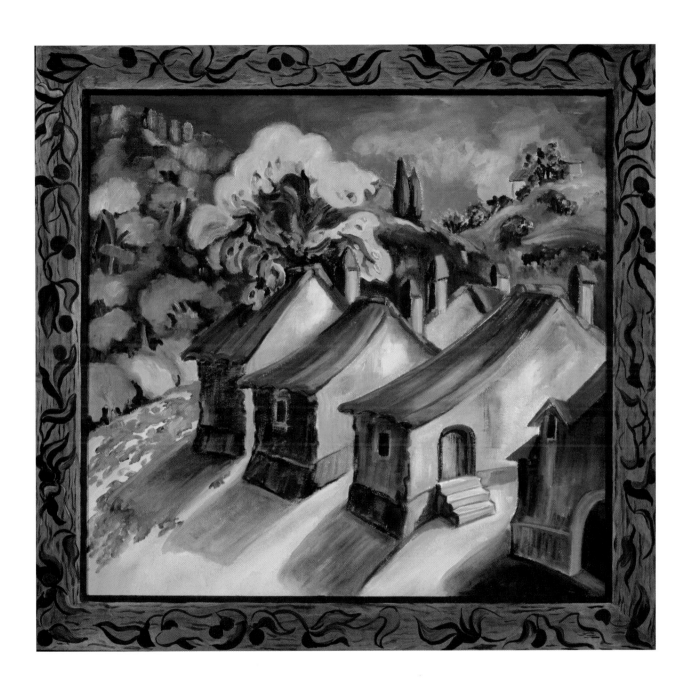

24. *Casas Catalanas*. 2004, oil on canvas, 34" x 36".
Private collection.

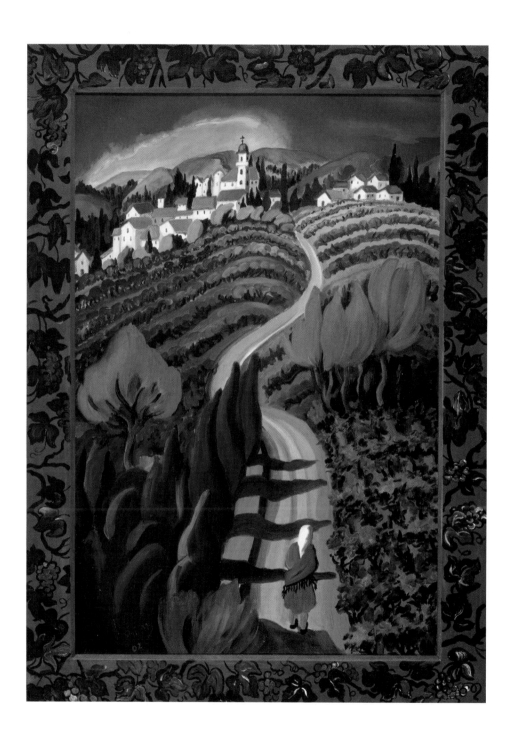

25. *Viñedo Ibérico.* 2002, oil on canvas, 44" x 35".
Private collection.

❧ mi colegio

I WENT TO SCHOOL IN A HILL TOWN IN MALLORCA, Establiments, ten or twelve kilometers outside Palma. My father had been killed during the civil war, and the rest of my family had to escape from Menorca under rather scary circumstances. I was constantly having nightmares and was often moody—crying over nothing. The doctor told my mother that the country air would be good for me, so she enrolled me in a small school that was a branch of the Colegio de la Pureza in Palma. I went half pension, which meant that I attended school six days a week, leaving home at seven in the morning and returning at seven-thirty in the evening. Our house in Palma was very near the larger convent school, La Pureza, so every morning I walked there to catch the bus with the Madre Bañó, the nun in charge of the children on the ride to the country. Because a nun could never be alone with a man, even their trusted bus driver of many years, Ramón, Madre Bañó and I got on the bus together. And so appearances were taken care of. It could be said that, at the tender age of seven, I was the chaperone for Madre Bañó and the bus driver, and, if not responsible for their proper behavior, at least could preserve decorum.

I remember well the first day I went to that school because it was dramatically eventful. Madre Bañó and Ramón had to find and account for every girl on their list, and because it was the first year for many of them, it was difficult to locate those who were not already waiting, dressed in their uniforms, at the curb in front of their houses. One of the girls, Maria Antonia, who lived in an apartment building, was not waiting for us, and Madre Bañó and I had to go upstairs looking for her (she was not allowed to go alone, so I was still her chaperone). We went to the third floor and rang the bell, and a wild-eyed maid opened the door and told us, "Come in, come in!" Without ceremony she pushed us into a bedroom where Maria Antonia was half hiding behind a curtain, as wild-looking as the maid. Spread

out on the bed was an elderly woman with tinted carrot hair, one arm hanging over the side of the bed. There were brilliant red spots on the bedspread and on her silk nightgown, and her eyes and painted mouth were wide open in a terrible fright. She was dead.

The nun felt for a pulse in the wrist, and could not find one, so she closed the old lady's eyes. After pausing a moment to pray by her side, she started to look for a telephone.

Maria Antonia and I just stood there in shock. The woman was the little girl's grandmother, and the red spots were not blood but nail polish. I had seen only one dead person before, the woman friend of my mother who had been executed in front of my family and me when we were trying to escape from Menorca. I had seen her body and the ground around her splattered with blood, and to me, red was blood. That scene in the harbor was the subject of one of my recurring nightmares; now I had another image to add to those already stored in my mind.

I don't remember what happened next, but I do remember that eventually the nun, Maria Antonia, and I boarded the bus and were finally on our way up to the school. I spent the whole trip throwing up on my brand-new uniform, my books, and the bus seat. It was a memorable beginning!

In spite of that, I have good memories of that place. It was not very large, with only about fifty girls and nine or ten nuns. It was like a villa atop the hill, and from there you could see the orchards of almond trees, with their white and pink flowers in the spring; country houses surrounded by pines and palms; and the cobbled streets of the village, with its white houses with green shutters and red-tiled roofs. We had beautiful grounds, kept by an old gardener who had a way with the geraniums, the jasmine, and the bougainvilleas that climbed the old stone walls.

We led a very regimented life, every moment carefully controlled by our teachers, and every day the same routine. Our studies included calligraphy, design, embroidery, math, geography, algebra, history, Latin, and *gramatica*, the equivalent of English, writing, and composition. The last was one of my favorite subjects. Two times a day we went to the chapel for prayers, and three times a day we had *recreo*, or playtime. Even that, however, was not really free, because we had to play ball or jump rope, and no conversations were allowed among

the girls. Talking could be harmful, as we might get ideas that would lead us into trouble. So we were supposed to be active and mainly silent. Of course, that was better planned than accomplished, for not even the concerted effort of ten nuns was sufficient to keep fifty girls' mouths shut—especially some of them. The rules only made things more challenging, so there was a lot of talking on the sly. The nuns knew that, of course, and tried to keep us scared with stories of demons, and apparitions of *El Malo*, "the Bad One," said to lurk in the dark corners of that very house.

One particularly graphic description stayed with me for a long time. One night, after everyone had retired to the dormitories, one of our teachers remained alone in a classroom to correct some reports. The school was silent, with most of the lights turned off for the night, when she heard a knock at the door. "Come in," she said, "*Adelante*." Nobody entered, but she heard another knock. After the third knock and the third invitation, the door slowly opened, squeaking on its hinges, and from the dark came a black, disembodied hand, slowly floating toward the sister's desk. Horrified, she fled past it, running through the darkened corridors and past empty rooms, heading for the chapel, where she took refuge. In that sacred place she was safe, for the devil's hand was powerless there. But the next day you could still smell sulfur lingering under the high-beamed ceilings.

In the years following the civil war, Spain did not have enough coal to produce sufficient electrical power, and on many evenings, while I was still doing my homework, the lights would turn a greenish hue and progressively darken until you could hardly see. For years I associated that with the imminent arrival of the Evil One, and I would rush to bed and cover my head. It was a difficult situation. On the one hand, my natural spirit of mischief made me do many forbidden things, while on the other, the horror stories kept me in constant fear. The time eventually arrived when I had to make a choice: either conform and lead a submissive life, or run the risk of eternal condemnation. Since I had never personally faced the devil or any of his surrogates, I decided it was better to believe only what I could see, and I became an agnostic at the tender age of eleven or twelve.

Because of the recent war, my all-girls school made an exception by allowing seven or eight young boys, brothers of some of the students whose families were still displaced in

other provinces, to attend half pension, as I did. They were very rambunctious and a lot of fun on the bus and at school. Everywhere we went—to the chapel, outdoors to play, to the refectory to eat—we had to form a line, always in the same order; the boys brought up the rear, and they were very unruly. They ate at a central table, and if one of the girls misbehaved she was made to sit with them. I sat there very often, and it was kind of fun.

For amusement, every time the sister in charge of serving turned around or went into the kitchen for a moment, we would send food flying in all directions, especially if we had been served dry cod croquettes. Those were the best. We hated eating them, and because they were hard and dry, they could be easily directed at a chosen target, where they left a light, rather inconspicuous, greasy spot. Sometimes it got messy, like once, when a mashed-potato patty flew through the open window and landed smack on the Mother Superior's rather prominent chest. It made a big splash on her black habit, and she came into the refectory with her face red as a beet. Only her saintly disposition kept her from swearing at us, but she gave us a piece of her mind and demanded to know who was the culprit. Naturally, we had our honor code, and no one came forward to tattle, so the whole school was under a cloud of suspicion, and we lost some of our small privileges. There were no walks through the woods on Thursdays for a couple of weeks.

In school I had two very special friends, sisters named Berta and Nuria. They were nieces of the Mother Superior and had been in the school since they were toddlers. They were full *pensionistas*, which meant they went home only once a month. For some reason, Nuria, the older one, became very protective of me, and I will never forget how she comforted me when one of the boys, as a joke, emptied a can of bugs down the back of my dress. I became totally hysterical and could not stop crying, even after every single bug had been disposed of. Nuria put her arm around my shoulders and let me cry until I felt better. The sisters remained my best friends even after we finished school, and a few years ago, Nuria's youngest son married my youngest daughter—another tie between us. Nuria died of cancer shortly after the wedding, but I still see her husband when I visit Barcelona.

At that time of scarcity after the war, everyone on the island was concerned about their food supplies. The nuns were no different and were raising four pigs in a small yard

behind the kitchen. That yard was forbidden territory, a part of the convent, like their living quarters, pantries, kitchen, laundry room, and a few small outdoor areas that only the nuns could enter. Those spaces were the *clausura*, the area dedicated to their monastic life. (One of our escapades entailed entering the terrace next to the laundry room and inspecting the sisters' underwear, which hung there to dry. We made fun of their voluminous long underpants and other items. If we were feeling particularly mean, we would take one or two of them and throw them outside so the village dogs would get them and drag them around the streets. It was an expression of freedom and retaliation for our controlled existence.) But about the pigs. One morning after history class, several of us sneaked out while the others were handing in their papers and, for the heck of it, went to the pen and opened the door. The exuberant pigs joyfully ran out as we shoved them down the path toward the village. It was a steep path, and soon the pigs, gaining momentum, were going full speed toward the square. Kids, women, and old men came out of their houses to watch them race by. Meanwhile, the nuns had started to run down the hill, and the unsupervised girls joined the chase, while the pigs, grunting joyfully, celebrated their newfound freedom. It was the closest thing to a riot the village had ever witnessed. The perpetrators of the crime made a big deal of trying to help, but the pigs kept roaming the streets of Establiments until men were fetched from the fields to guide them back to their pen. We all enjoyed a day of anarchy and mayhem that probably made history in the annals of the school, a story to be told for generations to come. ❧

dark stories

1 WILL NOT NAME PLACES OR PEOPLE, but you know my story and where I came from. You can make your own deductions.

This is a dark story of old times and times not so old, of things heard in stealthy whispers meant to keep secrets that would be best forgotten. And yet it is not easy to forget, because the fear and the shame will not go away.

These are events that happened among those who call themselves Christians, who are considered above reproach. They are regarded as honorable, the keepers of distinguished family lines that have survived centuries. Their feats have been recorded in the archives of history, and both name and wealth have survived through many generations. These are the people who call themselves *La Nobleza*.

This is not to say that all these families have something to hide. I would never make such an assumption. On the other hand, the stories do not tell of rare events. Perhaps some cases were not so extreme that they could be labeled criminal, especially under the laws of the past, but even if not violent, they were certainly psychologically damaging and responsible for changing the lives of many and depriving them of what should have been their birthright.

When I was a child, television was not even imagined, at least not in my world. On the long, dark winter evenings, there was a lot of visiting: to see friends and relatives, to talk, to hear the latest news, and, of course, to gossip. The largest houses were best for these purposes; my grandmother's house was a favorite place. She was already pretty old when I was a child and so did not go out very much, but she was a very popular, wonderful lady, and many people came to visit her. They would congregate in the spacious living room and talk

for hours while sipping wine. Such talk was much more informative than the evening radio news, or even the daily paper, and it came with a pinch of salt and pepper.

The many children would go to the dining room for *una merienda*, a snack, and then play. The house was very large. (It is now a small architectural college. In Spain, old houses like that are considered national treasures and cannot be altered.) There were *salones*, where we were not allowed, but the main-entrance reception room was very large and sparsely furnished, and we played there when it was raining or too cold to play outside.

There was also a secondary *tertulia* (gathering) in the house, that of the maids of the house plus other servants who had accompanied their master or mistress. They all got together in the sewing room and had a lively time telling all sorts of stories. Spooky ones were favorites and involved apparitions of saints and devils, or the ghosts that populated the attics of the old houses, pulling their clanking ankle chains in their nightly wanderings, doing penance for their transgressions. Tales of crimes of passion were also very popular, as were the interesting happenings between young men and women in the various households. These last stories were told in discreet language and suggestive tones if there were children present, so we immediately knew that something naughty was being discussed.

But the scariest tales were rumors of gruesome discoveries, infrequent for sure, but shocking and unforgettable. Those stories would be repeated again and again. They told of secrets that were eventually revealed, perhaps by a construction worker involved in the discovery who was unsuccessfully bribed to preserve the family's honor.

Many of the townhouses were very old; in fact, my grandparents' house must be more than six hundred years old by now. Sometimes, perhaps after an unusually long rainy season, a wall or a bridge joining a house across a street, like my own grandma's, would collapse to the ground. I remember times when such a thing would happen, and some hidden treasures from the past were found among the rubble. But, other times, the discoveries were not valuable interesting objects, but gruesome, unspeakable and fragile skeletons of young women hidden in the recesses of ancient stone and adobe walls, where they had been entombed—some after their deaths, others while alive—left to die slowly over many years,

fed through a hole in the wall, to allow the culprit to avoid committing the mortal sin of murder, in an act more cruel than any murder could have been.

Those old crimes were acknowledged with reluctance. Some were committed to hide a pregnancy, others to avoid paying dowries that would diminish the wealth inherited by the first-born male destined to continue the family line. I have heard of the same thing happening in Los Alamos, Mexico, where the families would announce that they were sending the girls to San Francisco to finishing school, and later would say they had been married there. Now, many years later, remains are being found in crumbling walls, pitiful witnesses to the avaricious cruelty that sometimes afflicts the human race.

In other cases, the disposal of bothersome girls would not be as drastic as entombing them. There were other means, after all. I very clearly remember when my mother took me to visit an aunt, Violante. When Violante was ten, she was placed in the convent of Santa Clara, very close to our house in Palma. Santa Clara is a very beautiful place, with an ancient church next to the convent. We always went to that church at Christmastime, attending the midnight Mass, *La Misa del Gallo*, the "Rooster Mass," as we call it in Spain. We went there because they had the best performance of "*The Sibila*," the medieval song of the Christmas prophecy, which tells of the revelation of the Sibyl of Delphos, one of the seven wise women who walk among us, unknown to us, even now, but who have the gift to predict the future. The Sibyl of Delphos had a revelation of the birth of Jesus. In Mallorca, at the midnight Mass, a young boy sings that haunting song a cappella, his pure voice rising alone and echoing on the *bovedas* of the Gothic churches.

Santa Clara is a convent of *clausura*, which means that once a nun passes through its gates, her face will never be again seen outside its walls. The convent has a very large garden that I have never seen, except from a distance, because it is forbidden to all but the cloistered nuns. It has tall cypress trees and palms, and the view must be magnificent. It is a good thing it has such a view, and I hope it provides the sisters some peace in their solitude.

Violante spent her life there, from her most tender years to her death. When I visited her, I did not see her face. My mother and I entered a cell-like room with a wooden bench facing an interior curtained window with iron bars on our side. From the other side, a

disembodied voice greeted us. It was a voice like that of an old child, meek and timid. I don't recall the conversation, but there were many references to God's will. We had brought her a present of vanilla and cinnamon, and some embroidery thread. She gave me an *escapulario*, a neck piece made of cloth and cord with one religious image hanging in front, and another in back so I would be completely protected. She also gave me a little silver thimble that had been her own. The *escapulario* is long gone, but I still have the thimble.

The only part of Violante that I saw was her small hand, vulnerable and pale and covered with blue veins, which she stretched toward me to give my presents and retrieve hers; I believe we touched, but it was an incidental touch, without meaning. She probably never had another human being touch her with any kind of affection after she entered the convent.

Sometimes I think about Violante and I wonder if she suspected what she had lost and why. I wonder if her undeveloped mind had even the capacity to entertain such thoughts. If not, that was merciful!

Another story I remember is that of Desolada. I knew Desolada and saw her many times, always dressed in black, going to church with her mother. She was my second cousin, but I spoke to her only a few times. Though she was much older than I, that was not the reason, for she did not speak to anybody.

Her family lived in a beautiful palace not far from my house, in the old part of town near the sea. Her parents were very conservative religious people, and extremely reclusive. They visited only on special occasions, perhaps at weddings and, of course, at every funeral. Funerals were grand on the island because so many of us were related.

Desolada was the youngest of a family of five sisters and a brother, the heir. They did not socialize, but sometimes when we saw them in the streets they smiled and said hello. I don't think they had any friends, and none of them married. But when the scandal happened I, like everyone else on the island, heard the story.

Desolada was pregnant! It was unheard of! To my knowledge it had never happened to an unmarried girl of one of the "best" families, the legendary seven, that had come to Mallorca with Jaime I, El Conquistador. Or, if it had happened, it had never become public,

instead remaining one of the dark secrets. The responsible party was the chauffeur, who wanted to marry Desolada. But that was unacceptable to the family, whose honor would never allow such a union. He was peremptorily dismissed, if not incarcerated, and Desolada disappeared from the face of the Earth for a long time!

It must have been awful for her and also for her sisters. I can't even imagine what must have gone on inside those walls, or what her punishment must have been. Later on, it become known that Desolada had been placed in a home for unwed mothers. After the child, a boy, was born, the family sent him to an orphanage.

The family was very Christian, so they knew their duty: they gave a little money to the orphanage, and after some time allowed Desolada to visit her son once a year, without revealing to him that she was his mother. To him, Desolada was "la Señora," a lady interested in charitable acts. Was that not an admirable arrangement?

Life went on, and only Felipe, the son and heir of the family name and wealth, was seen once in a while. He led a semi-normal life among his peers, looking for a "prospect" to marry—a well-to-do and well-born girl with whom to continue the family line. But even that was not to be. There was an automobile accident, and Felipe, the only son, was tragically killed on a mountain road.

It was then that everything changed: the forgotten bastard, the illegitimate son and grandson—previously the family shame to be ignored, but nevertheless a grandchild—the only male of his generation, was retrieved from wherever he was at that time and brought back to the not-so-loving family bosom. I met him a few times before I came to America —he was about nineteen by then, a good-looking guy who became the darling of Palma's society. But I did not know him well and have not heard how he was able to cope with his early life and reconcile it with what happened to him later. I hope it all worked out well for him and for his mother, Desolada.

The last of these dark stories is personal. I hesitate to write it, even now. I have never told it to anyone before, though a few people have suspected.

I lost my father in the Spanish Civil War, a father whom I adored and who was my idol. I did not get along very well with my mother, and so I transferred some of the traits

and memories I cherished about my father to his older brother, Emilio. He was a widower who had lost his children, two daughters, the older when she was in her prime and only recently married, the other when she was a young girl. He had never remarried because he did not want his daughters to have a stepmother, so he was left alone after they died. He asked his older sister, my aunt Luisa, also widowed, to live with him in his home in Alicante, on the Mediterranean Coast. The house was very large and beautiful, situated in a large square, la Plaza de Ramiro, at the edge of the city, by the sea. He had been an officer in the Spanish navy, like my father, but he had retired in protest when King Alfonso XIII lost his throne and Spain became a Democratic Republic elected by the people. My father chose to stay with the new government, and by the time he was killed in the civil war, he was already an admiral. My mother, my sisters, and I went back to Mallorca after his death.

When I was about fifteen, my aunt and uncle started to invite me to their house frequently. I was very happy because I felt close to them, especially my uncle, whom I iden-tified with my father. It became the norm for me to go to Alicante very often. Traveling alone made me feel very sophisticated. The ferry left Palma's harbor at noon and would arrive at Ibiza, the third of the Balearic Islands, around six. There the boat would dock for three hours, so I would disembark and walk up the streets toward the church and the center of town. Ibiza was quaint and pretty, with narrow cobbled streets and whitewashed houses, and at that time, the women were still wearing their traditional dresses. I would buy straw-berries and the famous cream pie to take to Alicante as a present and would be very careful to be back on board at least fifteen minutes before departure time, when the horn gave its first signal. After the third signal, promptly at nine o'clock, the boat would start to pull away from the pier. By then, it was already dusk or dark and I could look at the silhouettes of the castle, the houses on the hill with their tiny lights, and above it all, the illuminated circle of the church's clock, looking as if it were suspended in midair. I would watch on deck for a long time before going to sleep in my cabin, feeling important and grown-up.

When I was with my aunt and uncle, I always tried my best to please them, and they were very loving to me. Though it was a well-regulated house—my uncle required everything to be on time, to the minute—in general, I did not mind. For some reason, they

preferred me to my sisters. My mother knew it and was always encouraging my visits; Uncle Emilio was very wealthy, and she hoped he would leave his wealth to our family. She did not say that, of course, but I knew it.

When my aunt Luisa died a few years later, I continued going to Alicante to visit my uncle. He was very consistent in his habits, following the same routine day after day. He had breakfast in bed and read the paper. He had a suite of private rooms in the *entresuelo*, a floor many Spanish houses have between the street level and the main floor, with a lower ceiling than the main floor. It was there that he had his bedroom, his bath and dressing room, and a rather large den with a desk, bookcases, and comfortable armchairs. It was very private and, apart from the chauffeur, who also helped him dress, no one entered those rooms unless invited.

After reading the paper, he proceeded to his ablutions, which were slow and elaborate, and to dressing, which was always carefully done. He never wore the same suit on consecutive days, and he always wore a starched shirt, well-creased pants, and shiny shoes specially made for him by his shoemaker in San Sebastian, the elegant resort on the Cantabric Coast, where he used to spend the summers in earlier years. He would put on his hat and get his silver-topped cane, and, always at the same time, start walking toward the Church of San Nicolas for his daily Mass at eleven o'clock. The people in the shops claimed they could set their clocks as he was passing and be correct to the minute.

He was a devout, exemplary parishioner, edifying the other gents who attended the daily service. After Mass, he would proceed in his dignified, leisurely manner to his club on the Paseo de la Esplanada, bordering the harbor. There he sat on the outdoor terrace, weather permitting, or inside on cooler days, with some of his acquaintances. They never showed much familiarity toward him; they treated him with the utmost respect and deference, because he was a member of one of the oldest families—and he never allowed anyone to forget it. He was a respected Christian gentleman!

Finally, exactly on time and not one minute later, he would leave the club and, following the same route every day, arrive home to change his suit jacket for a more comfortable velvet smoking jacket, and enter the dining room at exactly two, when the main meal of

the day was served. If I had been shopping or walking with friends, I could find him without problem by calculating the exact time he would arrive at each corner, and so join him for the rest of the walk home.

As time went by, my uncle become more and more controlling. He did not want me to have friends and said they were not worthy of me. After the main meal, we played Parcheesi at the *camilla*, a round table covered with wool skirts, which has a platform with a brassier full of coals underneath it. Because old houses had heat only from fireplaces, every-one had a *camilla*, which was very comfortable in winter. We played three games, or two if one of us had already won both, then he napped in his armchair and I had a free hour-and-a-half. I either read or went for a walk by the sea, but he wanted me there as soon as he awoke and complained when I was late.

I was supposed to roll thirty-three cigarettes for him every day, which I did at the *camilla*. At five o'clock, tea was served, and after that, I could do anything I wanted, as long as I was seated at the *camilla*. I could sketch, embroider, sew, or anything else, as long as I kept the conversation going. If I insisted on going to a movie with friends, he would get in a really bad mood. No matter how long the movie lasted, I was expected to be back by nine, when supper was served—again at the *camilla*. It was agony to leave the theater before the film ended, so I always waited until the last possible moment and then had to run all the way home. If I was late, both my uncle and the maid serving dinner would be mad at me and wouldn't speak during the whole meal. The next day I would have to call one of my friends to find out the resolution of the drama, or the murder, or the intrigue.

I decided that I was going to go to the Berlitz school to study French and English. He did not want me to go, but I have always been very stubborn, and I like languages. Besides, it got me out of the house, though even so, I was spending hours at the darn *camilla*. Gradually, my uncle's conversation started to change in a surprising way, and he began talk-ing about things he would never have mentioned in front of his sister, Aunt Luisa. He did not want me to turn the light on when it began to get dark, and he would hold my hand and tell stories about his escapades with some of the married townswomen, especially one whose husband was often away. Sometimes, in the middle of a boat party with many people

surrounding them, he would sit by her, put a blanket over their legs, and, in his words, become affectionate. They also had an agreement that she would hang a white cloth on her balcony when her husband was away, as a sign that he could visit her. And they sent each other messages via ads in a popular magazine, *Blanco y Negro*. There were piles of them in the attic, and just for fun, I started to look for the ads—and found them, with his signature, Bebe. All this was absolutely ridiculous, but I was so naïve that I did not understand why I was starting to feel very uncomfortable.

At about this time, a recently married school friend from Palma came through Alicante with her husband, on their way to Murcia, were he was going to teach at the university. They stopped to visit, and my uncle enjoyed the conversation with Joaquin and Nuria. They invited me to visit them, and I accepted. My uncle, of course, did not want me to go, but I did anyway. He and the chauffeur drove me to the train station, and I spent about a week with them.

When I returned from Murcia, my uncle's pattern of behavior continued, but I still could not figure out what was happening. I just did not get it. The climax came when I became ill with a sore throat after going to the horse races. When my uncle came to see how I was feeling, he wanted to put his ear to my chest, but I would not let him. Fortunately, a maid came in with a cup of tea and he left. The next day, I was up, even though I was not feeling well. He called me to his den, telling me he wanted to talk to me in private. He showed me a document he wanted me to sign.

It said that if I agreed to stay with him and not get married until after his death, he would give me his house and enough money for its upkeep and to support myself, too. At last I understood what was happening. I was devastated and became very angry. He pleaded with me in the most humiliating manner, but I fled to my room and locked myself in.

That night, I packed my suitcase, and in the morning, before he was out of his room, I called a cab and went to the harbor. I was in charge of the day-to-day running of his house, and I used some of that money to buy passage on the ferry boat to Palma. I was gone by noon. When I arrived home the next day, my mother was shocked by my unannounced return, but I refused to explain. I was angry that she, who had always been so suspicious of

all my friends, had been for years sending me to the wolf's den. I wonder if she ever realized what had happened.

About a week later my mother received a letter from my uncle telling her that I had left his house because it had become known to him that I had misrepresented my trip to Murcia as a visit to my friend Nuria and her husband, when I had really gone off with a boyfriend. Not even my mother could believe such a thing. When he died, he disinherited not only me but my sisters, too. What a Christian gentleman! ✒

⚭ lisboa

WHEN I WAS NINETEEN OR TWENTY YEARS OLD, I went to Lisboa—Lisbon—to visit my cousin Isabel. Her husband, Nicolás Franco, was the Spanish ambassador to Portugal. He was also the brother of the Spanish dictator, Francisco Franco.

Isabel was the daughter of my father's brother, Ricardo, and was much older than I was. She was, in fact, closer to my mother's age. She was her husband's second wife; the first, Conchita (her cousin, the daughter of another brother, Emilio), had died in an automobile accident when she was very young. Tragically, it occurred while her husband, Nicolás, was driving them home from a summer vacation in San Sebastian, a very fashionable resort town in the north of Spain on the Atlantic coast. Her father, Emilio, was following in his own car when the accident occurred.

Isabel and Nicolás did not have children for several years; they finally had a son, Niki, when both of them were rather mature. He was the apple of his parents' eyes. He was about thirteen the summer I went to Lisbon, a handsome, brilliant boy. He was spoiled rotten, of course, but in a nice, rather amusing way, and we became good friends. We still are. Nicolás Senior was a real character; the family had many stories about his exploits and his absent-mindedness. It was typical for him to miss trains, planes, and boats, sometimes twice in a row. After arriving late for a train, he would wait in the station with a newspaper or a magazine and become so engrossed in his reading that he would not notice the next train until he heard its whistle as it exited the station. Then he could only watch it disappear down the tracks.

One time, he went bear hunting in Sierra Nevada, in central Spain. That night, while he and his friends were in a mountain lodge, he grabbed an armful of rifles to put

them in a corner. One of them discharged, and the bullet went though his chest. Nicolás was a very robust man, so there was plenty of room around his heart for the bullet to pass without piercing it. His life was spared, but the bullet lodged in his ribs.

It started to snow heavily during the night, isolating the group. Nicholás become concerned about infection and tried to convince his friends to extract the bullet with a hunting knife. When no one would do it, he drank a healthy amount of cognac, poured the rest on the wound, cut himself open, and extracted the bullet. Early the next morning, while his friends were still asleep, he got on his horse and rode until he got to a village, where someone took him to the nearest hospital.

I once went on a trip with him in a small airplane, on which we were the only passengers. He went to talk to the *azafata* (the name given to flight attendants in Spain at that time, after the maids of the Arabian princess Scheherazade). She was a beautiful girl, the granddaughter of the famous Spanish composer Isaac Albéniz. One of the pilots came to sit by me. He told me the story of another flight with Nicolás. They had been in the air when some trouble developed with a wing of the plane. The problem was so serious that Nicolás insisted on having himself tied with a cable so he could crawl to the end of the wing to fix it. At that time, planes didn't fly as high as they do now, and he was an aeronautical engineer, but I don't think many people would have dared to do what he did.

The Spanish embassy was in an old palace on the outskirts of Lisbon. It was very beautiful and had been completely restored and furnished with magnificent Spanish antiques and paintings by famous Spanish artists. Spain is not a very wealthy country, but it is a proud one, so the embassy representing it had to be first class. This was true even during the fifteen years or so following the civil war, when a lot of us were not doing very well. The embassy had a courtyard entrance, with a grand double staircase featuring carved stone steps and a balustrade, and large stone containers of bougainvilleas and other brilliantly colored flowers. The foyer also had a carved fountain, and the play of the water made a refreshing sound in the warm Portuguese spring. The rooms were spacious, with elegant *artesonados* (carved wooden ceilings) and hanging tapestries from the old Madrid factory. It had an

enchanting garden, and even a small horse-training circle where Niki could ride his pony. To me, it was like living in a fairy tale, since I could have anything I wanted—a change from the many deprivations at my mother's house in the years after the civil war.

One thing they had been unable to do, however, was get rid of the rats. Lisbon was full of rats—large, ferocious ones. I wonder if it is still that way. They had come from the shores of the Tagus River and populated the city's sewers. When the lights were dimmed in the house at night, the space under the wooden floor came alive with their rushing about. You could feel them scurrying under your feet if you happened to go to the bathroom, and you could hear their squeaking as they called to each other. From time to time, they would surface and run around the rooms. Once I went to my bathroom to get ready for a party and found one in the tub. It was trying to get out, but its feet could not grip the porcelain, and so it was running around, desperate, making horrifying, chilling screams—screams that were, however, nothing compared to my own—until someone heard me and came to my rescue.

Another day, we had been waiting for the arrival of a friend, an Italian count who frequently visited the house. We waited all day. When it was past dinnertime and he had still not arrived, Isabel suggested that we go to the movies, so we did: Isabel, Nicolás, Maruja, Niki, and I. (Maruja was a daughter of Isabel's sister Clotilde, whose husband had been assassinated in the civil war, like my own father. A few months after her husband's death, Clotilde died of a broken heart. So Maruja had come to live with her aunt Isabel, to whom she was almost like a daughter. Maruja was a few years older than I and was engaged to marry Alejandro, the second son of a Portuguese duke.) After we returned from the movies, about two in the morning, we went to the small family dining room for ice cream. There was a huge rat waiting for us. Instantly, Isabel, Maruja, Niki, and I were climbing on chairs and tables and screaming like crazy, with the rat frantically running among us. It made a real commotion in the previously silent house. But Nicolás did not lose his nerve, and he was fast. He ran out of the room screaming, "I'll kill her, I'll kill her!" (In Spanish, nouns are either feminine or masculine, and "rat" happens to be a feminine noun.) He opened the door of one of the guest rooms upstairs—one that had swords and shields decorating the walls, climbed on a chair, and grabbed a sword, all the while shouting, "I'll kill her, I'll kill her!" He did not notice the Italian count, who had finally arrived in our absence and, being

tired, had gone to sleep. The commotion woke him, and he was now sitting in bed in his striped nightshirt, thinking a crime of passion was about to be committed. Nicolás paid him no attention, running as fast as he could back to the dining room, where the rest of us were still screaming. He found the rat and, with a deft, strong hand, struck the animal, pinning it to the wooden floor. It was horrible, but we all recovered, including the count, who cautiously descended the stairs in his striped nightshirt to investigate the crime. Isabel decided that the affair called for a celebration, so she got out a couple of bottles of champagne, and we all had a drink. The rat's dead body was removed in the morning by some unfortunate member of the staff.

Lisbon is an interesting city. Visually, it is enchanting. The old houses are painted in pink and pastel hues of green and blue, and the streets and paseos are shaded by beautiful tall trees. There is a very old barrio, La Moreria ("the Moorish place"), where the cobbled streets are very narrow and turn at odd angles up and down the hill, in a dark, mysterious maze. There are many taverns on the wharfs by the harbor, where, at that time, fishermen and dock workers went after their hard workdays, to have a well-deserved drink and hear the *fados*, the old, sad songs of Portugal. *Fado* means "fate," and in those days, *fados* were sung only by women, who usually dressed in black, wearing a fringed shawl, or *mantón*, on their shoulders as they stood behind a chair, holding onto its back. *Fados* are poignant songs of mourning, lost love, and heartbreak. The *fado* was not fashionable then, appreciated mainly by the less-privileged people. I believe my cousin Isabel had a lot to do with bringing it to the attention of music and folklore lovers. Often, when she had a party at the embassy, she would invite one of the singers to perform. Some were too shy to accept these invitations, but one in particular, Amália Rodrigues, became a regular performer at the parties. She was in her thirties and had an incredible voice, which she would pour into her songs. Some said she would damage her voice by singing with such abandon, but she never lost it. She became internationally famous, and I read about her death a few years ago. I feel honored that I met her at a time when it was still possible to talk with her. She was a great artist.

Lisbon was very old-fashioned, even for someone like me, who had come from Spain. My cousin Maruja and I liked to walk downtown. It was a long way, but pleasant. Some areas we walked through had only country houses and villas; the paseos, with trees and

flowers, and fountains cooling the air and making refreshing sounds. Lisboa had very little car traffic. But rules had to be observed. For instance, at the Plaza del Rocío, the beautiful large square that is the heart of Lisbon, women were allowed only on one side of the street; the other side was reserved for men and was equipped with large screens on which the latest news was projected. The men would congregate there to read, so the rule was that women could not walk on that side of the plaza, to avoid distracting the men.

Maruja and I constantly argued about this because I wanted to walk on the men's side, just for the heck of it. I said we were Spaniards and we did not have to abide by their stupid rules, but Maruja was engaged to marry the second son of a duke, and she was afraid of making waves. Lisbon was a very gossipy town, and if someone saw her and told the family, she would have a problem. But I was a free woman, and so, when we arrived at Rocio, we parted and walked on separate sides, she with the women and I with the men. We met at the other end of the plaza, and though nothing bad ever happened to me, I got a lot of looks!

In the fashionable part of town, the area is full of attractive boutiques and teashops. Men would follow us up and down the hills, men with dark, intense eyes who murmured compliments about our beauty. They would follow us for a long time, waiting at the shop entrances for us to come out, or looking through the window when we were having tea and pastries in the teashop. I was used to the Spanish version of this type of courtship, where men would yell *piropos* (praises of your charms) at you. These were sometimes in dubious taste but were generally harmless, as the men were just having a good time. But in Lisbon, this behavior made us uneasy, so when it was time to go home, we would call the embassy, and they would send a car for us.

Maruja had good reasons for her cautious behavior, because Lisbon was almost as full of gossips as it was of rats, and the family of her fiancé, Alejandro, was old-fashioned, conservative, and religious—to the extreme. Once, Isabel, Maruja, and I were invited to a supposedly informal family dinner. We took special care to dress properly (high neckline, long sleeves, muted colors, etc.). Maruja was especially careful, even with her makeup. We arrived in state, in the embassy Rolls-Royce, and were observed with curiosity by the neighbors. The family house was a palace in the oldest part of town. I still remember the servant

opening the door for us in his *librea* (ceremonial dress) with the colors and the crest of the family. We were taken upstairs, to the main floor, and on every landing (the stairs were very wide) there were more servants in the same dress (so much for informality). We were shown into the family room, where the whole family had congregated to wait for us. The mother and father, who appeared to be very old, were soberly dressed in black, and all their children, eight or nine of them, surrounded them, all looking very circumspect, and I do mean all. I knew Alejandro and two of his younger sisters from their visits to the embassy. There they behaved very differently, but here in the august presence of their parents they were more reserved. Isabel was treated as though she were the Queen of Spain, but Maruja and I were lesser mortals, thank God! I was a little handicapped because I could not understand every Portuguese word, but it seemed to me that the conversation was not worth my effort, consisting only of platitudes. So I concentrated my attention on the beauty of the furniture and some of the paintings until dinner was announced and we all went to the large dining room, where the table was set with flowers and many forks and knives. It was a sumptuous feast, though not as many wines were served as at the Spanish embassy. Even on formal occasions, Spaniards have more fun!

After dinner, all the children approached their parents to kiss their hand and thank them for the wonderful dinner. Maruja did the same, but Isabel and I just shook hands and said "thanks." All of us then adjourned to the living room, and the father got his rosary beads to conduct the prayer, which consists of five *Padre Nuestros* (Our Fathers), fifty *Ave Marías* (Hail Marys), and five *Gloria Patris* (Glory Be to the Fathers), and then he said the *Letanía de Todos los Santos* (Litany of All the Saints). In this prayer, the leader says the name of each of the official saints of the Catholic Church, and the rest of the worshippers respond "*Ora pro nobis,*" which is Latin for "Pray for us." It can take a long time, especially if the leader wants to edify the audience. By the time he finished, we three Spaniards and, I suspect, most of the Portuguese faithful were ready to call it a day and escape. Any attempt at polite conversation was abandoned, the car was called, and we took our leave, mercifully restored to our sinful ways.

And as soon we got to the embassy, we had a relief party and congratulated Maruja on how much fun she was going to have holding court to her in-laws every Sunday and every saint's day. But that was part of the price you had to pay if you wanted to marry the second

son of a Portuguese duke in Old Lisbon. I wondered how much more would be required to marry the first son, the *primogénito*, the heir. In this particular case, the heir was still a bachelor and unattached; gossips said he was hard to get. For some time, he had been away in Africa, in the Portuguese colonies, where the family had valuable holdings. While he was there, he had become involved with a young black African girl who had subsequently given birth to a child. Of course, this was a disgrace for him and especially for the family, but as dutiful Christians, the parents had interfered and brought the child, a girl, to Lisbon. She was educated at a convent school, trained so that later she could have a job as a low-level worker, separated from her mother, and never acknowledged as a member of one of the richest and most distinguished families in the land.

Lisbon was a very interesting place at that time. There were many exiled royals living there or in Estoril, a resort town a few kilometers away on the coast. I met many of them because they were often invited to the embassy. I remember King Humberto from Italy, who was *muy simpático*, and I danced with him many times. There was Carol of Romania, with his famous lover, Madame Lupescu; and the Count and Countess of Paris, the presumptive heirs to the throne of France. I never talked to them but did go to their palace in the country for the coming-out of their daughter the princess.

On that occasion we left Lisbon in the early evening and crossed the river on the ferry. It was about a two-hour drive, and we arrived at twilight. The party was in the gardens —many terraced gardens, where Chinese lanterns hung from trees, illuminating the marble fountains and flowerbeds. The musicians were on an old-fashioned white stand, and there was a large stone circle for the dancing.

Waiters in formal dress, wearing the shields of the French royal family, were serving champagne. At the appointed time, the princess appeared, accompanied by about twenty other girls who were being presented at the same time. It was very pretty to see them among the trees, dancing their first waltz with their fathers.

I was merely a spectator most of the time, since Isabel and Nicolás were with the big shots, and Maruja with her fiancé. I spent most of the evening with another girl I knew from the embassy, the daughter of the Chilean consul. Except for the few times we were

asked to dance, we spent the evening together as wallflowers. We also had a great dinner under the trees, with the moon illuminating the gardens and the rushing waters of the Tagus River. It was very romantic!

Another time, we were invited to the rooftop apartment of an elderly Portuguese woman, a poet and writer. She was very bohemian, with her long hair tinted red and hanging loose over her shoulders. She was garishly dressed in a shiny black gown with a shawl printed with large bright flowers. She does not sound so out-of-the-ordinary now, but in Lisbon at that time, she was. Maruja did not want to go to this gathering, which she thought would be boring. However, it turned out to be very amusing. The apartment was full of Victorian furniture, sofas covered with Moroccan fabrics and pillows, a grand piano, and paintings of romantic men and women in compromising situations. From the windows and the terrace, you could see Lisbon's rooftops, the pastel colors of its houses, and the ornate classic designs of the balconies and the spires of its many churches, with the Atlantic Ocean in the distance.

Among the guests there were several other poets and musicians, including the *fado* singer Amália Rodrigues. Also in attendance was King Carol of Romania; his paramour, Madame Lupescu; and Humberto of Italy. It was my impression that, among the royal residents of Lisbon, King Carol and King Humberto were the most likely to have fun and appreciate the company of lesser mortals. I was very amused by a young poet who kept looking at me with languishing eyes. I was wearing a red long dress, very Spanish, and felt very sophisticated.

I went to the poet's house several times, and always the highlight for me was Amália Rodrigues. She was, at that time, already a mature woman, with striking dark eyes and long black hair. She was always willing to sing and never seemed to tire. You did not have to understand every word to feel the poignancy of her songs, for she poured herself into them—her heart, her body, her sorrows. She was like the tragic essence of the *fado*, as if the sadness of generations of Portuguese women was flowing like a river from her soul.

Another memory that stands out from my time in Lisbon was when I got to meet the Spanish royal family, who were living in Estoril. They never came to the Spanish

embassy, which I suppose would not have been an appropriate act for Juan de Borbón, the father of the present king, Juan Carlos I. He was, after all, the heir to the Spanish throne, and the dictator Francisco Franco, who thought of himself as the *caudillo*, the head of what he called *El Imperio*, had taken that throne away and was not ready to return it.

In spite of all that, and despite the fact that Franco had appointed his brother Nicolás to his post as ambassador, what I personally saw makes me believe that the relations between the embassy and Don Juan de Borbón were at the least very respectful. Sometimes, coming back from the beach in Estoril, Nicolás had papers or documents to deliver to Don Juan. We would usually wait in the car while he went upstairs, but one time when I was alone with him, he said, "I want you to meet Don Juan. Come along with me." And so I went and got to meet him and also his wife, Doña Maria, and the then Prince of Asturias, the present king, Juan Carlos. Nicolás introduced me as the daughter of the *Admirante* Luis Pasqual del Pobil, who had been a naval commander at the time of the civil war, and who was killed in Menorca with all his officers. They were very kind to me, and I started to cry— for many years I could not hear my father's name without crying.

I saw them another time, at the bullfights, when we went to see them in their box. They liked to visit with Spaniards because they were homesick. I understand that now, because the same happens to me; I love to meet people from Spain.

One time, something happened that I never forgot. One afternoon we were at the horse races, and I left our box to place a small bet. On my way back, I saw the Prince of Asturias, our current king, walking in my direction with his aides. I stepped to the side, like everyone else, to let him pass. In Portugal, with so much royalty among them, people knew the protocol. But I was amazed when he stopped in front of me, called me by name, Pilar, and asked me on what horse I had placed my bet. I could not believe he would even remember my name, not with all the people he must have met all the time. I was very flattered. He must have been about thirteen at that time, because he and my cousin Niki, along with several other Spanish children, attended a small school together in Lisbon, organized so that they could grow up among Spaniards.

I talked to Juan Carlos once more, after he was already king. My husband, Walter, and I were in Madrid, and Niki, who by that time had matured into Nicolás, invited us to have dinner at Jockey, a very exclusive Madrid restaurant. The place was full, and we did not have a reservation, but we saw that a whole area had been cordoned off. Nicolás went to inquire (I don't know what he said to the maître d'), and we were seated at a table inside the cordoned-off area. My cousin said that they were expecting the king, and he soon arrived, along with his wife, Reina Sofia. After they were seated, Nicolás went to talk to them and then came back to get us. He introduced us as his cousin Pilar Pasqual del Pobil, my legal name in Spain, and her husband, an American citizen. I told the king I had had the honor of meeting him before, in Portugal, though naturally I did not go into details. He was again as gracious as he had been before, and so was the queen.

One last memory from that time deserves to be mentioned, because it is so beautiful. Shortly before going back to Mallorca, we were invited to the home of one of Alejandro's sisters, in a small inland village. The house was in the town square. They were very hospitable, and their home was charming, but what I remember most was what happened after dinner. We heard singing and went to the balcony. A full moon was flooding the square with light so bright that the shadows receded toward the old houses and the facade of the little church. The young boys and girls of the village had gathered in the center of the square to serenade us. They stood there, the girls in white, the boys in black pants and white shirts. They had their arms around each others' waists and, as they sang, they swayed from side to side with the cadence of the old songs of Portugal. This is my last memory of that time in Portugal, when I was young. 🖎

✄ *a new story*

1 FIRST MET WALTER, MY HUSBAND-TO-BE, sometime in November 1954. I was helping my next-door neighbor, Lolín. Lolín and her husband, Antonio, were going on an extended trip, with him perhaps taking a new job in a distant city on the mainland. They had leased their house, next to my mother's, to a brother and sister from America who had been traveling in Europe for a while and had decided to settle in Mallorca for at least two years. I was standing on the kitchen counter hanging a crisp, starched, red-and-white ruffle from the shelf on the tiled hood over the stove when Walter walked in to talk to Lolín. He was so tall that I did not have to lean very far in order to shake his hand when she introduced us. He was blond with blue eyes—very Nordic—and, I thought, good-looking.

Lolín was attempting to figure out when they were planning to move in, but she did not speak English, and Walter, at that time, spoke barely any Spanish. I, with my Berlitz-School English, immediately became the invaluable translator. After we discussed the details, I told them that if they needed more help they could just give me a call over the wall that separated our gardens.

On my side of the wall, there was a terrace over the garage, with a stone bench where, on sunny mornings in winter and cool evenings in summer, I would sit to read or sketch or embroider. Our gardens stood higher than the street below, and I could see people going by. It was entertaining. By then my mother had sold our old house in Palma and we were living on the outskirts, near the hills of the Castillo de Bellver. It was a very pretty and, at that time, semirural area, with houses and gardens often separated by fields, gullies, and small woods. We did not have a car, so we walked everywhere or took the *tranvías*, the dark-red street cars that ran back and forth on the main road between Palma and the nearby

neighborhoods. Our own street was conveniently situated away from the main road, sparing us the noise of traffic, but we were close enough to catch a *tranvía* if we needed to get someplace faster than by walking.

I was out of school, and my mother would not allow me or my younger sister to go to college. It would have been free, as it had been offered to us by the government because our father had been an admiral in the Spanish navy who was killed in the war, but my mother was very conservative and believed girls belonged at home or in a convent. We were not allowed to have a job, either, because girls in our family were not supposed to work. However, I was taking some classes, because I knew that if I did not get married soon, I was going to have to move out, perhaps even to another town, to escape my mother's overbearing control. My four older sisters and the younger one had all allowed our mother to dominate their lives. The results were terrible, and my sisters, except for the younger one, whom I was trying to help, did not have friends or a social life, were very insecure, and were dowdy-looking, even though they could have been attractive if they had been more assertive. They were *amargadas*—bitter, unpleasant women who spent their time feeling sorry for themselves and blaming my mother for their unhappiness. It was an example I did not want to follow, so I was considered an unmanageable rebel, when all I wanted to be was normal.

My mother, who had been and still was a beautiful woman, could on occasion be rather charming when talking to other people. But with her own daughters, she had became totally neurotic, embittered, distrustful, extremely religious, and full of fears that all kinds of mishaps were about to befall us. She would use any pretext to keep us at home under her rule. I remember once, being invited to go to Soller, a town some distance from Palma, with some school friends—Francisca and Araceli—and their aunt and uncle visiting from Galicia. We were to travel on an electric train that, in order to reach Soller, goes through a tunnel under the mountains. To this day, there has never been an accident, but that day my mother decided it was too dangerous because the tunnel was sure to collapse from the recent rains. To live under the control of someone like her was intolerable to me, so I would not obey her. I was very stubborn and would have my way, so the situation was often very tense between us. (I went to Soller!)

I had many friends, and they were all decent people; there were no drunks, no libertines, and no delinquents among them. We just wanted to get together, usually in groups, to go to a movie, a dance on a Sunday afternoon at the Yacht Club, or an excursion to the beach or the mountains. If the dance was a formal occasion, there was always a chaperone. My friends were mostly from families my mother knew, and sometimes they were even cousins or other relatives. At the time I met Walter, I already had a special boyfriend; his name was Juan, and I loved him very much. He loved me, too, but it was a troubled relationship because he was almost always depressed. I used to tell him that even in the most beautiful place in the world, all he could see were the flies.

He was a *teniente de navío*, an officer in the navy, and one of the reasons for his depression was that because so many of the admirals, contra admirals, and so on had been killed in the war (like my own father) and their posts filled by younger men, he thought there was little chance for him to advance. He did not want to marry me and take me to live in a *cuchitril*, a small, cheap apartment, and watch me do the household chores. It was really just a Spanish macho thing, and although I told him that the important thing was to be together, he would not accept it. So we would break up for a few months, then resume the relationship a little later and be happy for a while, until the cycle restarted.

Even though I had a boyfriend, my mother had no reason to distrust me—or him. I was a virgin until I got married, and it was not a great accomplishment on my part. The fact was that none of my male friends would have dreamed of approaching me, or any of my girlfriends, with any kind of sexual designs. To them, we were totally off-limits. To my knowledge, none of us ever had to fight off advances. And in my own case, I was almost totally ignorant of what it would take for me to lose my "virtue." I had a very confused idea of the whole process and was very surprised when it finally happened, because I had always believed that babies were conceived through the navel. I was twenty-six years old! That should show in what naïveté and ignorance we were raised.

My mother always thought I was a rebellious daughter, in constant danger of becoming a loose woman. We had continual arguments because I would not conform to her wishes. I had to sneak and lie in order to do totally inoffensive things such as swimming. We lived on an island, but to her the surrounding waters were a peril to my chastity. The group

Acción Católica had established some beaches for young women that separated the male and female bathers with fences built of palm fronds. The male side was always crowded with men and boys looking through the fronds at the girls and women on the other side, all of whom were properly clad in canvas bathing suits (canvas does not cling to the body) with skirts barely above the knees, high necklines, and cup sleeves. If you tried to swim in those outfits in deep water you would have drowned from the weight of them.

I had secretly bought myself a regular bathing suit, which I had to dry under my bed. My friends and I never went to the beach; we swam from some rocks at the end of the harbor. Our male friends often came to visit in their sailing boats, usually Snipes, and invited us to go with them to race in the middle of the beautiful blue and green Bay of Palma. My aunts knew this went on, but they never told my mother. From time to time, the local newspaper would have a front-page headline: "Sharks Sighted Close to Shore," and "Bathers Beware." As there are no sharks in those waters, we would all say, "The bishop's sharks are acting up again!"

If I was going to a dance, all dressed up and thinking myself pretty, my mother would give me her last admonitions: "Pilar, you and I are going to hell. You, because you are so bad and willful and don't mind me, and I, because I am weak and can't stop you. But be sure of one thing—if you dance and allow a man to put an arm around you, you are committing a mortal sin!" I must confess that I committed innumerable mortal sins, and enjoyed them, too!

After that first meeting, I did not see Walter again for a while; he and his sister, Edith, moved in, there were furniture deliveries, and sometimes I saw people who I supposed were their friends going in and out of their house. There was a British Club nearby, where many foreign people got together to play bridge or have cocktails and dance. But these were unknown to me, since I had my Spanish friends. Then, one sunny morning in January, as I was reading on the stone bench on the terrace, Walter came to the other side of the wall. It was the first time we had talked since our meeting in the kitchen. He said he had seen me often going for a walk in the hills; he liked to walk, too, and wondered if I would allow him to go with me. I said that would be fine, and that was our first date.

I knew all the little lanes crossing the dry creeks and the gullies, up and down the

hills. He helped me cross rocks and water, although I was perfectly able to do so on my own. We went to La Bonanova, a small village in the mountains with an old stone church and a view of the Bay of Palma. It was a very romantic walk, and he told me how he had seen me many times in the *tranvías* with my younger sister, before he came to live next door. He said he had wanted to meet me, and that he never had known a girl like me, "so fresh and charming and natural." I was not convinced by that and thought that perhaps he was just a sleek talker, but it was pleasant to hear, and the walk went on for a long time. We made it all the way to Palma, to a café in the Paseo del Borne. We had sherry and olives and toasted almonds, and we talked and talked. I asked him where he was from, and he said he was from Utah, to which I replied, "Oh, La Ciudad del Lago Salado (Salt Lake City)! I asked if he was a Mormon, and he told me that he was from a Mormon family. Of course, I also asked if he was a polygamist. He was blown away. He told me he had been in Vienna, Rome, Copenhagen, Paris, and London, and no one had ever known all those facts about Utah. "How do you know?" he asked. I would not tell him, but I had read many of Zane Grey's books about the West.

When it was time to go home, we took the *tranvía* and walked to our street. Before I opened my gate, he kissed me. That was unexpected, as none of my Spanish friends would have dared, especially on a first date. But I did not get mad at him, and from that day, we knew we were going to get married. I did not have any doubt, and neither did he. It was on the fifth of January; I remember because it was the eve of Three Kings Day, *Los Reyes Magos*. He made me feel as though I was very special, and that never changed in the many years we were together. He always said that meeting me had been serendipity, the luckiest thing in his life. This is not to say we did not have problems sometimes, but our relationship was unchanged to the end of his life. His belief in me made me try harder and be better than I probably would have been without him.

Walter was brilliant, really intelligent and always full of interesting conversation. He could see things from different points of view that would never had occurred to me. He was knowledgeable in many diverse subjects and, when confronted with one he was not familiar with, he had the mental curiosity to investigate and read until he understood it. Over the years, our children and I benefitted greatly from his extraordinary intellect.

 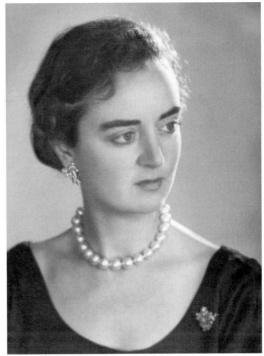

Walter Smith in Palma, Mallorca, around September 1955. Pilar, around February 1956.

Of course, I did not know all in those first months, but I knew enough to over-come the many difficulties of marrying a man so different from me. He was older and much more mature than I was; he was from a distant country largely unknown to me and of a very different background. There were many obstacles to face with my family, and there was my own pain at leaving the island I loved so much, with its lovely coves that welcomed the transparent waters of the blue Mediterranean Sea, and the mountains and villages of old stone, and the pines, the *algarrobos*, and the olive trees. Just the thought of leaving all that was breaking my heart. At that time, really, places were much farther from one another, especially for Spaniards living under Franco's dictatorship, when even having a passport was not very common. Fortunately, I did happen to have one because of my cousin Isabel and her husband, Nicolas, in Portugal. Any way you thought about it, America was very, very far away! But I knew I had found the best man for me, and I had fallen in love.

Walter wanted to visit my mother almost immediately, to tell her about us, but I told him we had to wait, as he had no idea what my life was going to be like after we told her. I was a real expert in hiding things from my mother and sisters, so even though we lived next door to each other, Walter and I rarely talked over the garden wall. When we did, it was in a very casual way. We left messages beneath a flat stone under a jasmine vine on the wall about where and when to meet. I would go out alone and meet him at the next corner. If I was going to Palma for a class or for some other reason, he waited for me at a café terrace, and then we would go to a movie, or have a drink and dance at a *boîte*. Because my family's move to the outskirts of the city following my grandmother's death had left us rather isolated, there was not much chance of someone telling them about me. The people we did meet were usually my friends, who were not going to go to my mother with stories.

One of the best weeks Walter and I had was during my *Ejercicios Espirituales*, a yearly retreat during which one spent seven days in a church or a convent listening to sermons, meditating, making decisions to dedicate oneself to God, and renouncing the temptations of evil and the ways of the perverted world. There were separate retreats for young men and young women, for *padres de familia* (fathers), for *madres de familia* (mothers), and for children, and so on. We were supposed to sit on those hard wooden benches for hours, with our *mantillas* covering our heads, in our modest dresses with long skirts and sleeves, and listen to a vituperating priest yelling at us from the pulpit and insulting us in the most preposterous manner. I still remember one priest admonishing that if we girls walked in front of a group of men and even one of them had a lascivious thought, it was our fault and we had committed a mortal sin. It was so unreal that years before I had decided that salvation was an unattainable goal for me, and I might as well relax and forget it.

That year, my mother was pleasantly surprised when I agreed to attend the *Ejercicios* for my age group. I left very early every morning, with my *mantilla*, my missal (prayer book), and my rosary beads. After turning a couple of corners, I would find Walter waiting for me in his little French car, and we were off for the day. We went all over the island, to places he had never visited before. It was still winter, and the roads were almost empty, especially on weekdays; anyway there was not much chance of someone recognizing me, as I was riding

in a foreign car with a blond American man. I used my *mantilla* as a scarf against the wind, because we had the top down when it was not raining. It was freedom!

We stopped at small country restaurants for a bowl of *potage*, beans and *salchich* (sausage), and good cheese and olives, or *sobrasada* and the local red wine. My English was improving very quickly, and Walter was learning Spanish, too. Seeing Mallorca through my eyes, he was starting to love my island as I did—it was a love that also stayed with him forever!

We went to the Monasterio de Lluch in the mountains, to Se Calobra by the sea, to Valldemosa and the famous Cartuja where Frédéric Chopin and George Sand spent a cold winter in Mallorca and where he composed most of his sonatas, including one dedicated to Mallorca, *Rumores de la Caleta*. We went to Soller and Fornalutx, and visited the famous British author Robert Graves at his farm near Deyá, on the north coast of the island. It was an exhilarating, memorable week!

Shortly afterward, Walter got news from Utah about a job he had been expecting, and he told his sister he would be leaving soon. She was going to stay. (The main reason for their European tour had been her recent divorce from a rather wealthy Texan; she had asked her brother to accompany her. But she had made friends among the British and American group and was no longer worried about being alone.) Finally, I had to let Walter speak to my mother. I was terrified, anticipating a nasty scene, but that time it was my mother who fooled me. She must have heard rumors about me and Walter and so was not surprised. She took the whole thing in stride and agreed to our marriage. I even had a very strong feeling that she was relieved and happy to get rid of me.

Walter had to leave almost immediately; it was agreed that we would marry by proxy, if possible, and if not, I would go to Salt Lake. Walter's father had already become my sponsor, something I needed to obtain a visa, and I started to arrange my papers. So Walter left, but four months later I still did not have a permit to marry. The American consulate was making it difficult because they suspected that people were getting married as a way of gaining entrance to the United States. Finally, I was able to get a tourist visa, valid for a few months, and Walter bought passage for me on an Italian cargo ship. He had traveled in the

same way and found it was very good—and less expensive than a regular liner. Walter's sister traveled with me from Mallorca to Cádiz, to see me off on the boat departing for the United States.

Leaving Mallorca was almost more than I could bear. I don't cry easily, but I started as soon as we left my mother's house and did not stop until I was way out to sea. I stood on the deck of the ferry and watched the sailors pulling the ladder off the dock. People were waving handkerchiefs and yelling goodbyes, but not to me. I had not let anyone come to see me off. The ship left slowly, gaining speed as it reached the deeper waters in the middle of the harbor. It was twilight, and I could see the familiar shapes of the city's buildings so well known to me—the cathedral; Almudaina Palace; la Murada, my late grandmother's house; and the Bellver Castle on its wooded hill—and the lights of Palma receding into the distance. Too soon, only the outlines of the coast were visible—Illetas, the coast of Andraitx, Cabo Blanco. My former life was disappearing in the vanishing light, my island turning into a shadow sinking in the immensity of the sea. And then it was gone, and I had only dark water, ultramarine sky, and the uncertainty of whether I might ever return. I know it sounds like an exaggeration, perhaps overly dramatic, but America was such an enigma to me, so far away from what I knew. I felt very alone without Walter to reassure me.

After reaching the mainland and before I set off from Cádiz, Edith and I rented a car and took a short tour of the south of Spain—Sevilla, Córdoba, and Granada—which she had never seen. By the time we arrived in Cádiz, I was already feeling like my usual self, optimistic and excited by the adventure. The cargo ship was great, with just nine spacious staterooms with private baths. The passengers had dinner in the dining room with the captain and the officers, and during the day we could go to the refrigerator to prepare a sandwich or anything else we wanted. It was the first time I had ever had "Bimbo bread"; we could also have Kool-Aid, but I felt that was going too far. I stuck to plain water or lemonade.

I became friends with two other girls, one a young, very pretty Italian girl married to an officer of the merchant company, who because of company rules could not travel with her husband; the other a girl from Barcelona on her way to Texas to visit an older brother

and his family. It was summer, and at the start of the voyage, the weather was balmy and sunny. We spent most of the day on an upper deck, returning there after dinner and staying until late at night. The moon reflecting a shiny path on the water was so lovely we did not want to go to bed, but we noticed that the captain kept vigil on the deck and would not retire until we did. He was very protective and every night would tell us to make sure to lock the door when we went to our cabins. I guess he thought those Italians were not to be trusted. One day, we passed an island newly emerged from the ocean, volcanic and still on fire. The captain allowed the boat to go as close as was safely possible, and we had a startling view. It remained visible for hours, the red and orange flames illuminating the sea and the sky.

When the weather changed, we were suddenly in the middle of a terrible storm, with high waves tossing the ship about like a toy and washing over the decks where, of course, we were no longer allowed. We had to lock all the portholes, but there were fans, so it was not too unpleasant. Suitcases rolled from one side of the cabin to the other, along with everything else that was not nailed to the floor or the walls. I had been in storms before, on crossings between Mallorca and the Peninsula, but that one was among the worst and the longest I had ever experienced. It lasted three days. Most people were sick, but my friend from Barcelona had an endless supply of dramamine, which we popped like candy, so we were in good shape and even a little euphoric. We kept going to the dining room for dinner, but we could not even play games, because the chips would fly off in every direction. Our captain pulled us through, and we arrived in Havana a few days later. That was 1956, and Batista was still the president.

We spent a week docked in Havana Harbor, close to the *malecón*, the *paseo* along the sea. Every day, we walked up the narrow cobbled streets toward the center of town. It was very hot and humid. I remember large black women lying on the sidewalks, staying as close to the walls as possible to take advantage of the sliver of shade, and smoking cigars. We ate fried bananas and rice and bought small trinkets and went to the plazas. We wanted to see Havana at night, in the moonlight, but our captain would not allow us—just girls—to go alone; he commissioned two trusted officers to go with us. It was so beautiful, the old

palaces already starting to decay, the cathedral's shadows concealing some forms while the moon illuminated others, the wrought-iron balconies with hanging vines and blooms, the tropical flowers perfuming the night air. There were groups of people in the squares playing guitars and singing Cuban songs. It was evocative and voluptuous!

At last, after the ship delivered some of its cargo and perhaps took on more, we set out on the last part of the trip. Twenty-three days after leaving Cádiz, we arrived at the Mississippi River, making our way to New Orleans. In spite of the heat, I was on the top deck, looking at the riverbanks. The water was yellow, not blue like the sea, and there were riverboats and canoes and many black people, as there had been in Cuba. I don't remember how long the journey upriver took—it seemed quite a long time, perhaps several hours—the ship unhurriedly sliding forward. At last, we reached New Orleans, and for the first time, I set foot in the United States, my new country. We had to wait in the heat for a long time on the docks to go through the emigration gate. I could see Walter far away, waiting behind a barrier. He waved at me, and I was reassured that I was not alone anymore, that he was there. When I finally passed through, he took me in his arms and gave me flowers.

Welcome to America! ❧

desert paintbrush

becoming an artist in utah

❧ first impressions

ARRIVED IN SALT LAKE IN THE SUMMER; the city was vibrant, with its green lawns and trees, the mountains so very close, almost looming over the city. The sky was blue and the clouds white and puffy, different from Mediterranean clouds. I liked Salt Lake.

The first people I met were Walter's parents, Sidney and Katherine, and they were very welcoming, especially Sidney. Katherine was a little reserved, perhaps suspicious. After all, I was from a foreign country, spoke another language, and was definitely not Mormon. But she was nice to me, and Walter did not notice anything. It was just one of those feelings between women, nothing serious, and it slowly vanished after a few days as she saw other people accepting me, in particular her two sisters, Ruth and Blanche. I stayed in Ruth's house on First Avenue for a few days, while Walter stayed in his parents' apartment, also on First Avenue; by then they had already sold their house on Canyon Road, where Walter had grown up.

We were married right away. In fact, we were married twice in about a week, first in a civil marriage to please Walter's mother, who would have been disgusted by a Catholic wedding, and afterward, secretly, in a Catholic church in Brigham City, to please my mother. So, we were very married. After the ceremony, I sent a copy of the Catholic papers to my mother, thinking she could have them translated if she wanted so that she could relax in the knowledge that everything had been properly executed. I also gave her permission to display the documents in the window of one of Palma's elegant and fashionable linen shops, Antigua Casa Bonet, for everyone to see, if it made her feel any better, but I don't think she did it.

We went to live in a very large and old apartment building that belonged to the Mormon Church, the Canyon Road, on the corner of First Avenue and State Street. This was the same building where my parents-in-law were living. It had three separate sections,

each with its own entrance; they were in the easternmost section, and we were in the westernmost one.

Although we did not have any furniture of our own, the first thing Walter bought was a grand piano; there was no way we could live without a grand piano—it was a must. He bought an antique Chickering made before World War II, and it is still in my living room. Walter had gone to the University of California at Berkeley to study anthropology, but he had also attended the Music Conservatory in San Francisco to study piano, and music was very important in his life. Our apartment was on the third floor, and the stairs were very wide and open, but the piano was so heavy that the delivery men could not bring it up. They had to leave it on a landing and go for reinforcements. For a few days we were not very popular with the neighbors.

Walter's sister had given him permission to borrow some of the antique furniture she had in storage, and his boss's wife, Amanda, gave us a large number of cinnabar-green silk damask curtains that she was taking down from their recently acquired house on Capitol Hill. The curtains were beautiful, but they were much too short for the four very high art deco windows in our living room. However, because there was so much cloth, I immediately saw the possibilities: by matching the design and setting the horizontal seam at the line of the windowsill, where the light stopped coming through the fabric and they looked naturally darker against the walls, the seam would be very hard to detect. My mother-in-law thought I was going to make a mess and was in favor of calling an expert, but I knew what I was talking about and went ahead. With careful sewing and a good iron, the curtains turned out beautifully. After the maintenance crew came and painted our walls a fantastic blue I had chosen, we had an apartment we could be proud of!

Walter worked during the day, and I took advantage of the opportunity to start exploring my surroundings. I walked along South Temple Street, with its Victorian mansions and its tall leafy trees that provided refreshing shade. I sometimes stopped for a hamburger at a little stand called the Merry-Go-Round. I thought hamburgers were one of the best American inventions! I walked up and down State Street and visited the State Capitol and the City and County Building; I became very fond of them because they reminded

me of old Europe. I walked along Main Street, window shopping at ZCMI, Penney's, and Kress's, then headed down to Auerbach's at the corner of Third South and State, and back again. My favorite small boutique was Adrian and Emily, and I later became good friends with Emily. And, of course, I went to the LDS temple grounds.

I was very curious about the temple and wanted to go in, but I could not find an entrance. I found a uniformed man who seemed to be in charge and asked, "Where is the gate to the temple? I want to go in but cannot find the entrance."

He looked at me strangely and asked if I lived in Salt Lake. "Yes, I do," I replied, whereupon he asked if I had a "recommend." I told him that I did not have one with me but could easily get one. "My mother-in-law lives nearby," I said. "She is a very good person and a Mormon and she will be happy to give me one." Of course, that did not work out, and Walter nearly died laughing when I told him the story. He told all his friends, and they had a great laugh at my expense, amused by my direct approach to problems.

The first house I visited was that of the Swaners, on Thirteenth Avenue. Louise Swaner was a childhood friend of Walter's, and they had grown up together on Canyon Road. The Swaners' house was very large and rather disorganized, but it was a place where people felt welcome. They had six children, five girls and one boy, all of whom were free spirits, independent and happy. Friends were always invited to use their swimming pool, and it was there that I met Rose on my second day in Salt Lake. She was to become my best friend for many years. She and Hal, her husband and another of Walter's childhood companions, had four children, three sons and one daughter, Daryl. Daryl was about twelve or thirteen, and on that morning of my visit she was at the pool taking care of her youngest brother, who was about two years old.

I was lucky to meet several extremely nice people who accepted me and became my friends. Though many of them have now died, including my own husband, their children are still my friends.

That summer, we were invited to many parties, but I especially remember the ones we went to at the Swaners'. They went on and on through the night and usually ended with swimming in the pool and—once in a while—with an early breakfast. I would get really tired

from the effort of following conversations in English. Because they were among friends of similar backgrounds, much of what they discussed required very little explanation among themselves. But it was all totally strange to me. The altitude of Salt Lake often made me feel light-headed, coming as I did from sea level. When I could not stay awake any longer, I would sleep on the kitchen sofa until Walter woke me to go home. Sometimes we'd get in a Jeep and go into the foothills to look at the city lights way below in the valley.

During that first summer, on evenings after work, if we were not going out with friends, we would pack our dinner and drive up City Creek to one of the picnic grounds in the canyon. Sometimes we made a fire and cooked hot dogs or hamburgers, or else I would make a small paella. Walter loved City Creek Canyon; as children and as teenagers he and his brothers and friends had used it as their own backyard, camping there in the summer and playing with their sleighs and learning to ski in the winter.

Walter's family had a long history in Salt Lake City. One grandfather had been the city's watermaster, and another, Walter Squares, had been Brigham Young's barber. His barbershop, the Silver Palace, has been preserved and is now in Pioneer Village. I heard a few stories about him. He once went with Brigham Young on a horse-and-carriage trip to St. George. One evening, as they were seated in the living room of Young's house with several important townsmen, a servant came in with a silver tray, a bottle of wine, and glasses. All of them were offered a glass of wine. Young did not take any and, following his example, all the others refused it, too. All, that is, but Walter's grandfather, who accepted and drank it. Later that evening, when everyone else was gone, Young reportedly said, "You know, Walter, if I had not been here with them, all those men would have taken the wine. You were the only one that dared to do it in front of me, and I respect you for it."

Another of Walter's stories involved the Mormon Church and its antipolygamy proclamation. Walter Squares, who had five wives, ran away to Mexico. After some time, he came back to visit the family. His youngest wife's name was Favor, and she wanted him to leave the other wives and keep her as his only, legal wife. But he would not do it. So she got very mad, and on the eve of his departure to return to Mexico, as the family was having a farewell dinner, Favor called the "Feds," the federal marshals. They came to the house,

arrested him, and took him to the penitentiary, which was, at that time, located in Sugar House. He was there for quite some time, and Walter's mother remembered visiting him there when she was a child, and taking him cookies.

I came to love City Creek Canyon very much, almost as much as Walter did. During all my years in Salt Lake, first with Walter, then with our children, and now alone, I must have walked many miles there. It's a privilege to have so close a place where I can hear the water running and the birds singing, and where once in a while I can see deer or other wildlife. It's a place where I can think and refresh my mind while walking with my dog (and good friend), Kiva.

As soon as the weather cooled off that first year, Walter started taking me to southern Utah for long weekends. It was marvelous! I thought I knew what to expect since I had read many books about the West by Zane Grey, James Oliver Curwood, and others, and I had seen cowboy movies. But the movies were in black and white, and I was unprepared for that explosion of color. The distances were so "distant," the expanses of land seemed to go forever, and the red-rock mountains emerging from the sage-green vegetation were startling in their fanciful forms. It was a landscape of the mind, almost not of this Earth.

The Silver Palace. 1986, stoneware, 20" × 9½" × 9½". Collection of Marcia and John Price. This sculpture depicts Walter Squares, who was Brigham Young's barber and also the great grandfather of Pilar's husband, Walter.

Walter loved to drive, and he knew the land, so we went to rather remote places. In those days, there were fewer visitors than there are now. I remember how sometimes, in the middle of nowhere, we would pass an Indian, still and expressionless at the side of the road. I would ask, "What is the matter with him? Should we stop and ask if he needs help?" And Walter would explain that probably the man was waiting for someone who would eventually

show up—perhaps today, perhaps tomorrow or the next day—and it was all right, as that was the way it was.

I remember the first time I saw the Colorado River. I wanted to touch it so I could write to my friends that I had actually touched the water of the mighty river. I took my shoes off and went across some mudflats toward the water, where I got to put my hands in it, but when I turned around to return, I started to slide and could not go forward. Walter was not anxious to get into the muck himself, so he tried to give me instructions about how to do it. That didn't work either, so, finally, he had to get in to give me a hand. We ended up falling in and having to crawl out. It was the first time he got really mad at me, but, in the end it was so hilarious, both of us covered in mud, that we could not stop laughing.

I had another adventure in a grocery store in Moab, where I discovered an Indian woman, dressed in her native clothing, with her papoose on her back. I was ecstatic! I followed her along the aisles, trying to be very unassuming (I did not want to alarm her), and from time to time I carefully and lightly touched the baby. I wrote home that I had touched a papoose, but they all thought I was making it up. We also went to Bluff and visited a very small mission where an Episcopal priest was dedicated to helping the Indians living on the reservation. We went to the Four Corners, to Torrey, and to Zion. I think Utah has some of the most beautiful landscapes in the world, and I hope we can preserve them forever.

When winter came, that first winter, I was very sad. I did not want people to know, so I tried to hide my feelings, but I missed Mallorca so much. I remember waking up early in the morning, when it was still dark, and I would hear the water coming through the pipes into the radiators that heated our apartment. It made underground sounds, like a monster breathing and sliding through narrow, constricted spaces. I don't know why that sound was so sad to me, it made me think of cold, of darkness, of being far away. I was not unhappy, I did not want to change anything, and my homesickness seemed an unreasonable feeling, but I could not help it. It persisted for months, until it gradually became less intense and I was able to ignore it—sometimes.

I loved the snow and had never lived in a place with such heavy snowfalls, covering the roofs and the trees in a pristine white mantle. Walter's brother, Paul, and his wife,

Ruth, lived in Emigration Canyon, and on Sundays we went to visit them. They were both well-known painters, and they had a very attractive house and studio by the creek. It was so beautiful to see the water running between the glistening white rocks, and the pine branches heavy with snow. It was like magic, like a fairy tale.

The following summer, I had our first child, a boy we named Luis after the father I had loved so much. He was handsome and intelligent and rather mischievous, and I adored him. After that, there never was much time for the blues, as I was always busy. We bought an old house on Eighth Avenue and started remodeling. Then came our second child, Monica, a reddish-blond, beautiful girl with a personality all her own. Still later, and last, came Maggie, "La Ratita," our "Little Mouse"—a brunette with blue eyes like mine. I may sound prejudiced, but I have to say that my children were the cutest and smartest I had ever seen, and we loved them so much. We took them everywhere and were totally proud of them. Now that they are older and on their own, I miss them if they are away. I like them all as individuals and consider them my best friends. I am thankful to have them in my life.

I am also thankful for the way this country accepted and welcomed me, and for being able to live in the beautiful land of Utah. I consider this a privilege. I have so many friends, old and new, who make my life worth living. I have traveled to many places during my life, and I hope to go to a few more. I still love Spain and consider myself Spanish as much as American, but now I know that I belong in Salt Lake City. I hope to spend the rest of my life here, in my old house on Eighth Avenue. The house has been witness to many wonderful experiences with the people I love; the house in which I've enjoyed the same neighbor, Chris, who was only a child when we first came; the house that has grown with me over the years to became like an enclave of my old country, with the colors that were on our walls in Spain—and the tile, and the wrought iron, and my paintings that represent places and people as I remember them; the house and the garden with the grape arbor, where my friends are always welcome to visit and share ideas about the world, about beauty and art and books and music, about all the things that make our lives worth living. This is where I am and where I hope to stay for the rest of my life. ❧

the house across the street:
a neighborhood story

MY HOUSE WAS BUILT IN 1893 and was the first one in this area of the Avenues, which in turn is where Salt Lake City began. The property deed states that the lot where my house stands has been inhabited since 1860, thirteen years after the first pioneers arrived in the Great Salt Lake Valley in 1847. I don't know what kind of dwelling was then at the place where I now make my home, but people lived there who are forever strangers to me. They could have been interesting or boring, happy or sad—I will never know.

Later, my house was built, and generations of families came, living their lives or a part of them in this house. Sometimes at night, when I hear the walls settling, or feel the wooden steps of my beautiful stairs trembling when I climb them, I wonder what secrets the house holds. I wonder how my life secrets will be added to its past for the people that follow me to wonder about.

The house across the street from mine is a lovely house, though not as old as mine. I don't know what year it was built, but I'd guess it was in the late twenties. When my husband and I moved to our house in 1960, the house across the street already had a nice green patina on its red bricks, and beautiful vines covered most of the front facade. The house always had a quality of mystery and loneliness, to my romantic notions, with its stained-glass windows, pointed dark roof, and neglected surroundings.

A very formal but pleasant old lady lived alone in the house. She always dressed in black, with her snow-white hair matching the lace at her throat and wrists. Her husband had been a president of the LDS Church, and she was a widow. She was very reserved, but on

one occasion she invited me into her home to show me a wonderful collection of old Utah art that hung on every available wall. She was very proud of it and found in me an appreciative audience.

Shortly after our visit, she died, something that happens with unfortunate regularity to the best of us. I don't know where her art collection went, but I hope the Springville Museum of Art was one of the main recipients of her treasures, since it is the most important museum of Utah art. The house was closed after her death and remained so for some time, aging and deteriorating a little more, but in a classy way, and retaining the charm of its former owner.

But one day the house opened its doors and windows again; it would be an exaggeration to say that it came back to life, because it did not, but it started tentatively breathing from time to time. When I was out gardening or washing windows or painting a fence, or sometimes, in the evening, sitting on the terrace sipping a glass of wine, I would glimpse the new owners. They were not outdoor people; on the contrary, you might have called them reclusive. Gradually, with contributions from my next-door neighbor Emily, a lovely lady who somehow kept good track of the neighborhood "goings-on," I learned that the new family consisted of a patriarchal husband, his wife, and their two sons.

This sounds normal enough, but in reality, and without being too harsh, I have to say that they were quite peculiar. The husband was an English gentleman (and when I say "gentleman" I really mean it); he was also a dwarf, his limbs were short and deformed, and he walked with a difficult gait. On the rare occasions when he talked to me, he was very courtly and complimented me about the beauty I brought to the street with my gardening, mentioning how he enjoyed the view from his window of the blooming flowers of my rock garden and terrace. I could not honestly return the compliment because I never saw as much as a single bloom or flowerpot in their front garden; we neighbors were all thankful if somebody cut their lawn once in a while.

The wife was also English and very formal, and she was very tall and very thin. You might well describe her as a beanpole. She was also an extremely nice, very polite person who presented herself as an artist. She had once painted a watercolor, though I was never

privileged to see it. She was very active in her church and very deferential and obedient to her diminutive husband.

The two sons were tall, like their mother. One was in his early twenties, the other a teenager. The older boy, Lucas, was obviously mentally deranged. He was an unmanageable rebel and a thorn in the side of his faithful LDS parents. I never knew him well, but from my outsider's perspective he looked like impossible for anybody to handle. He would sit in a straight wooden chair on the lawn in front of his parents' house chain-smoking for hours at a time with the deliberate and declared purpose of killing himself. He must have been enrolled in some rehab program, because he would disappear for weeks, only to show up again in the middle of the night, breaking the windows of his parents' house to get in. Police cars would arrive, with their sirens and flashing lights, disturbing our quiet neighborhood and bringing the neighbors to their windows and front porches. The next day, there would be Lucas again, sitting in his front yard smoking cigarettes.

One morning I read his name in the *Salt Lake Tribune*. He had been jailed for threatening to kill President Reagan. He was away for a while after that, but eventually he came back. Another time he set fire to a halfway house, purportedly because they were giving him decaf instead of real coffee. But he always came back, to sit in front of his parents' house in his straight chair, smoking cigarettes as fast as he could.

I had two beautiful young daughters and was a little worried about him, as he was always looking at them with obvious interest from across the street. But he never bothered them. My next-door neighbor also had a very attractive daughter, a little older than mine, and he wrote her some letters, but nothing really came of that. He also wrote me some letters. He said I would be more understanding of him because I was from Spain and was Catholic, not Mormon like his parents. I ignored them.

Some time later, when my next-door neighbor Chris was getting married, I decided to have a wedding shower for her and invite the neighborhood ladies. I called Mrs. Forrester, the lady across the street, to ask if she could come. But I also warned her that I would be serving wine. She got very excited, for there was not much fun in her life. She answered, "Mrs. Smith, I would love to come, but first I must ask Mr. Forrester if he thinks it would be appropriate." I held the phone and she came back. "Mrs. Smith, Mr. Forrester says yes,

he approves. Of course I can come to your house, and I will be very happy to do so." So she came, along with the other neighborhood Mormon ladies. She did not drink any wine, though some of the others did, with girlish giggles and glances of complicity with each other, secure in the fact that in a "gentile" household like mine they were not being watched.

Poor Mrs. Forrester had cancer. She was taken to the hospital, and one night at about 11:30 P.M., she called me. She had tried to contact her husband and had gotten no answer. She was very worried for fear that Lucas had done something to hurt his father. She asked if I would be so kind as to go across the street to check. I assured her that, of course, I'd go make sure he was OK, and I'd have him call her. I was not exactly eager to pay a lonely midnight visit to Lucas and his father on a winter night, but heck, the poor woman was worried. I told my husband about it; he was already in bed reading, and he said, "Go, and I'll watch you from the window." Great help! This is what husbands are for! Well, I reluctantly checked on Mr. Forrester, who was all right and, as always, gentlemanly grateful. He had not heard the phone and promised to call his wife right away. It was not long afterward that Mrs. Forrester died and Mr. Forrester was left alone. The younger son had married and moved; Lucas was sometimes at home and sometimes not.

My husband also passed away. After his death, I adopted a wild dog—"Kiva"—a mix of German shepherd, husky, and a little wolf. She is beautiful and very intelligent, but at first she gave me a hard time. Every time I left her alone she either jumped the fence and ran away or went through the upstairs windows and screens to the roof, to sit and supervise the neighborhood.

On such occasions, I invariably returned to find my telephone blinking with messages: "Mrs. Smith, this is Mr. Forrester from across the street. Your dog is on the roof again. I thought you would like to know." "Mrs. Smith, your dog is still there, out on your roof." "Mrs. Smith, I am sorry to bother you, but your dog is still on the roof."

Now Mr. Forrester has gone somewhere, but not yet to the great beyond. My dog is growing more mellow and does not go to the roof as often as she once did. The house across the street is still there, empty again and lonely, its mossy walls a little darker and its windows gradually disappearing behind the vines.

The neighborhood goes on. ✍

❧ about my art

MY ART STARTED TO EXPRESS ITSELF when I was very young. I was always making things with whatever materials happened to fall in my hands—small pieces of wood, thread, paper, little constructions that did not last very long or were thrown away by the maid cleaning my room. When my father was in town (he was often away on his ship), he would take me to an old bookstore in the Plaza de Cort, Antigua Casa Guasp (which still exists), which also sold art and writing materials. He bought many children's books for me—*cuentos de hadas*, fairy tales, the Brothers Grimm, Hans Christian Andersen, Charles Perrault—because I had learned how to read before I was four. He also bought me drawing books and colored pencils, erasers, and a really nice pencil sharpener that was my prized possession for many years. I developed a habit of taking pencil and paper with me everywhere in the house; I would sit on my little stool, often in my favorite place in the *mirador* (the lookout), a glass-covered balcony in the corner of the house that overlooked several streets, and sketch anything that drew my attention, especially people. When I went to Son Vida, my grandmother's country house, my cousins and I built small caves and landscapes in the garden, and when the ponds were being cleaned and the silt and clay removed from the bottom, we made small cooking pots or shepherds' figures and animals—lambs and roosters and turkeys—for the Christmas nativity scene. Of course, most of them would break while drying, but once in a while some would survive. The wife of Jorge, the woodskeeper, was a potter, she was nice enough to fire them for us. We were very proud of our work.

It has always been very easy for me to look at an object and see how it could be used for a different purpose. I believe every idea brings forward another one, one perhaps totally unrelated to the first one. This is one of the reasons I find art so tremendously interest-

ing. There is no end to it, for you can spend a lifetime working, and in front of you there remains a whole world of unexplored possibilities.

My father was always interested in my creations, but my mother was not; she was very worried because when I was alone I was always busy either reading or sketching or doing something that, in her opinion, was taxing my eyes. She often told me I was going to go blind, with the result that I often hid from her, sometimes even under a table, to do my thing. It is not that I was a total bookworm, I loved to play and run and climb trees with my cousins, but I have always been unable to be idle. I am still that way.

This pattern continued throughout my childhood, even after my father's death, when I no longer had much encouragement. Without my mother's knowledge, when I was about twelve, I even started a little business: I was painting greeting cards for various occasions, especially Christmas. Though the custom of sending greeting cards was not yet very popular, I painted Mallorcan country scenes, peasants dancing in typical dress or going for water to the stone fountains in the village square, or seascapes, that sort of thing. I did them with a small set of watercolors that had only a few basic colors. But I learned to mix them and could get almost any color I wanted. I took my cards to small souvenir shops, and the owners always wanted more. They paid peanuts for them, but for me it was a source of pride that they showed interest in my work, and it was gratifying to see my cards in the picture windows. On top of that, I had a little secret income!

For a while, my younger sister and I had a teacher who came to the house to encourage her with her reading, for which she had a real mental block. Doña Matilde was a very nice woman, and her methods of teaching rather unusual; she gave us lessons in a great variety of unrelated subjects, from the Latin and Greek roots of the Spanish language to prehistoric animals; she even had us embroider espadrilles to sell in her brother's souvenir shop, where she also took my greeting cards. She encouraged me to design a magazine; she had three other students doing the same project. Our magazines had to be "published" every two weeks, and then we had a competition. Each magazine consisted of two or three articles of our choice, stories about events that had drawn our attention, with illustrations, a poem or two, and a couple of humorous cartoons, plus the cover and a few advertising notes. It

was not easy. On the contrary, it was very challenging. My magazine was called *Luz y Colores* ("Light and Color"). I wish I could remember what I wrote and designed at the time but, unfortunately, all these publications disappeared after I left Mallorca. My mother was never sentimental about keeping mementos.

I was always trying to express my desire to create, and I did it with whatever was available to me, painting the furniture in my room or doing embroidery without following patterns. I wanted to go to the Academy in Madrid, and the Spanish government had offered to pay for me and my younger sister to go to any college we wanted because our father, an admiral in the Spanish navy, had been killed in the war. It was our right to get a free education, but my mother was very old-fashioned and did not believe girls needed formal training; the protected atmosphere of the convent school was sufficient for the likes of us, so the Academy was out of the question. As time went by, I thought I had lost my chance to do real art; it was like I had a mental block for a long time. But I never lost that desire; I was always doing small works. Even after I married and had children, I still worked on my art.

In the years after the war, I had learned to make do with whatever I could get. Though not much was available, I had a good imagination and so could produce attractive things out of stuff someone else would have thrown away. After I came to America and could get more things, I started making Christmas presents for my friends—painted bottles or small objects, or embroidered pillows—and was surprised by how much they were appreciated. I also decorated furniture for our house, and my husband, Walter, thought the pieces were beautiful. I knew he would never tell me that just to make me feel good. Whenever he returned from a business trip, he was surprised by some project I had wanted to do and knew he would have discouraged me from doing. I'd often stop at the hardware store after taking him to the airport, buy what I needed, and before the children came back from school, be deep into remodeling. I did the brick fireplace in the dining room, the floor in the entrance, and the bathroom upstairs, including taking out the toilet to set the new linoleum; I never knew a toilet could be so heavy, but I was able to reinstall it! In fact, I am famous in Barcelona because my daughter Maggie has told all her friends about it. When

they admire her many talents, she explains to them that she comes from good stock—her mom even installed a toilet, and it doesn't leak!

During those years, I met Dolores, a young woman who was working at the office of a friend of ours. She shared with me an interest in fashion, and together we designed a collection of dresses. We hired some high school girls as models and presented our designs at the Ambassador Club and the Fort Douglas Country Club. They were all very original, and some of mine were also hand embroidered. We sold everything and got orders for more; I was even commissioned to design the clothes for a whole wedding party: dresses for the bride, six bridesmaids, and the bride's mother. At night after my children were in bed and I was free from interruptions, with only the fabrics and measurements, I made my own patterns and cut the pieces on the kitchen table. It was a lot of work because I had no help and still had to run the house, produce meals, and care for the children. Success was very stressful; my husband wanted to get a small cottage on Seventh East to start a boutique, but I got cold feet. All that

The "Fruit Bowl Chair." Photo courtesy of Tom Erikson.

sewing was too much for me, and I had no idea there was such a thing as delegating, or that I should have hired others to work for me, so our plan evaporated. But we went down with honor, defeated by our success.

My real art career started when my oldest child, Luis, was about fourteen; he wanted to take a photography class at the Art Barn. Since he could not drive and I had to take him, Walter had the brilliant idea that, instead of dropping him off and returning to get him a short time later, I should take a class myself. I agreed. I decided to take a pottery class, remembering my childhood pleasure in working with clay and making a real mess. Besides, I adore pots.

Pilar at work sculpting a figure, winter 1988.

The class was crowded, and there were only five wheels. The teacher was a young fellow who seemed to prefer to call on the younger girls more often than the rest of us, so there was a lot of standing around doing nothing. Since Christmas was coming, I recalled my childhood in Mallorca and started to make figures for a crèche: Mother and Child, Saint Josef, the shepherds, and camels and other animals. I didn't need a wheel for these. When I found out I was good at it, I abandoned the idea of the pots. I went to Capital Ceramics on Main Street and 2100 South, purchased clay with a little more grout, and a basic ceramics book, and once again started to work on my kitchen table. Ceramics is a pretty complicated subject with rather strict rules. If you don't follow them, you will ruin the work when drying or firing it. I was doing figures, and with wet clay you can't use stiff armatures to hold the form because the clay shrinks as it dries. If it finds resistance, it breaks in the weakest point. It is a law of nature, and you can't do anything about it. It shrinks again in the kiln.

So I designed my own armatures of stiff cardboard, which collapse when pushed by the drying clay and can remain inside the sculpture even through the firing. I have never heard of anyone using this method, but it works very well for me and I still use it. Several years later, I made a large-scale nativity with many figures, approximately twenty-eight to thirty-eight inches tall, that included camels standing in groups, their heavy bodies sup-

ported only by their thin legs, and airy angels whose feet barely touch a tall rock. I took the sculptures to be fired at a ceramic studio at Ninth South, where the owner often told me that my works would not survive the firing. But they did, and they are now in the permanent collection of the Utah Museum of Fine Arts at the University of Utah. I remember that Frank Sanguinetti, the museum's director, once gave a lecture about my Nativity when it was displayed in one of the galleries in an installation I had also constructed. He said that, although several nativities had been created during the Renaissance, including a very famous one now in Vienna, to his knowledge, in modern times, there had not been another artist who had done a work of the scope of mine to represent the Christmas story.

But that first year, I was not particularly ambitious, just doing the figures of Mary and Joseph and Child as Christmas presents for friends, and trying to learn as much as possible. After Christmas I began other subjects, portraits of people I remembered: Catalina La Cocinera, our cook, seated in her chair peeling potatoes; Se Dída, my mother's wet nurse, with her Mallorcan native costume; Luis Candelas, our Spanish Robin Hood, who stole from the rich to give to the poor. Months later I had the audacity to take my sculptures to the Phillips Gallery. When I think about it I can hardly believe it, but I have always been rather optimistic. The amazing thing was that Bonnie Phillips, the owner, looked at them and told me she would include them in her Christmas show. I don't think she has ever realized what she did for me, for she gave me back my dream, pride, and confidence and the conviction that it was not too late, that I could still become the artist I was always meant to be. She opened the door for me, and I will be forever grateful to her.

Soon I realized that sculpture was not enough for me because it is something that you always have to do in your studio. (By then I was working in our old garage, which Walter, with the help of a young neighbor, had fixed, installing a window to provide good light and an antique iron stove for heat.) When we traveled to Planet Ranch in Arizona, where Walter often had to go for work, or to Spain to visit my mother, or anywhere else, I was lost without my art; I could not stand it. So I decided to paint watercolors, which are easy to carry around. Walter suggested that I take a class at the university, and I thought about it. But I had noticed while going to shows in Salt Lake that I could always tell who the

artist's teacher had been. It seemed to me that it took a long time for each artist to develop his or her own style, and sometimes they never did. I know it was wrong for me to think that way, but I did, so I just started on my own. It was hard, and I wasted a lot of paper and paint before I got the hang of what I wanted to do.

I think art had been in me all my life. In Spain, it surrounds you; it is everywhere—in the streets, in the squares, on the outside of buildings and the inside of buildings. The cathedrals and churches, and even the walls of the old families' homes, like my grandmother's, are graced with works that would make museums proud. If you let it, art will get into your blood and never leave. Unknown to you, things that you look at casually will remain in your subconscious and pop out when least expected. This is why there are so many artists in countries like Spain and Italy, for we are being challenged from the cradle by what we see and by the light and the color in our landscapes. If you don't find an outlet for those inner feelings, you are going to suffer because your life is incomplete—you are being repressed; it is like being hungry, with nothing to eat. I am grateful that, though it was later in life than I wanted, I was able to find the expression of my art and had a companion who gave me a lot of encouragement, along with criticism, for Walter had lived in a family where art was always appreciated. His maternal uncle, Lawrence Square, was a well-known Utah painter who died very young after inhaling mustard gas during the First World War in France.

Walter knew a lot about art and had a good eye for it, so when I made a "mistake" he did not let me get away with it; he was very critical of my work. At the same time, he also said, "Do your own thing, don't let anyone tell you what to do." It sounds contradictory, but it isn't, and I understood that very well. His criticism helped me very much because it made me work harder, while at the same time it encouraged me to follow my instincts and keep the integrity of my inspiration.

Among the things I like about my sculptures are the facial expressions of the figures. I find that some sculptors emphasize the expression in the bodies but not in the faces, which in general look sort of bland or lacking in personality, a thing I totally detest. Because my figures are not large, viewers sometimes fail to see that their expressions are quite strong. This is what inspired me to do large oil paintings of people. Because they are large and colorful, they command the viewer to look at them; viewers are unable to avoid what I want

The Pregnant Madonna. 1993, painted stoneware, 27½" × 10" × 10". Photo courtesy of Tom Erikson.

them to see: the moment in life—of irony, or sadness or joy, or the plain static intensity of a certain look. Here I am in charge, and viewers are going to see what I see, whether they like or not, because it is right there in front of their eyes!

And that is the power of art, a power that can be used as the artist chooses, a power that can pull you into a subject you had not thought about before, or that can create a mood that makes you laugh, or cry, or that shows the injustice of the world or the beauty of nature. Art elevates the mind and contributes to the goodness and the enjoyment of people.

I was once asked to bring my work and a documentary about it ("Dreaming in Color," by Fabiana Cesa) to a correctional facility for young men who were serving time for serious crimes like rape and murder until they were old enough to go to the penitentiary to serve the rest of their sentences. My daughter Monica, a very talented musician, composer, songwriter, and singer, provided the score for the film.

It was a rather chilling experience to pass through an iron gate and, after it locked behind me, pass through another. My guide, a counselor, directed me to a room that was set like a small theater, with a little stage that had a TV for my video and an easel for my paintings. A group of about ten or twelve boys between fifteen and eighteen years old entered the room; they were rather shy, and all had very short institutional haircuts but were otherwise ordinary-looking in clean jeans and plaid flannel shirts—not at all scary. I introduced myself and asked if they were interested in art; a couple of them responded that they had been exposed to it only very recently, and they were really interested. In fact, they had prepared a show in another space for me to see. We soon became a group of friends, they commenting on what they preferred in my paintings, discussing problems they wanted to solve in their own work, and asking questions about what I would advise them to do next. It was obvious to me that because of their situation—being locked up and unable to do anything else—art had initially been an escape from their problems. Now they had actually begun to enjoy it and even be passionate about it, and there they were, a bunch of delinquents who had committed some terrible crimes actually having a good time with a Spanish lady of advanced years with whom they had nothing in common except art. I wondered what their lives might have been if they had been exposed earlier to something beautiful, like art or music

or literature, instead of being on the streets, abandoned among drugs and gangs. What if the money spent incarcerating them now had instead been used for education, allowing them the opportunity to discover what lay hidden in their souls? They might have found interests of genuine value, contributing to their well-being and also the well-being of their victims. The power of art is being wasted!

My visit with them was a very positive experience; they were attentive and respectful, and after my presentation we all went to another room where they had displayed an impressive number of acrylic paintings on paper, several of which were quite good, strong and expressive. We parted as friends, united by our common interest in art, and a week later I received a letter of thanks from them.

Many among us believe that art is a distraction, a luxury for the rich, or a way for the idle to spend their hours instead of dedicating themselves to useful work, but they are wrong. Art is one of the most important parts of the history of the civilizations, if not the most important. Art is what persists, what remains, when other things are gone.

Art preserves history and has done so since the beginning of time. Think of the primitive paintings in the caves of Altamira, Spain, or on the canyon walls in southern Utah, or in the pyramids in Egypt, or in so many other sites around the world. Art brings forth the best in our souls, and even when a war or a natural catastrophe causes its destruction, a memory remains, along with the desire to restore it. Art is the most important demonstration of what we are as human beings, what makes as different from other forms of life.

I am not ashamed to say that, for me, art and my children are the most important things in my life, and I am proud to know that in different ways, art is also important in my childrens' lives because they carry it in their blood, that is my blood, and I think they are lucky to be that way. For me, art is a long road that never ends, because there is always more to learn, more to discover, more to attain.

I am grateful that even though I did not have the opportunity to start my work as early as I might have wanted—perhaps in some ways because I denied my desire for so long—I feel it is all the more important and urgent to dedicate myself without compromise to my work now. I hope it can be so for the rest of my life. ❦

❧ the planet ranch

THE FIRST TIME WE WENT TO THE PLANET RANCH our arrival was pretty dramatic. We were taking our three children, Luis, Monica, and Maggie, and each of them had been allowed to bring a guest, so Jeffrey, Dawn, and Amy were also with us. It was Easter vacation; the weather was expected to be fantastic and the desert in brilliant bloom. We had a rather big station wagon and it was packed to the limit because we were prepared as if we were heading on a safari deep in Africa.

I knew the ranch house was at least thirty miles away from any sophisticated grocery shopping and did not have any idea if there were supplies in stock there, so I was going well prepared and had tried to remember every last thing, olive oil, garlic, *azafran*, Mexican vanilla, and any really indispensable item whose absence would have ruined my cooking. We were taking bathing suits to go swimming in the nearby Havasu Lake, games for the children, art materials, and books; I had packed everything but the proverbial kitchen sink. When I say this, I really mean it because Walter was always too occupied with his office's work and was not supposed to keep track of "minor" things such as daily necessities; it was only when they were missing that they became extremely important to him, to the point of making him inordinately annoyed. He was a typical man of the old school, the kind that thought ordinary household problems were strictly a woman's responsibility.

We were supposed to leave as early in the morning as possible because the trip was very long, but as usual, Walter had some last-minute things to take care of at the office. We were all ready to go, all except the commander-in-chief, who was missing. There was no point in getting upset; being late was Walter's thing, and we were used to it. So, we waited, and waited. The children had a second breakfast, and I was finishing putting the dishes in the washer when he finally showed up—we all had to get in the car as fast as possible, and away we went!

At that time, Interstate 15 was still being constructed, and only parts of it were in operation, so we had a number of detours. At other times only one-way traffic was possible and we had to wait until the cars going north had passed and it was our turn to go south. It was slow traveling, with stops for drinks, gas, and other necessities, plus attending to little Maggie's occasional motion sickness. We went through St. George, stopped for a hamburger, and continued driving while eating. We discovered that someone had forgotten to put the meat in Maggie's sandwich, so she had to share mine. Honey, our cocker-poodle, also had part of it, but we had other stuff with us and did not suffer from hunger. Maggie, however, still remembers.

We went through Las Vegas and did a little sightseeing because I think it was the first time there for the children. We went to Caesar's Palace and the Strip and some cowboy place, the name of which I don't remember. It was all very interesting, but it was taking time, and we had a long way yet to go. Past Las Vegas we continued south toward Needles, an old semi-deserted mining town in the middle of nowhere; had to stop for a never-ending train, a haunting sight as it made its way slowly across the arid Arizona desert; and soon started to see the Needle Mountains, with their pointed peaks piercing the brilliant blue sky. They were supposed to signal the proximity of Havasu City and the lake, but it was still a long way. All this time, we were playing games to entertain the children: "What is the capital of Chile? Where are the Andes? Where are the Himalayas?" When we finally arrived at Havasu it was very late and almost dark, but we had to see London Bridge, the venerable English relic that had come across the Atlantic Ocean and the American continent to spend its old age in the heat of the Arizona desert—like any other retiree happy to warm its old bones and look at the clear blue heavens, so different from the foggy English sky, and watch the Colorado River, rather than the gray Thames, slide peacefully under its arches. The scene was charming, with the lights of the antique lampposts reflecting in the slow water, and we walked across the bridge savoring a delicious sorbet as if we had all the time in the world, as if arriving at an unknown place in the dark, in the middle of the Sonoran Desert, with six children and a dog and a station wagon heavy with my packing was the most natural and easy thing in the world.

The road that leads to the Planet Ranch is about fifteen miles south of Havasu City.

It's a dirt road that begins at the side of the highway by the lake and makes its way across mountains and cliffs and the Bill Williams River. That river is a tributary of the Colorado that spends most of its time meandering through the Planet Valley with barely enough water to qualify as a real river except when the summer rains hit the higher lands and torrents descend through the narrow canyons, rolling with gusto and taking along anything in their path.

It was very dark when we finally reached the gravel road, which was winding around rocks and promontories and crowded with cottonwoods and tamarisk. The headlights illuminated the occasional rabbit or hare, and even a fox or skunk pursuing its nocturnal prey. Walter had visited the ranch only by plane (it has a small airstrip), and had no idea of the road; he just knew it went only to and from the Planet Ranch. We were bumping along the road when suddenly we hit water and were submerged to the bumpers in the Williams River and stuck in the mud. Walter had a lot of practice driving in wild places in southern Utah, and at first he was not worried as he tried to maneuver the car out of it. But the more he tried, the deeper the car got stuck in the mud. The wheels were spinning but finding no traction. Luis, Jeffrey, and I took our shoes off and tried to push the car while Walter tried to rock it back and forth—to no avail. It was a lonely place. It was dark, we were covered with mud, and it looked like we were going to spend the night there. This was in the days before cell phones could get us out of trouble. At least it was not cold. We decided to accept our fate and relax as much as possible. Out came the sandwiches, cookies, and lemonade, and we started to sing to pass the time. Well, lo and behold, our voices carried through the desert air, and a ranch hand got curious about what kind of celebration was going on at the riverside. He came to investigate and perhaps join the fun and found the party was not on the shore but in the middle of the river! He saved the day, bringing a tractor to pull us out, and we made our triumphant arrival at the Planet covered in gray Sonoran Desert mud after an adventure that I, at least, never forgot.

The Ranch guest house was not luxurious, but it was pleasant and sufficiently comfortable. There was one bedroom for the boys, one for the girls, one for Walter and me, and two bathrooms. The kitchen was nice, with all the necessary wares and cupboards full

The Virgin River. 2005, oil on canvas, 40" × 46".

of canned goods. It had a large living-dining room with a large stone fireplace, handsome cowboy furniture, and French doors opening to a long, wide screened porch. This porch immediately became my favorite place, looking as it did across the valley toward the Raw-hide Mountains. The first morning, I had Walter and the boys move a game table from the living room to the porch. I covered it with a round Mexican cloth, and it immediately became the center of the family's activities. I can still feel the cool spring breeze that carried to us the perfume of alfalfa and wild herbs, the singing of birds in the day and owls and coy-otes at night. The screens protected us from mosquitoes and other bugs, as did the *lagartijas,*

the lizards that stick themselves to a wall and stay there minding their own business, catching any fly or mosquito brave enough to invade our mutual territory. I have always been very fond of *lagartijas*. I miss them in Salt Lake, as I was very used to them in my Mallorcan home on the outskirts of Palma; they were like family, and less obnoxious than some of the members of mine. They silently keep you company and provide for your comfort by devouring bloodthirsty mosquitoes. They live in my house in Guaymas, Mexico, and my Mexican housekeeper knows better than to chase them away (or worse) if she wants to stay out of trouble. They delight me!

The children loved the freedom and the adventures that waited for them everywhere. There were horses to ride and interesting rocks to find. They could wade in the river, run the dune buggy up the dry washes, and explore the nearby canyons. I am mixing events; we went so many times with different children and adult friends, and there were always special adventures. There were also interesting people, like Kenner Ness, "Big Man," an amazingly tall Indian who used to cut the lawn around the house. I always took lemonade to him, and he drank it by the bucket. I could offer him glass after glass, and he would never say no. He had many sons, and they all worked at the ranch. On Saturdays they went to Parker to the bar, and on one occasion they ran their truck off the road and landed in a hollow. It was a cold night, so they decided to make a fire under the truck, where there was a handy gasoline leak. I don't know how they survived, but they did, and in the morning the police took them to jail for intoxication. They had a dog with them, a German shepherd and Labrador mix. It was a very young dog, not much more than a puppy, but smart. He was abandoned at the wreck site and made his own way back to the ranch. My son, Luis, was there for a summer job, and he befriended the dog, and cleaned and trained him, and they became best friends. He called him Buddy.

When Big Man got out of jail and came back, he wanted the dog, but we could not part with him; we loved him too much. So I went to Big Man and told him I wanted to buy him. He never hesitated, selling him to me for five dollars. I suppose the money was spent in the bar, but even so, Buddy was the best money I ever spent in my life. He was the closest an animal can be to a human, and he was the luckiest, because he had a wonderful long

life, loved by our entire family to the end, when he went to rest on a hillside by the Mar de Cortés, in the shade of a Palo Verde tree and a saguaro, where I go to visit and remember him every time I go to Guaymas.

Maggie also found a friend. His name was Ralph, and he was a giant frog that lived by the water tank. For several years, every time we went to the ranch, Maggie would go get Ralph in the evening and bring him into the house. She would hold him in her hands and caress him, talking to him all the while. The frog didn't seem to mind, and Maggie was very gentle. When it was time for her to go to bed, she would walk back to the water tank and place Ralph very carefully where she had found him. I don't know how long frogs live, but if Ralph was not Ralph after a few years, one of his descendants took his place and we were never told. Once, at Christmastime, I surprised Maggie with a huge, stuffed, green-felt frog and told her Ralph had come to visit. It became a favorite, and I have not had the heart to give it up. Now it inhabits a corner shelf in the garage.

The land around the Planet Ranch was very dry, so sometimes we would hold a rain dance, which never failed to work. I suspect Walter had something to do with that—he may have had private information that the rest of us did not—but he would tell us that the land was dry and we better start to work to remedy the problem. So we did, with a lot of fanfare, banging on pots and pans and yelling and jumping in a circle. The ranch hands joined us, including several Native Americans who worked on the land. They showed us some moves and the prayers to the Indian gods to ask the sources of life to open the sky. You would not believe how successful we were! In a short time we would have a deluge, water falling in beautiful cascades from the nearby cliffs. If the roads flooded we could be isolated for a week or longer.

Speaking of floods, I remember one time on our way to the ranch when we met the Buyers family, their truck loaded with mattresses, cots, bundles of blankets and clothes, pots and pans, and the children on top of everything. Mr. Buyers was a very important man at the ranch, a mechanic, and a very good one. Walter was worried that something was wrong, or that he was mad and had quit, so we stopped to find out what the problem was.

There was no problem, it turned out, except that the weather forecast was for big

rain, and the oldest of the Buyers' children, Lee Ann, was a finalist for the Miss Parker competition. They did not want to miss the event. So, they proceeded on the trip with our best wishes for her success. In fact, Lee Ann was elected Miss Parker, and although she did not get to be Miss Arizona, she did marry a banker. I firmly believe she lived happily ever after.

But they were right about the rain. That was the day I saw one of the most amazing sights I have ever seen. There was Bill Williams River, barely a few puddles of water, and advancing at full speed in the nearly dry riverbed was a wall of water twelve or fourteen feet high, straight as a sheet of steel. As it passed us, the river turned into a wild torrent of churning foam, carrying along broken tree branches and desert cactus on its way toward the Colorado River and Lake Havasu. When we got to the ranch, the lowlands were under water, and the riverbed, which at that point is considerably wider, was like a minor Sargasso Sea.

We had a new Jeep, and Walter wanted to try it out by crossing the river toward the stables, necessary if we were to tend the horses. Luis was going to photograph our crossing, just me and Walter in the Jeep, and we waited as he erected his tripod. He gave us the signal and Walter started to drive. Next thing we knew, Luis had abandoned the tripod and was running toward us, yelling for us stop. Walter did, just in time to avoid another wall of water, not as high as the first, but powerful enough to have carried us and the Jeep who knows where. We became very respectful of that kind of thing.

Another time, we went to visit LeRoy and his wife, an older couple from the ranch who were semi-retired and often spent time in their trailer in the high desert. LeRoy was a great man, and his wife, Leona, made wonderful chocolate cakes. This time we had our two daughters, Monica (Mony Pony) and Maggie (La Ratita); they loved the desert, and it was always a place of great adventure for them. Along the way, we stopped for a picnic at a place that looked like another world—a primeval place that might still hide dinosaurs, with extravagantly shaped rocks and contorted trees and saguaros and teddy bear cholla—a place that challenges the imagination. There we followed the creek beds and burro paths that climbed the hills. For those adventures, we always carried a compass and plenty of water because getting lost in those parts can be fatal if you are not prepared. Walter always had a good sense of direction and could remember his way as I never could.

Anyway, we arrived at LeRoy's hideaway without problem and were warmly welcomed by him and Leona, who immediately got busy baking a cake for us. We had coffee, the girls had lemonade, and we listened as the couple started to tell stories about their life in the desert. It seemed the area was a favorite landing place for UFOs. LeRoy and Leona saw them nearly every night. We ourselves had occasionally seen something hanging in the sky over the Planet Ranch. The sky there is very deep and dark, and sometimes in the middle of the night we would wake up and see a spherical form floating in the still air, among the stars but much closer to us, very close. It was very mysterious; we did not know what it was, that luminous sphere of blue light. Walter and I would speculate about the meaning of it, for there was no doubt it was there—it was just in front of our eyes. We were not dreaming or hallucinating.

But nothing compared with LeRoy and Leona's narrative, amazing as it might seem. They saw them coming like a luminous train, sort of rounded wagons crossing the sky. The lights would stop on the mountaintop, and one smaller form would detach itself from the rest, float silently toward Earth, and then disappear behind another peak. Sometimes the form returned, and then the whole train would move again and slowly disappear into the profound darkness.

Monica and Maggie were fascinated and would listen, their eyes as big as saucers, eating their cake but never missing a word. After we left, taking a long time to say goodbye and promising to visit again, the girls would not stop talking all the way back to the ranch. The crooked desert roads were alive with small animals at night, pursuing their own agendas, pausing with surprise in our headlights, their round eyes looking at us as if we, too, were beings from another planet. In life, everything is relative.

Monica is now a great singer and songwriter, and she composed a song about LeRoy and the UFOs. It was one of Walter's favorites, and she sang it at a celebration we had in Walter's honor in our garden, after he died. He would have liked that.

I cannot finish this story without talking about the general atmosphere of the Planet Ranch. It was a place so unique that we felt quite removed from ordinary, everyday life. The sky was wide and usually blue, sometimes with cottony white and silver clouds, their

shadows crossing the dark red mountains and the green alfalfa fields. Wildlife frequently honored us with unexpected visits—we saw all kinds of birds, including herons and egrets, and witnessed the nightly flights of large white and brown barn owls pursuing bats and mice. The mourning doves woke us with their mournful song, and deer and burros often showed up in the nearby fields. The Canada geese dropped in the field between the higher ranch and the lower ranch twice a year to rest on their migrations in winter and spring. And we spotted all kinds of western tanagers, hummingbirds, vultures, hawks, and so on.

Once, Walter and I were walking in the evening in one of the nearby canyons and heard an unusual sound, so we approached carefully and discovered a large pack of burros surrounding a hollow of deep sand, taking turns rolling in it to rid themselves of some obnoxious insects. Standing very erect atop a mound of rocks, the patriarch of the group was supervising the operation: ensuring fair use of the sand, with the animals taking their (obviously prescribed) turns, and exercising his authority when necessary by loudly neighing. They obeyed him immediately. They were so intensely occupied that they did not see us or pay much attention if they did, and we stood there watching them for a long time, totally in awe of the spectacle.

It was at the Planet Ranch that I started to paint watercolors with real dedication, carrying water and paints and a wooden board as I walked through the fields and washes early in the morning when the light was so new and cool and the colors so fresh and lovely, and in the late afternoon, when the sun was low, the shadows long, and the colors hot and brilliant. It was exciting to try to transfer onto a piece of paper the beauty I experienced; that excitement became for me a way of life that still fills my days with unending pleasure.

During the evenings on the porch, watching the vanishing light over the wild Rawhide Mountains, listening to music, and having a glass of wine or two with friends or alone with Walter, I would feel the nostalgic ending of another day, a day never to return. The Planet Ranch has a special place in my memory and in my heart, for it was a place where we were a family together, where the children were young and dependent on our love, before time and circumstances and just the way of the world separated and scattered us. ❧

❧ la ermita de valldemosa

ONE OF MY FAVORITE PLACES IN MALLORCA is on the North Coast, Se Tramontana, named after the wind that comes down from the Alps, across France and the Pyrenees. This region has high mountains and granite peaks—gray rock piercing the sky—and cliffs covered with pines right down to the sea. It has small *calas*, inlets where clear blue and green water caresses tiny beaches of white sand. One cala is celebrated in the Chopin sonata "Rumores de la Caleta," which the great composer dedicated to Mallorca.

Some of the hillsides have been terraced since time immemorial, planted with millennial olive trees with contorted trunks of tarnished silver and leaves of soft, velvety green. The region has some beautiful villages hanging up there near the sky: Valldemosa, Deyá, Fornalux, with old churches and stone towers, houses of red-brown tiled roofs, and bridges that are remnants of ancient Roman times. The coast is open and wide, dotted with *atalayas*, the small defense towers that were once needed to guard the coast from pirates and invaders. The sea is immense, stretching toward a horizon that looks like a distant circle, the line between sky and water often blurry, concealed by the pink and mauve morning mist.

In the late 1800s, the Archduke of Austria, Francisco Jose, was enamored of the Tramontana; he built himself some exquisite tiny palaces on the steep mountainsides, classic little jewels with white columns and graceful arches perched precariously among the trees. He loved Mallorca, and especially the Mallorcan peasant women; in fact, one became his lifelong mistress, although he never took her to the Viennese court. He had several children with her, including the great-grandmother of my cousin Alfonsita, who had no idea of that fact until I opened my big mouth and spilled the beans.

The story goes like this. When Francisco Jose started having babies with Catalina, his peasant love, he wanted to make it "legal," so he made the most logical arrangement. He

married her to his Majordomo and put the couple, primarily Catalina, in charge of his Mallorca properties. He also gave the newly married couple some properties, and everyone was happy. The family prospered over the years and became "accepted." They did not belong to *La Nobleza* (the aristocracy on the island), but everyone knew they were descendants of the Bourbons, the Austrian royal family, and thus were related to most of the European royals, including the kings of Spain (but not the English, who were lesser than the Bourbons). They were *parientes de la mano izquierda*, "relatives of the left hand," which means they are descendants of a bastard son. Nobody cared, and few thought there was much wrong with it. It was just a fact that everybody knew, except evidently Alfonsita, until I opened my big mouth and put my foot in it.

"*Metí la pata!*" I put my foot in it! It happened when Alfonsita came to visit me in Salt Lake, and a group of my friends invited us to a luncheon in her honor at the Alta Club. She spoke a little English, barely enough to understand and keep up with the rest of us. During the course of the afternoon, the conversation took a turn toward the old times in Salt Lake, and naturally polygamy was mentioned. There were several women from out of town, including Alfonsita and myself, and polygamy is always a fascinating subject among us "gentiles," as non-Mormons are called in Utah. We talked about Brigham Young and his many wives and how local people are often related in convoluted ways. Not wanting to fall behind my American friends, I pointed to my cousin and very importantly said, "Of course, Alfonsita here is a direct descendant of the Archduke Francisco Jose of Austria." It was as if I had thrown a pail of cold water in her face; she was astonished! Apparently, she had never heard what was common knowledge among the rest of us in island society. The entire table of women suddenly went silent, realizing that something dramatic had just occurred. They could feel the tension. "What are you talking about?" my cousin said. I could not believe she did not know. In English, and then in Spanish when she did not understand, I proceeded to tell the whole story. Everyone was fascinated, and most interested of all was, of course, Alfonsita. She immediately realized I was telling the truth. Details she had not understood before became clear to her, such as her first name, Alfonsa Maria, which was not a name used in our family but one that was often used in the royal houses. (The grandfather of

our present king, Juan Carlos I, was Alfonso XIII.) Also, Alfonsita's grandmother strongly resembled the king's sister, which everyone had noticed.

Now that she understood her name, Alfonsa Maria, she was rather elated. "Now I know about my name; I had always wondered." "Wait until I tell my brother Emilio. He is such a snob; how is he going to feel when I tell him he is descended from a bastard!" (This brother and sister did not get along very well; he is a general in the Spanish army and very chauvinistic.)

Other famous people have loved Tramontana. Frédéric Chopin spent a cold winter in the Monasterio de la Cartuja, in Valldemosa. La Cartuja was built by the religious order of the Cartujos monks, who are committed to silence. Chopin and George Sand went to Mallorca hoping it would improve Frédéric's health because he was suffering from tuberculosis. They chose the coldest place on the island, where the highest peaks are often covered with snow. Nevertheless, Chopin was very inspired by the island's beauty, and while shivering in the austere atmosphere of the monastery, he composed many of his sonatas at an upright piano that is still in one of the cells at La Cartuja.

In more recent times, Robert Graves, the British poet and author of *I, Claudius*, made his home at an old farm between the villages of Valldemosa and Deya. I was privileged to visit him there with my husband, before we were married.

On one of the mountains near Valldemosa, there is an *ermita*, a small retreat where a group of men—usually no more than three or four—disenchanted with the modern world's temptations and evils retire to dedicate their lives to prayer and contemplation. They live frugally, cultivating a small lot to provide for their needs. They are *ermitaños*, hermits, who spend their hours in meditation, accepting the knowledge that everything in this world is temporary. To remind themselves of that, every day they spend some time digging their own graves. If you ever decide to lead such a life, you could find no more exquisite place to do it. The ermita is very high in the mountains looking across an infinity of sky and sea. It has a small and modest chapel; a central patio with a *cisterna*, a well that is specially equipped to collect rainwater; and a stone terrace that hangs among the clouds. To the side of the terrace is a cemetery, with its simple crosses bearing no names.

When I was an adolescent and later a young woman, my friends, old and new, young and not so young, would get together on Sundays for long walks across the island. We called this activity "the excursion." We would pack our lunch, put on tennis shoes, grab an old sweater, and head off. We left early in the morning, taking a train or bus to some village, and from there we would walk across country, up and down the mountains and hills, on trails used by the shepherds and their sheep. We stopped at noon to have lunch by a stream or a fountain among the trees and perhaps play games until it was time to resume the walk to reach another town before dark, where we'd catch a train home.

One of our favorite destinations was La Ermita de Valldemosa. We climbed the mountain from the road below, enjoying the views at every turn in the long trail, inhaling the fresh smell of pines, herbs, and the profusion of wildflowers. Upon reaching the ermita we were welcomed by the ermitanos, and to please them we would go first to the chapel to say a prayer, then look around where it was allowed (the *clausura*, the private quarters of the monks, was forbidden to outsiders). Afterward, we would get water from the well and go to the terrace to have our lunch. One of the hermits brought us a bowl of olives, a symbol of their hospitality, and we gave them a small gift to help them in their poverty. The entire process was charming and we were grateful for the privilege of talking to them and for being able to share their lives even for one short moment. The terrace where we lunched was one of the most beautiful places on Earth; it afforded a bird's-eye view of the curving coastline. Pine trees twisted by the wind grew all the way down to the great extension of the blue Mediterranean that was surrounded by the transparent light of space. It was hard to leave. I wanted to stay there forever, to became part of it, and get lost among the invisible molecules floating in the clean air. Those images are engraved in my memory forever, and I still have a clear vision of their beauty. They often reappear in my paintings, and I am grateful I was allowed to be there. If there have been changes, I don't care to know: what exists in my mind is the truth for me.

When my daughter Maggie was thirteen, we went to Mallorca together, to visit my mother. One day, I decided to take Maggie to the ermita. Because I wanted her to share some of the experiences I had had at her age, I did not take the car I had rented for the summer. We went by bus to Valldemosa and walked the road to the ermita's trail and up

26. *The Talavera Vase*. 1994, oil on canvas, 38" x 45".
Private collection.

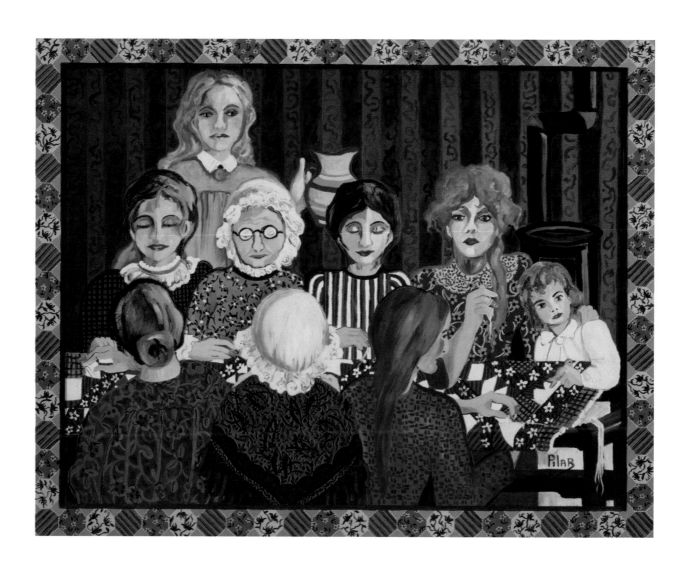

27. *The Quilters*. 1997, oil on canvas, 40" x 48".
Eccles Community Center Permanent Collection.
The child at the far right is a self-portrait.

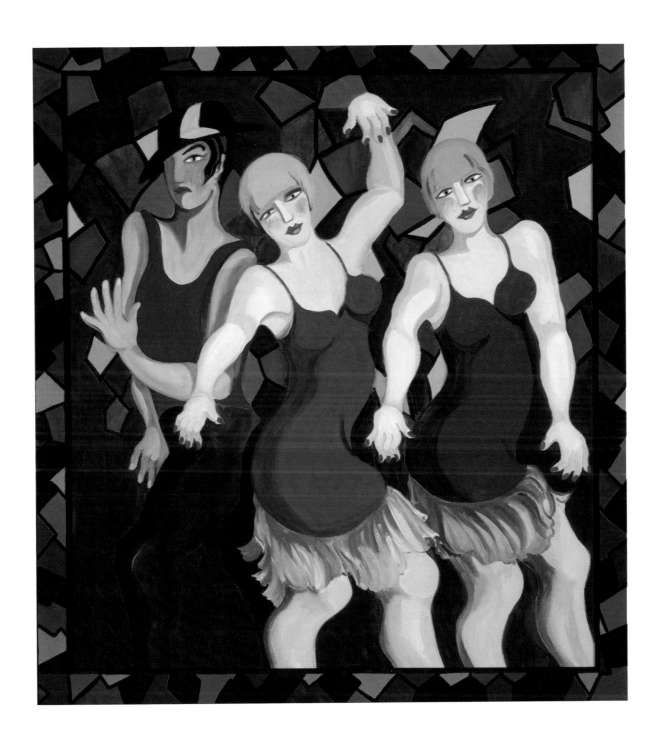

28. *La Salsa*. 1993, oil on canvas, 53" x 49". Private collection.

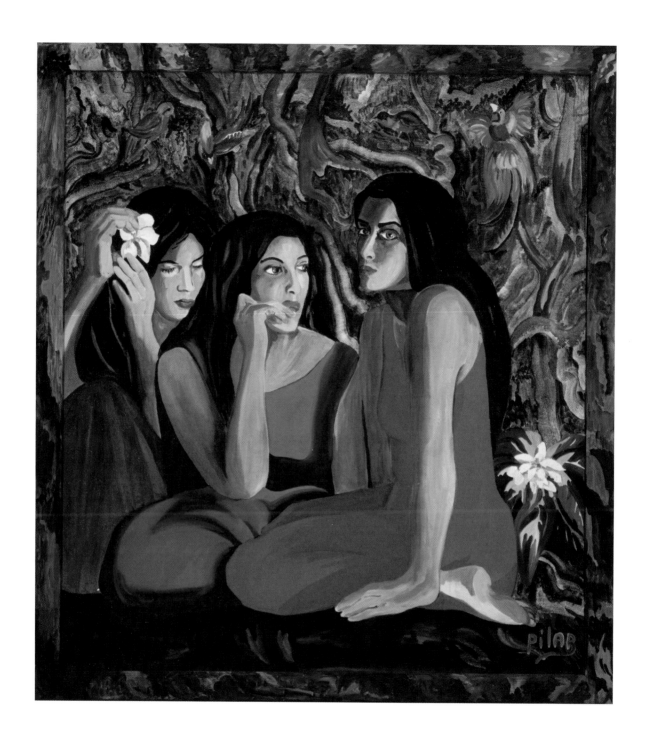

29. *The Three Sisters*. 1993, oil on canvas, 46½" x 42½".

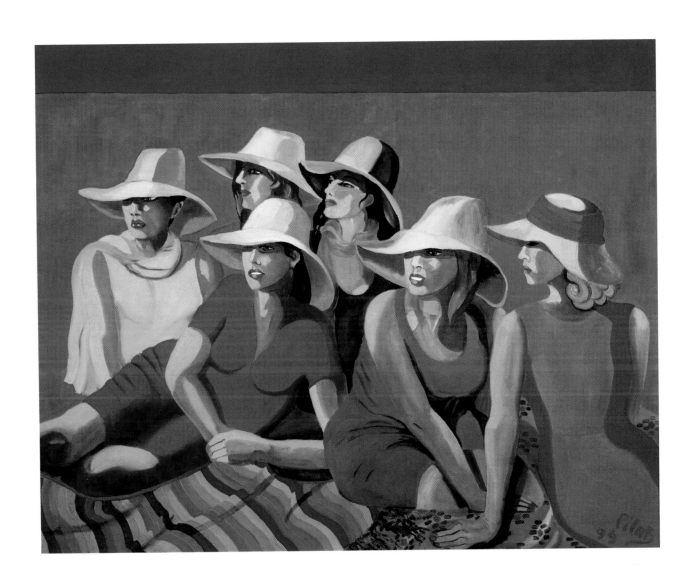

30. *The Expectators*. 1999, oil on canvas, 42" x 56".
Private collection.

31. *Woman in Red.* 1992, painted stoneware, 15½" x 10" x 10".

32. *La Bailaora.* 1980, stoneware, 27½" x 9" x 7".

33. *The Lovers (Memory Grove)*. 2005, oil on canvas, 25½" x 21½".

34. *House on the Edge.* 2005, oil on canvas, 45" x 35".
Private collection.

35. *A Window to Southern Utah*. 2000, oil on canvas, 38" x 42".
Private collection.

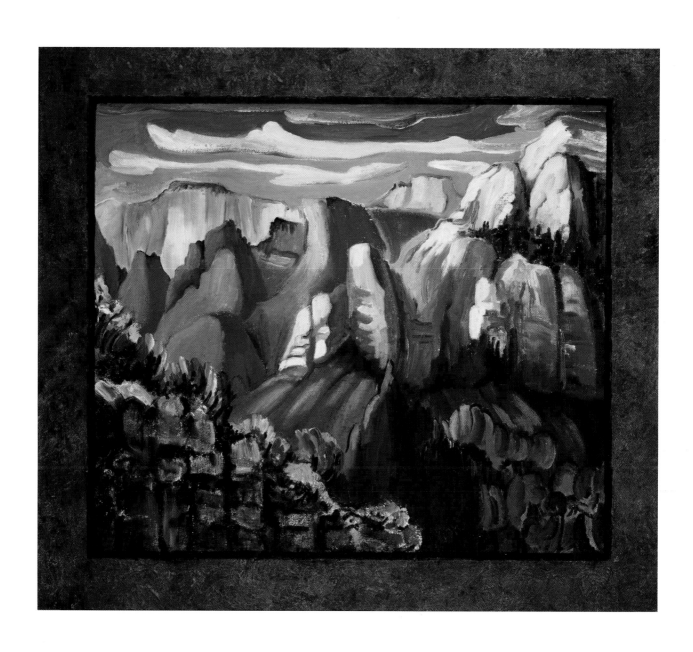

36. *Sunset in Zion*. 2003, oil on canvas, 24" x 28".
Private collection.

37. *La Sombra de la Brisa*. 2006, acrylic on canvas, 22" x 30".

38. *Mujeres Maya*. 2001, watercolor, 38" x 31½".
Private collection.

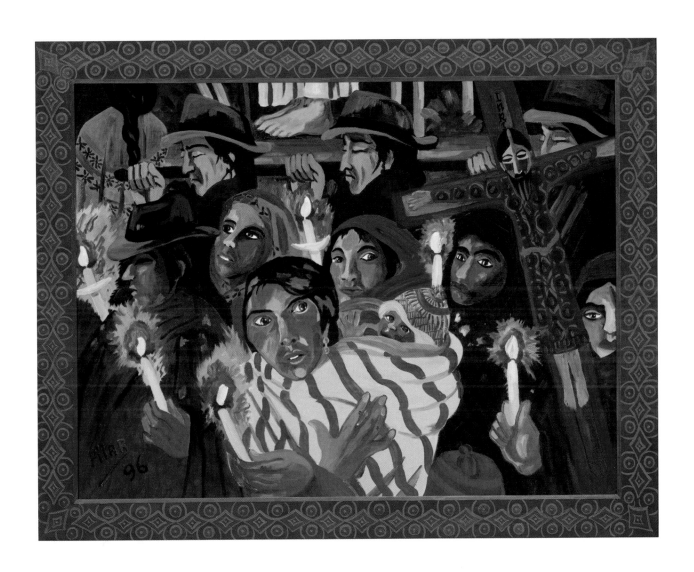

39. *La Procesión*. 1996, oil on canvas, 35" x 45".

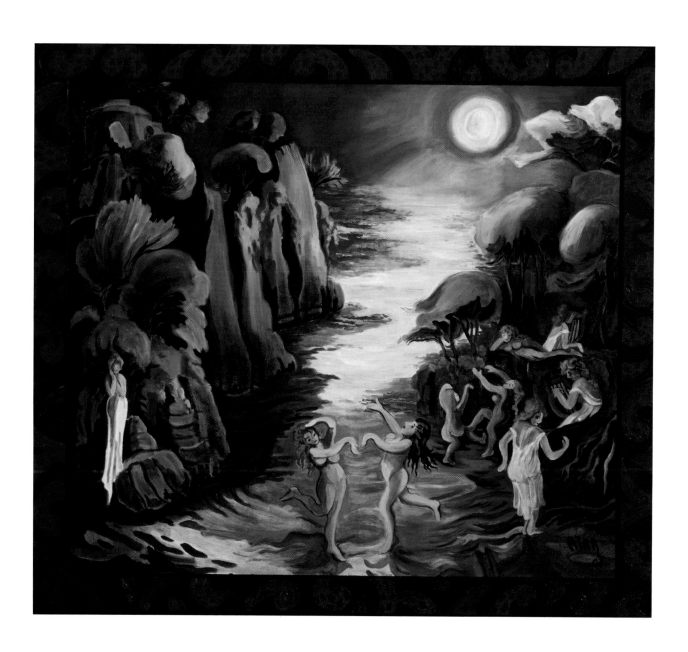

40. *Claro de Luna*. 2001, oil on canvas, 38" x 45".

41. *Sugar Daddy.* 2002, oil on canvas, 45" x 35"

42. *En La Sombra del Bosque*. 2003, oil on canvas, 35" x 42".

43. *The Cinnabar Dancer*. 1992, oil on canvas, 45" x 35".
Private collection, Barcelona.

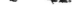

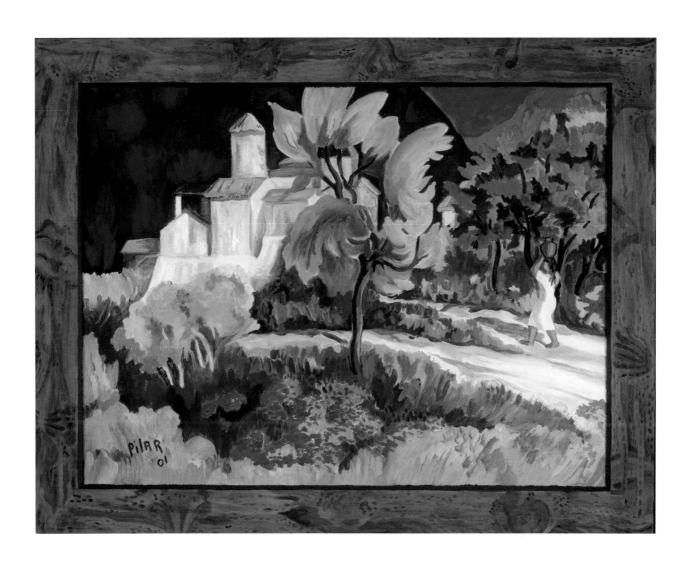

44. *House in the Hollow, Cataluña, Spain.* 2001, oil on canvas, 34" x 36".

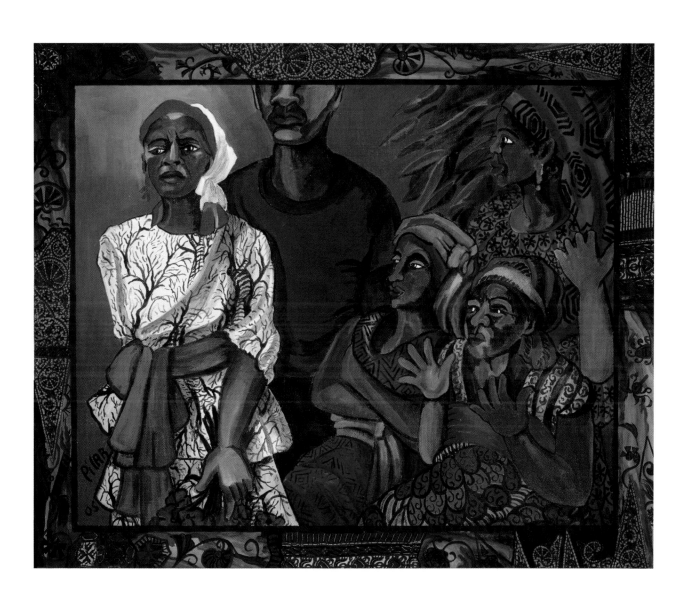

45. *Mourning.* 2006, acrylic on canvas, 38" x 42".

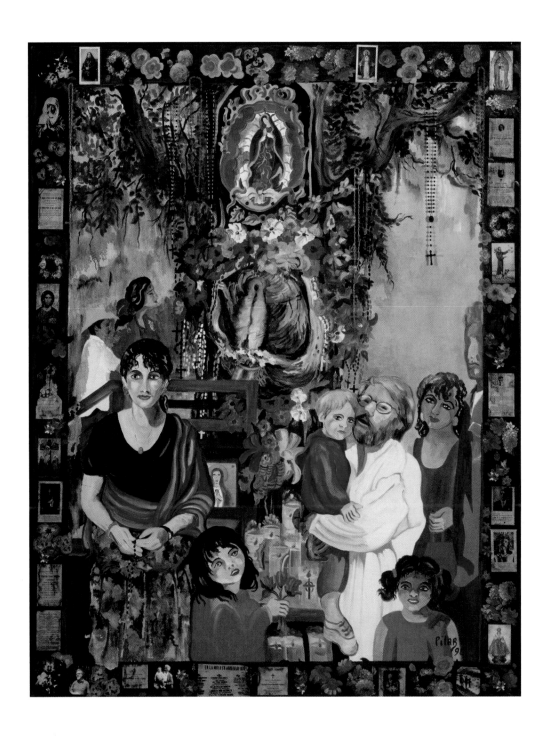

46. *El Milagro del Setecientos Sur.* 1998, oil on canvas, 64" x 42".
University of Utah Museum of Fine Arts Permanent Collection.

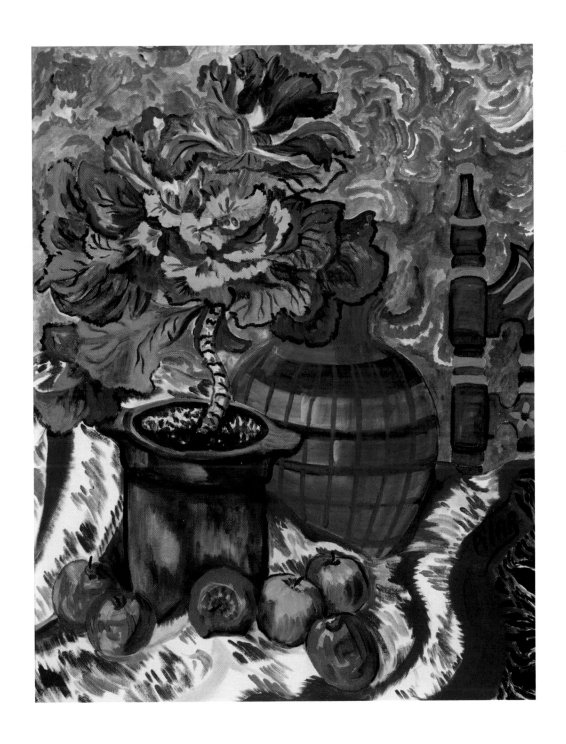

47. *The Cabbage Rose.* 2002, oil on canvas, 36" x 30".
Private collection.

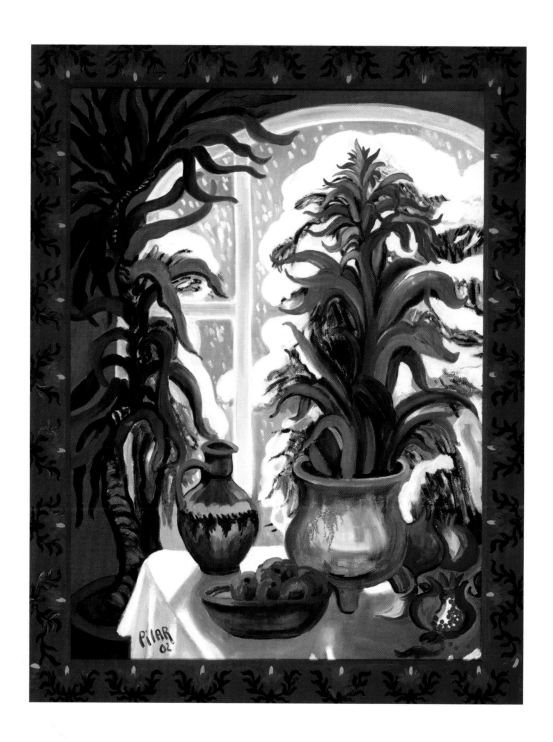

48. *My Kitchen Window*. 2002, oil on canvas, 45" x 35".

the mountain. Soon after we began our ascent on the trail, I noticed a young man of rather peculiar appearance, his long hair not really neglected, but his clothes very old, and his backpack bulging. The strangest thing about him was the expression on his face, a sad, dreamlike expression. He would pass us on the hill, and then we would meet him again, standing by the side of the trail as he gazed into space. This happened several times; he would overtake us, and later there he'd be again, with an unsmiling look of concentration and an almost deathlike expression in his eyes. It started to make me nervous. Here I was, on a very lonely mountain, no one nearby, with my beautiful young daughter and this odd man. I didn't say anything to Maggie, as I didn't want to alarm her, but I was prepared to fight and scream at the slightest provocation. Nothing happened, and we reached the top and entered the ermita. As always, we were greeted by the monk and went through the ritual of prayer in the chapel. We looked at everything that was allowed, including the cemetery, and went to the terrace with our olives, to have lunch. When we needed more water, I went to get it at the well. One of the cell doors was open, and I saw the young man talking to one of the hermits. I was intrigued and curious, so I lingered by the well, watching the scene of the old man in his dark brown woolen habit, with his long beard and sparse white hair, seated in the only chair, and the young man across from him on a stool, leaning forward with an earnest expression on his face, his elbows on his knees, his hands in motion. They were talking slowly and deliberately, the young man's words filled with anxiety, the old one's with calmness and reason. They did not pay attention to me and did not seem aware of my presence, even though I was rather close to them in that small place. It was as if I were a cross or a tree.

"I am tired, Father. I have seen the world, and I have sinned. I feel sad and want no more of it; the world is not for me. I want to change my ways."

"My son, you are young. This life is not so easy; it is not a solution for sadness or disappointment. Every day is a challenge; a hard commitment is required. It is a constant sacrifice."

"Father, I know; my eyes are open. I have given it a lot of thought; I am ready, and I want no part of my past life. God will help me."

I took the water to my daughter and felt ashamed of my suspicions. Here was a seeker who was no threat to Maggie or me. ❧

≈ los narcos

1N 1978, WALTER BOUGHT A HOUSE in Bahia Bacochibampo, on the Sea of Cortés. He got it for me because I so missed the Mediterranean island I came from, and the Sea of Cortés has the brilliant blue-green, transparent waters of my memory.

The house is a few kilometers from Guaymas, a seaport in the state of Sonora; our little neighborhood is called "Colonia Las Tinajas." Tinaja is the Spanish word for a pretty large amphora-shaped container; in my family we used them mainly for curing olives and the other fruits of the Earth we enjoyed. Every fall, our cook, Catalina, would prepare several tinajas with different varieties of olives, including black and green olives; a very small, delicious one that was almost pink in color; and *aceitunas partidas*, broken olives. She "broke" the olives by hitting them with a flat stone before dropping them in the salted water. Those olives cure faster and are ready to eat sooner. I often watched and helped with the olive curing. To achieve the right amount of salt, you keep adding more until a whole boiled egg can float in the water; then you drop in the olives and add herbs and plenty of *hinojo* (fennel) from the hillside.

The house in Mexico was pretty ordinary but had plenty of possibilities, and I soon transformed it into a totally different place, one with a definite Mexican and Spanish feeling. The walls were painted in warm, sunny colors and decorated with some of my early watercolors and oils. I painted chairs and tables with typical Mallorcan designs and added some beautiful Mexican pottery and crafts. We built shelves for our books, in both Spanish and English; magazines; and stereo. The sounds of *Concierto de Aranjuez* and the guitars of Narciso Yepez filled our rooms and spilled out through the open windows into our small gardens and patios. The fragrance and color of the orange tree, bougainvilleas, slender palms

The Sea of Cortés. Photo courtesy of Tasha Lingos.

swaying in the breeze, and oleanders mixed and competed with the brilliant sea and the deep blue of the sky.

Our neighborhood is called "Las Tinajas" because no more than a few hundred feet from our houses are the Tinajas Mountains, so called because they are full of natural holes and basins that retain rainwater. Water is a precious commodity in the Sonoran Desert. All kinds of small mammals—tiny deer, coyotes, raccoons (*bandidos*, as they call them here), skunks, and fox—go there to drink. It is also here that a point extending into the sea marks the boundary that in the old times separated the territories of the Yaquis from those of the Seris, who were said to practice cannibalism until recent times. Modern Las Tinajas is separated from the nearest neighborhood of Miramar by "El Estero," an inland seawater lagoon, a favorite habitat for pelicans, egrets, herons, and many other seabirds. When we first came here, there was a small bridge joining the two neighborhoods. Later it was removed, and now, in order to leave, we have to take a winding road around the estuary.

Bacochibampo is a beautiful little bay; from my windows I can see a small island, La Peruana, that is completely white with the guano of pelicans and other birds that make it their home. Across the bay from us, there are also mountains, dark brownish-red. Like Las Tinajas, their ridges are lined with small lacy trees whose twisted silhouettes you can see against the blue sky. Down below, by the shore, there are palm trees and yucatecos growing in the gardens of the beach houses and the "villas" of Miramar. We have spectacular sunsets that drench the water and the sky in gold, purple, and pink fire, and very often you can see the three peaks of Las Tres Marias on the distant shores of Baja California. As twilight deepens, long lines of pelicans skim the water as they head to spend the night on the small rocky islands and cliffs that abound.

As my husband neared retirement, we were able to spend most of each winter in our warm, sunny abode. Walter would bring all the *Smithsonians*, *New Yorkers*, and *Saturday Reviews* he had had no time to finish reading. I would bring my watercolors, oils, canvas, paper, and brushes. We also brought our favorite olive oil for cooking my Mediterranean dishes, and our latest dog or dogs, often acquired from one or another of the children. Life was exciting and full with going fishing, or whalewatching, or looking for clams. There was never a dull moment for us.

One year, I believe it was 1986, we arrived at Las Tinajas late in the afternoon in early November. I got out of the car to open the gate of our driveway so that Walter could drive in, and right away I noticed something was strange. Our driveway is separated from the driveway next door by an open-design concrete fence, not very high, with chain-link forming the upper part. Both driveways are long, wide, and open. At least, they had been; that day our drive looked like a gigantic shoe box. The neighbor's side of the fence had been lined with sheets of cheap particle board at least ten or twelve feet high. The house next door had been vacant for a number of years, and a great, solid iron gate had blocked the entrance to the drive.

After Walter parked the car, we went out again to the street to investigate. The iron gate was wide open, and junk littered the yard. It looked like vandals had been there. We were so surprised that we walked up the drive toward the house. The front door and

windows were open and white curtains blew in the breeze, but when we called, no one answered. The house appeared to be empty, though as we started to leave we saw a pink bedspread covered with large red-brown stains lying on the ground, with an ice pick next to it. Walter picked up the ice pick and brought it into our house. It is still there.

We unloaded the car, going in and out of our house, wondering what was going on. Eventually, our next-door neighbors, a couple from Salt Lake who were friends of ours, came home from shopping. They invited us to their place to have a drink and hear the latest news. They had been in Mexico for about a week, so they were up-to-date on what had happened.

Mexico is a different kind of country. It can be calm and peaceful for a long time, life going by slowly, almost as if time is standing still. And then, suddenly, drastic changes

Interior view of the house in Mexico. Photo courtesy of Tasha Lingos.

can happen overnight. And so we learned that within the last couple of weeks a gang of *narcotraficants* from other states, and some from as far south as Colombia, had moved to our area. They were fleeing from Federales (state police) and relocating to our state. About a month before, they had invaded northern Sonora, carrying obscene amounts of cash in big black plastic bags. They would coerce decent people into selling them properties very fast for instant cash—American dollars—without any documentation to make it legal. That was how they had acquired the house next to us, and others near by. They had done the same in San Carlos, a resort town about thirteen kilometers north of us, a town much more touristic and Americanized than Las Tinajas.

We were told that, the week before, there had been a murder. Early one morning our neighborhood gardener, Armando, a middle-aged man living in a *casita* on the grounds of one of his employers (just across from us), had gone on a walk with his dogs, as he does every day. He discovered the naked body of a young woman among the rocks by the sea. Armando ran home as fast as he could and called the local police in the nearby town of Guaymas. A crowd soon gathered in the *malecón*, the road that follows the contour of the bay in front of the houses. Our street is the last one before it ends; beyond it there are only footpaths that lead to small coves, beaches, and the mountains, until even those end at another lagoon, El Estero del Soldado.

Evidently, the girl had been at a wake in Guaymas the night before. The wake had been for a police officer, and she had been accompanied by her *novio*—her sweetheart—another officer. Her father had been there, too, but when he left she did not want to go home with him. Instead, she left later with her sweetheart, the policeman, on his motorcycle. They had been invited to a party at the house next door to ours, the narcos' house. Though this might seem like a strange gathering—narcos and police—in Mexico it is rather normal.

Armando didn't know what had happened, perhaps a misunderstanding or a fight, but the result was the policeman was wounded and had taken off on his motorcycle (so much for chivalry) and disappeared. The girl had been killed, apparently stabbed repeatedly with an ice pick. She was found on the rocks and, according to the neighbors and everyone else I talked to, no questions had been asked. Armando later told me that on the morning of the discovery he had observed the narcos and the police in a friendly give-and-take, practically in the presence of the corpse.

The modus operandi of the gang was very irregular. Some days the house was full of people and cars and constant activity, with many men going in and out constantly and trucks parked not only in the drive but in the garden and on the lawn. At other times there were just a few men and some women and children. Then, suddenly, everyone would disappear, leaving the place abandoned, the gate, and the windows and doors, open. It would be quiet for a few days, then the cycle would start again. It was during one of these lulls that we had

arrived, and we deduced that the bedspread and the ice pick were evidence that the crime had been committed next door. It was not a comforting feeling.

Soon enough, however, I got to meet the top guy, *El Huero* ("The Blond One"). I was going to drive Maria, our housekeeper, back to Guaymas. She had opened the gate and was going to use a rock to hold one iron door open while she held the other one with her hand, when a man in jeans and a cowboy hat helpfully came and held it open for us. I drove out and stopped for Maria, and the guy came to my car window and said hello. He immediately asked if I owned the house, pointing at mine. I replied that I did and asked if he owned "that other one," pointing at his. "I do," he said, "And I want to buy yours because mine is not large enough for me." "Well," I responded, "my house is not for sale. And, by the way, what is all that cheap cover-up between my drive and yours? It looks atrocious. If you want privacy, please take that junk down and put up something decent." He was kind of taken aback and said that he couldn't afford to buy anything else. By this time I had a full head of steam. "YOU CAN'T AFFORD IT? AND YOU PRETEND TO BUY MY HOUSE?" I hit the accelerator and left him standing there.

Because I am from Spain, I don't have any language problems in Mexico; I can express myself very well, thank you. I also have many very nice Mexican friends, and so I talked to some of them to find out what we could do about our situation. It is not very comfortable to live next door to a bunch of criminals. Everyone gave me the same advice: "Ignore it; do nothing. It will pass. In the meantime, it is very dangerous to get involved. Don't even speak to them."

That was easier said than done, however. Some of the women from next door had already come to my door to borrow tortillas and *fería*, petty change, because they had only twenty-dollar bills, and the vendors that came by selling strawberry jam or cheese or oysters would accept only pesos. So, we were already establishing a friendly relationship. The women also wanted to tell me all about their children, how cute they were, their ages, how smart, and so on. They did not mingle with the other Mexican people, and among the gringos I was the only one who could understand them.

And then there was Walter. He said there was no way he would keep quiet and do

nothing. He was an American citizen, a property owner paying taxes in Mexico. Nobody was going to tell him what he could or could not do. He knew his rights, and he was going to act as he thought he should, and that was that. Actually, he expressed himself with much more eloquence, but I will not talk about this now. He decided that, for starters, we would drive to Hermosillo, the capital of Sonora, and pay a visit to the American consulate. I became emboldened by his speeches, so the next time I spotted El Huero—when he came out to supervise his women while they were buying taquitos with my money—I decided to take advantage of my lending powers and express to him my disgust at the way they were using our street as a dumping ground. I said, "This is a decent street in a decent neighborhood, and we don't want all this filth that you and your people are throwing around. Please clean up."

He did not know what to say. I guess he was not used to being ordered around and it took him by surprise. But when he recovered he told the women to go and get some of their garbage sacks and get their butts moving and behave better in the future. He was a neat guy.

A day or two later we went to Hermosillo. At that time, the consulate was already secured with iron grills and gates with detection devices. It was the sort of security I had never seen before here or in Europe. They had many Mexican employees who wanted us to explain to them our problems, but Walter would have none of that. After much effort we were able to speak to some DEA agents. They were immediately interested; in fact, they were all ears. They took our address, and the next day they came to our house in an unmarked car. I was not at home, so I don't know if they were the ones to ask for help, or if Walter volunteered it, but the result was that from that moment Walter was in constant contact with them. I was furious. I guess it gave him something to do, but I knew how dangerous it was, and I did not trust the Mexicans in the consulate. I had already seen how the police had acted in Guaymas, and I did not trust the employees. For all we knew they had been bribed by the narcos. But there was not much I could do as Walter was very stubborn and he was having fun. He equipped himself with a yellow pad and his binoculars and spent all his time keeping track of the neighbors.

He sat at the round table in our dining area, which had the best view of the cars and trucks coming and going, and recorded the license plate numbers of every one of them. When he could not see well enough, he used the high-powered binoculars I had given him

for his birthday to watch boats (and sometimes the dolphins) from our windows. Our windows have slightly tinted glass because of the strong sunlight, but our friends and I were not sure that was enough to keep him from being seen by the narcos. In addition to the license numbers, he wrote down the time and dates of departures and descriptions of the cars and trucks and their occupants as they departed to head north for the border.

During one of the cartel members' temporary absences, Walter manipulated the particle boards covering our driveway ever so slightly so he could spy, at night, as they loaded and unloaded cargo brought up from the south in various vehicles and moved into trucks for the run north.

Fall turned to winter, and it was unusually cold and often rainy. The leaves of our fig tree had fallen and were flying around our driveway. Walter was more than six feet tall and rather heavy. He was also hard of hearing. He would step on the hard, leathery fig leaves, and they would crack under his shoes. I could hear it while I was cooking supper in the kitchen and was scared to death that the bandits would discover him spying on them. It would have meant instant death for him, and perhaps for me, too, but he was totally oblivious. I could not stop him. He was reporting to the DEA, and he was "big time."

During the day, I was often painting in a back room, with French doors that opened onto a patio and small garden. At that time, the garden shared a hibiscus hedge with the narcos' garden, so I could hear their telephone and two-way radio. The American agents wanted Walter to go into their house during one of their absences and try to get their telephone number so they could tape conversations; evidently, they did not trust the Mexicans to help them. Walter promised to do it, but I was totally against it. He was not an agile man, as he had been injured in the Second World War and never completely recovered. Besides, being hard of hearing, he would never have been able to hear anyone arriving unexpectedly. And even if he did hear, the only way in or out was the driveway, so the whole idea was insane. Without telling him, I decided to do it myself. There was a hole in the hibiscus hedge that was covered only by an old lattice frame. I knew that if I were the one to go I would hear any car or truck approaching (I heard very well and still do). Since I am small I could escape through the hole. I felt as if I had no choice but to do it, and I did it.

So, early on a Sunday morning, when the neighborhood was very quiet, I went

through the open drive and entered the house. It was an experience. Chaos is a mild word for what I saw: broken windows, broken toilets, broken bottles and glass everywhere, doors barely hanging from their hinges, the curtains a distant memory of white, leftover take-out food, plastic containers, diapers, old shoes, and clothes scattered everywhere. To find the telephone was a challenge, and no number was penciled on a wall, or a notebook, or on the phone itself. So I went home defeated and unhappy, because I knew that Walter would not give up. He was a very determined man and very brave (he had two Purple Hearts and a Silver Star to prove it). I tried to think about what else I could do; he was sleeping like a baby while I was racking my brain. Suddenly, I had a brilliant idea. I went back to the house and placed an urgent collect call to the DEA at the American consulate, and they accepted the call. I told them where I was calling from, and they got the number.

Our shared life with the narcos became a routine. From across the street Armando watched nonchalantly, feigning indifference, but he missed nothing. He is my friend, and all he saw he passed on to me. The neighbors made a point of looking past all the extraordinary activities as though nothing were happening.

El Huero had a wife and a little girl about five years old; he often brought them to Las Tinajas, along with the wife's sister. The three of them were very pretty. The little girl, Yesenia, had a large rooster as a pet. The rooster often came into my garden through the hole in the hibiscus hedge, and Yesenia followed to retrieve it. Naturally nosy, I would give her milk and cookies while trying to extract bits of information. Her daddy had given her a motorized play car large enough for her to get in and drive, and she was always imitating the role models around her, backing out of the drive at full speed, making sharp turns with screeching wheels, and speeding downhill to the corner. She was adorable.

Friends from Salt Lake, Hal and Rose, came to visit during this period, and Hal enthusiastically joined Walter in his investigation. Now the spying gained another dimension. They followed the narcos in our friends' car, which they hoped was less recognizable than our own. Rose was not very happy about this, but, like me, learned there was not much she could do. Both Walter and Hal were stubborn old geezers and it was impossible to bring them to their senses—if by chance they actually had any. They followed the bandits in their

forays and very soon Walter had a list of their regular hangouts to add to his reports to Hermosillo: Hotel Ana, El Restaurant Los Barcos, Le Bar, and several houses in San Carlos that had been "confiscated." Walter was worth his substantial weight in gold, but he was working for free.

One night Walter did finally get really scared. Our friends were gone, and he was in his normal position by the driveway particle boards, peering through a small space in the boards, when suddenly he found himself staring down the barrel of a cut-off rifle. He nearly fainted but then realized that the man holding the gun had not seen him. Still, that cured him for a while.

Throughout this time, El Huero would bring up the subject of our house every time I saw him. He thought I should understand his problem: he needed more room. My feelings, the feelings of my husband and our children, were never of the slightest importance to him. It was as if we were obligated to perform a public service for the community. Our house was needed.

Once, after midnight, when we were already in bed, we heard a frantic knocking on our front door. I got up and looked through a window to see who was there; it was one of the women, the sister. I opened the window and asked what was the matter. She said they had had a phone call: their father had had a heart attack somewhere in the south, and they were alone and needed a ride to the bus station in Guaymas. They probably had six or seven cars in the drive, but they needed a ride.

Neither Walter nor I was very anxious to get involved in that deal—taking them across the bridge, on deserted roads, and through the dark streets of Guaymas, but it seemed it could not be avoided. We started to get dressed but did not have to finish because suddenly we heard the iron door bang open and a slick red sports car tear down to the corner. Just like that, they were gone.

By then it was February, but the situation was unchanged. One day when Walter and I were standing at our front door a taxi stopped in front of us. Inside was a very fashionable couple, the man in jeans, cowboy boots, and sombrero, the woman in a beautiful red dress. They had the little girl, Yesenia, with them. They wanted to borrow money from us because

the taxi driver would accept only pesos. Naturally, we gave them the money. Yesenia had a huge piñata in the shape of a rooster, and I asked her if it was her birthday. The woman answered, "Oh, no, it is just that she wanted *el gallo* ("the rooster"). She is very spoiled."

Shortly afterward, El Huero gave me an ultimatum: he said he was going to come to our house in the evening to talk to us about purchasing our place. It was not a question, it was a fact, and not open to discussion. I told Walter, and we did not know what to do. Of course, we had talked about it before and knew we could not start an argument with the guy—the odds were on his side. Walter thought it would be better if I saw him alone. At least then I could avoid giving a firm answer, saying I had to talk to my husband, who was sick in bed. Walter would be on alert in case things got ugly. But that did not seem very probable because actually the fellow seemed sort of fond of me.

El Huero showed up around seven thirty. I asked him to sit at our dining table, by the window, and offered him a beer. I did not want to get too chummy, so I stuck to my tea. He was in his early thirties and very good-looking, but his face was already showing the signs of hard drugs and too much drinking. He was handsomely dressed in designer jeans, cowboy boots, and a plaid shirt. He was wearing two heavy gold chains. The longer had a huge gold cross studded with very impressive diamonds, the shorter one a large head of Christ, also gold, beautifully sculpted, with the crown of thorns and with rubies for the drops of blood. Both pendants were magnificent and I told him so. He said they were presents from a friend.

Then he got down to business. He started to look around from his chair (I did not offer to show anything). He said he wanted everything just as it was, even the paintings. I responded that the paintings were extremely valuable. No matter; he wanted the place exactly as it was. If in three or four years I wanted to came back for a visit he would lend it to me, and I would find it the same as it was today. Unknown to him, I had been privileged to visit his present abode, and it took little imagination to visualize what my house would look like after a few weeks of his occupancy. But he did not allow me room for argument. His words were law, and I knew for a fact he had the guns to prove it. He told me that the next day he would send an appraiser and everything would be done fair and square. After checking his Rolex he said he had another appointment; we shook hands and he left.

Immediately, my "sick" husband got out of bed and prepared a vodka tonic with lemon for me and a scotch for himself, and we sat at the table to deliberate. We knew we were powerless. We could not go to the police; they were collaborating with the narcos and on their pay—we all knew that. It would be worthless to go to the American consulate, because they had no power to act in Mexico. We could file a complaint, but it would take too long to get any results. We were on our own.

El Huero would pay with cash, probably a large amount; for them, money was no problem. But what could we do with it? We could not go to the bank and deposit it; there would be questions. We could pack, get in the car, and head for the border (225 miles north). But the police would know about it and likely follow us, stop us in the middle of nowhere, and arrest us for breaking some law or another. The best we could hope for was that they would simply take the money and let us go, but even that was not guaranteed. We had already discussed a crazy plan we had hoped never be needed. It was an improbable plan, but what else was there to do?

We would make a big deal of letting all the neighbors know we were leaving Guaymas. We would pack the car in full sight of them, in our driveway, filling it with whatever would fit. We would give the canned food, the perishables, and other supplies to the maid and the gardener, transporting it all to his casita across the street.

On the evening before our planned departure, we would pad our bodies with the money, using bandages under our sweatsuits; hide our passports in my purse; and take a leisurely walk to a restaurant on the beach of Miramar, La Bocana, for a farewell dinner, taking our dog, Nipper, with us. (In Mexico, most restaurants allow you to bring your pet, and we had done so many times before. Nipper was always welcome with us in La Bocana.)

We would have a leisurely dinner, and when we left we would stop outside for a moment, talking, as if we were debating whether to go back home or take a walk. We would decide to walk and keep walking until we saw a convenient taxi with no witnesses nearby.

We would take the taxi to the train station (we already knew the schedule) and take a train south instead of north, which would be the logical direction for our escape. We planned to go to a town not very far away and change our form of transportation. We would continue to do so until we reached an airport and made our real and final escape to

the United States. We figured we had at least fourteen hours before the narcos or the police would get suspicious. The house had lights that turned on and off at certain hours, and in Mexico everyone is late, so we were counting on all of that plus a lot of luck. We were very stressed.

But the next day came and nothing happened. We waited for the appraiser, hoping he would not show up, and he did not. Things were very quiet next door. Early the morning of the following day we heard shots at the entrance of Las Tinajas, near the bridge. Later we heard talk that there had been a raid of the narcos in northern Sonora. The Federales had intervened and were arresting, eliminating, or otherwise running the narcos out. The house next door seemed empty, and a foreboding quietness settled over our neighborhood. Everyone was indoors waiting for events to take their course.

At about two in the morning, I heard a truck next door. Snooping had become a way of life for me, so I opened the back door and walked silently down the dark driveway, cautiously putting my eye to one of the prearranged slits in the particle boards that covered the fence, which by now were disintegrating along the edges from rain and humidity.

Two or three men were haphazardly dumping everything from the house into the truck, indifferent to ruining the fridge's enamel or getting the mattresses soaking wet in the rain. If things had not been damaged before, they were certainly getting mistreated now, with every imaginable object piled in a big heap in the truck bed. It seemed the men were in a real hurry, and soon afterward I heard them tearing down the street, wheels squealing as they turned the corner. Away they went and that was that.

The gate was left open and the house a shambles, but for three or four days we still felt insecure, afraid they might return anytime. The stormy weather, unusual for sunny Guaymas, increased the gloom in the neighborhood; we were waiting, afraid to hope. But nothing happened, and rumors began to spread that our private band of narcos had disintegrated: most of them had been killed or arrested, while some disappeared into thin air. In a small town northeast of us, five men had been found dead in the bottom of a dry well. So they were gone, and with a surprising mixture of regret and relief—I must admit it was mainly relief—I wondered what had became of "my friend" El Huero.

I waited three days and could wait no more. It was still gray and rainy when I pushed a ladder to the end of the fence, looking directly at the house next door across what had once been a garden. It was dismal, like a scene from a Fellini movie. The house stood there derelict and sad, the formerly white curtains floating haggard and wet through the broken windowpanes. The holes where air conditioners had been were open, like black, empty eyes. The trampled lawn was littered with empty cans and broken bottles, discarded plastic, boxes of fast food, and disposable diapers.

As a final reminder of the narcos, Yesenia's rooster piñata was hanging from an improvised clothesline, its head and crest falling to one side, the gay, brightly colored streamers limp from the rain. It was a forlorn creature abandoned to its fate.

But the real rooster, Yesenia's pet, had a somewhat better fate. It was mercifully left behind and roamed freely through our neighborhood, eating crickets in our gardens for a long time. One day it finally disappeared, probably ending up in somebody's pot, the final act in a life of service. ❧

the mayor

I HAVE A FRIEND WHO HAPPENS TO BE the mayor of Salt Lake City. I admire him very much because he has a lot of character; he is outspoken and says what he thinks and believes. And he is a LIBERAL, in Utah! Can you believe it?

Well, I think I have some things in common with him, but, of course, on a more personal level. I am not an important person in the community as he is but, like him, I speak my mind. Sometimes (in my case) I talk faster than my brain can process the consequences of my pronouncements.

I admire him because he is totally committed to his job and to his constituents, and he works to achieve what he considers best for our community in matters of growth, the environment, education, and so on. He does not stop to consider what is best for his political career, or what would please the people who are influential in the state, or how to get more votes. He is true to himself and he expresses his opinions in the forceful manner that is part of his style. I admire all this in a public figure, whose duty is not to conform to gain approval but to act as a public servant to do the best for the people in accordance with his judgment and abilities. I wish there were more politicians like him because that is the root of true democracy. See how opinionated I am?

But, now, back to the story. On a recent Sunday afternoon I went to an art show in the studio of some friends. The work was beautiful and the company charming, and at one point, when I turned around, there was the mayor. I was glad to see him, particularly as I had not seen him for a while, and I think he was glad to see me, too. He told me I looked great (a nice compliment for a lady of advanced years) and admired my painted shoes and my purse. I told him I had just returned from my house in Mexico, and he asked if I had been painting. "This time I painted less," I told him, "because I was concentrating on writ-

ing and editing some stories that I have been working on for a long time and that I have now decided to finish."

He wanted to know more about that and asked if I would let him read them. I told him I'd be happy to but explained that I was in the process of typing them from my long-hand notes and that I am very slow at the computer.

"Well," he said, "let me type them for you. I am very fast, 105 words per minute, and I would read them while I type."

I started to laugh. "Can you imagine, the mayor of Salt Lake City doing my typing?" With all the important matters waiting for his attention, I would have the mayor doing my typing!

But he was serious. He asked if I had a pen and a card in my pretty purse. On the back of my card, he wrote:

"ROCKY

Will type whatever you write."

He also wrote his home, office, and cell phone numbers on the card so I could call him! I really, really admire a dedicated public servant, but this is well beyond the call of duty! ❧

❧ my memorial day, 2000

TODAY, MEMORIAL DAY 2000, TOOK ME BY SURPRISE. I had no thoughts of it being different, just the last day of a long weekend that would give me enough time to finish some frames for my next show, Art in Pilar's Garden.

I had finished the frames on Sunday, and that evening three friends came to dinner. We were in the garden, where it was cool and pleasant and we could enjoy the first blooms of the spring. After they left, I remained there, listening to the water in the fountains and "Romance de Amor," a song by Narciso Yepez, a classical guitar player from Spain whose music I adore. It was a still night, and I was thinking of Walter and the children and the happy times we had had together in this place. There were so many times, over so many years that are now gone.

After a while I turned off the lights, checked the locks, and went upstairs. I took some Valerian pills to help me fall asleep and went to bed with a book.

I woke up with the morning light, but instead of getting up, I lay in bed. I knew my garden was tidy and the frames were finished, and the world would not fall apart if I did not start another project. My dog, Kiva, was with me, the Venetian-red room was pleasant, and the house was silent. I turned over and went back to sleep.

When I awoke, the morning was bright and sunny, though still cool and fresh from the night air. I put on my robe and went out to inspect the garden, looking for snails (my enemies) and admiring the new growth and the light green of spring. I got my newspaper, made some coffee, and settled down to read, feeling that, in spite of everything, I was a pretty lucky human being.

And then it happened!

On the front page of the *Salt Lake Tribune* was a photograph of a woman with her

sons standing in front of a tombstone at the cemetery. The woman explained the stages of grief she had felt since her husband's death in February: her shock and the immediate sense of loss, the realization that it was forever, and then the complete change in her life now that she was alone. Finally came anger at the bureaucratic details she had to face amid her sadness—problems with Social Security, VA benefits, and insurance, and the way some of her friends had started to ignore her after their initial attention because they could not deal with her grief. There were other stories about her and others, discussing how, in today's society, we don't allow ourselves to feel the sorrow and the trauma of losing someone who has been so significant and important in our life.

And suddenly I started to cry and could not stop. I have been crying more lately than I did at first. Walter, my husband of forty-three years, died eight months ago, in August. My experiences have not been like those of the woman in the *Tribune*. My friends have been wonderfully supportive, never avoiding me. My husband had been very ill for many years and I had taken care of him at home almost to the end, which was not unexpected. I had known he was going to die soon, and the hardest thing for both of us was that he had to spend his final weeks in a nursing home.

Our two daughters, Monica, who lives in San Francisco, and Maggie, who lives in Spain, had come to Salt Lake to visit him but had left a few days before because they could not be away from their jobs any longer. Before Maggie left, she helped me paint our bedroom. I was thinking of bringing Walter back home, and we wanted to make the room brighter for him. We were in the middle of that when the August tornado hit Salt Lake. Our house is in the Avenues and we looked out the bedroom bay window to see objects flying in every direction; we did not even know it was a tornado. I went out to the garden to take down the umbrella and secure the flowerpots and chairs, and saw there were tree branches everywhere. Soon we lost the electricity and the telephone, and the street was closed. We had no serious damage, but I thought it an ironic coincidence that while Walter was dying, City Creek Canyon, where he had been born, where his family home had been, where he had grown up and played and met many of his lifelong friends, was being nearly destroyed. Mercifully, he never knew it. He would have been so sad to see all those trees torn from their

Pilar and Walter in City Creek Canyon, 1985. Photo courtesy of Maggie Smith Cerdá.

roots. I could not go there for a long time; somehow I connected the damage to Memory Grove with the loss of Walter.

After the girls left, I spent most of my time at the nursing home. I could see that the idea of bringing Walter home was not possible. I spent his last three nights in a recliner in his room because I wanted to be sure that when the moment came I would be there. When it happened it was a beautiful moment.

I was holding him, telling him to be happy, telling him we were going home together, that the children would be there any moment and it would be like so many other times in the garden. I was telling him we all loved him so much. He could hear me but had not been talking for days and was very calm. He stopped breathing, and I kept talking, telling him how much I loved him. He started to breathe again, and then stopped, and then the breathing did not come back. I waited and waited, motionless, still talking, and after a while I knew, and closed his eyes. I went out to find someone. It was late in the evening and the place was almost deserted, so it took a moment to find help. Then I called my son, Luis, the only one of our children in Salt Lake. He had been with us earlier and had left because Walter's condition had been unchanged for many days. It was impossible to predict the end.

Luis and I stayed with him for a while, my husband, his father. We made the arrangements and they came for him, to take him to the crematorium. It was time to say goodbye. I kissed him, and we followed his gurney through the empty lobby and the dark

parking lot. I saw him being pushed into the hearse and watched the door closing behind him. It was over, and Luis and I went home in different cars.

My son and his companion of many years came to the house. Shortly after, another friend, Susan, came too. She had stopped by the nursing home, as she had other times, and had been told. She had also been Walter's friend.

The four of us sat at the kitchen table, had beer or wine, and talked about Walter. I brought out his medals, his two Purple Hearts and his Silver Star, his tags, his ribbons, and his Honorable Discharge, and also his diplomas and watch from the University of California at Berkeley. We talked about how at the beginning of the Second World War, because of his high IQ, he had been sent to the University of Pittsburgh to study German, Russian, French, and political science with some other bright recruits. This was all to prepare him to be sent to Europe at the end of the war to help establish the new order of law after the defeat of the Nazis. We talked about how, without explana-

Son Luis and his partner, Monica.

tion, the project had been canceled after just a year, and he and all the other students had been sent with the infantry to the front line in France, without the benefit of even the most basic training. He went to battle almost immediately after his arrival and, when his captain was killed, he took command of his unit and defended his post until he himself was wounded, with bullets in his spine, thigh, and torso. It was late November, and they were in the north of France, in the Ardennes forest. It was raining, and he lay among the dead for two days and three nights, going in and out of consciousness and suffering unbearable thirst but not calling out because German soldiers were shooting any men still alive. He told me

how finally some of his companions had found him and taken him to the barracks, and how the doctors had asked him, "Why did you not die?"

We were not married then, of course. In fact, I was still a child going to school in Spain. It was much later that he told me, "But I wanted to live!"

That night I told of many things Walter had never said to anyone but me, and even to me only in his last years. He never wanted to present himself as a hero even though he was one!

We did not have a funeral, but we had a beautiful memorial in the garden, where we had shared so many good times. My son helped me repair the tornado-damaged garden, and our daughters returned, Monica from San Francisco, with her partner, Tom, and Maggie from Spain, with her husband, Jose Luis. Many of our friends came to remember Walter and give us their love, and they talked of their experiences with him. Our daughter Monica, a talented singer, composer, and songwriter, sang her own songs, the ones that Walter loved most. We had good food and drank good wine in his honor. Walter would have loved to be there, and maybe he was.

All these memories came rushing at me this morning, and I was overwhelmed. But after a while I said to myself, "Enough is enough." I used several Kleenex, put on my shorts, and went to the garden to give my flowers a shot of Miracle Grow; this is good for the soul. I also called the Cathedral of the Madeleine to inquire about the time of services. I am certainly not a regular (if I were, I would not have had to ask), but I go there sometimes because it is such a beautiful place, because once in a while they play Gregorian music, and because it reminds me of my youth in Spain when I spent a lot of my time in churches.

So, I called the cathedral because I felt it was the best place for reflection. A human voice, not a machine, answered the phone and told me there was no Mass at 11:00 because they had celebrated an earlier one at the cemetery. When I sounded disappointed, the human voice told me that the daily Mass would be at 5:30 in the evening. "OK," I said, "I'll be there."

I went on with my day. Later, some friends came by and brought me flowers; another cry. When they left, I went back to the garden and got a seedling of a shrub, a Rose

of Sharon, and took it to a neighbor, and we planted it in her garden. This time I did not cry, but it was not easy to control myself.

By then it was time to have a snack and get ready for my Memorial Day service at the cathedral. I took a bath in my blue Jacuzzi, a sure way to improve my mood, put on some spring clothes, got in my car, went down B Street, and parked in the shade of an old tree about a block from the cathedral. (The parking lot would probably be very full, I thought, for the Memorial Day service.) I walked down to the church's back door on B Street, but it was locked. I continued walking to the main entrance on South Temple; also locked. This was strange, but I proceeded to the east side, to the other back door by the piazza with the lovely fountain. That door was also locked.

There was a group of five or six people trying to get in; they were from out of town and were disappointed because they wanted to see the cathedral. I told them, "Don't worry, I have been informed by no less than a human voice that at 5:30 a Memorial Day service is to be celebrated, so someone should be here momentarily."

A very tall, blond, German-looking man was sitting on the stone bench by the fountain, smoking a cigarette. He approached and told us that the door was supposed to be open. When, after some effort, we were able to convince him that it was not, he produced a key, but it did not work. His English was somewhat deficient, but he succeeded in explaining that if he were able to open one door, another would open automatically. The whole thing was rather confusing, but all of us waited with great determination. We wanted to get in! Finally, the tall blond man knocked on a windowpane, and a stout, blonde woman, who spoke no English, came and opened the door from the inside.

We all trooped in, and I went ahead because the others had stopped to admire the vestry and the small rooms next to it. I went through the halls to the main inside entrance, opened the door, and entered the cathedral. It was breathtaking!

The nave was inundated with brilliant light streaming through the stained-glass windows. The sun was near setting, and the west windows were receiving its direct light, which the glass converted into a rainbow of colors. The luminosity was staggering, vibrating, brilliant and diffused at the same time. The cathedral was glorious, glowing and empty,

and I was alone amid the trembling shards of purple and red and green and gold! I started to walk as in a dream, seeing what I had seen often before but never in that light. I walked along the sides, looking at the ornate columns and at the Stations of the Cross Sam Wilson had painted—they are such masterpieces! I kneeled, perhaps to pray, perhaps to absorb the beauty surrounding me.

The other people must have come and gone; I never noticed, for I was alone in the light. It was beyond experience, beyond life. I wandered around, approaching places I had never been near before. I climbed to the pulpit to see what the church looked like from above. I went behind the altar and sat in the bishop's chair. Below the main retable center-piece, beneath the painting of Maria Magdalena, there was another altar, with a large bouquet of flowers in front of it; I moved the flowers to see what was behind them. It is the tomb of the first bishop of Salt Lake. I wandered into every nook, every corner, always looking back toward the light.

I had wondered what it would be like to be in the baptismal fountain, so I removed my sandals and got into the pool. The water felt good and refreshing, and I liked the sound when I walked in it. Afterward, I sat on the marble edge. It was so cool, so divine! I have gone through many churches, cathedrals, convents, and missions in my life, but I believe this was the strongest religious experience I ever had.

Suddenly, it occurred to me that perhaps it would be as difficult to get out as it had been to get in. I put my sandals back on, did my genuflections, and made for the door, wondering if there was a telephone available in case I was locked in and the eloquent German couple was no longer around. But, no problem, the door opened easily from inside, and I was out!

I walked to my car, and the city looked luminous in the early evening light, the shadows getting long and making quivering patterns on the sidewalk; there was the fullness of spring in the fresh green of the trees and the blooming roses. I decided to drive around to places I had often visited in the past and did not go to much anymore. I went to Sugar House Park and walked along the creek, already deep in shadow and with the rushing water tumbling down from the mountain snow. I stayed a while and then decided to visit my friend Rosie, who was very ill and perhaps would welcome my company. But her house was

silent, no others' cars were out front, and when I looked into her back garden I heard no voices, so I did not ring the bell for fear of disturbing her rest.

I went by the houses of some other dear friends because I needed love, I needed to know that I was not alone, but no one was home, the places were silent and deserted, adding to my feelings of loneliness and sorrow.

I had done my pilgrimage and decided to go home, to my dog and my garden. I turned on the radio in my car and heard Spanish romantic songs. That inspired me to make one last stop, at the shrine of the Weeping Tree on 700 South. A few years ago, an elderly Mexican woman, Graciela Garcia, who lives nearby, was seated in a small city park and saw what, to her, appeared to be the figure of Mary in the hollow of an old tree. The people of the neighborhood, mostly Latinos, started to visit and brought flowers, *relicarios*, and *veladoras* (candles placed in tall glasses so they remain lighted even in the wind). They brought photos and mementos and ex-votos and rosary beads and hung them from the tree. They built wooden steps so you can climb up and touch the shadow of Mary. The place is beautiful and has become a shrine where people worship the Virgin of Guadalupe, *Patrona de Mexico.* (The tree has been the subject of two of my paintings, one of them in the collection of the Fine Arts Museum at the University of Utah.)

I parked the car. The downtown streets had that empty holiday look, almost deserted. I walked through the little park, approaching the tree from behind, and what a sight!

There was a group of about a dozen people facing the shrine, and Graciela Garcia, the woman who first saw the miracle, was there. She was kneeling in a wooden *reclinatorio* in front of the group, beautifully dressed in her turquoise skirt and silk blouse, with a lace mantilla, also white, over her gray hair. She was reciting the prayer of the Rosary, holding the beads above her head. By her side, also kneeling, was a young girl in white shorts and a hot pink halter, and another woman, who was trying to keep some ornate long candles lighted against the breeze by lighting them over and over again. Standing behind them were the rest of the people in their Sunday best, the men holding their wide sombreros respectfully in their hands, the women in tight pants with babies in their arms. The scene was like a painting by Diego Rivera.

Graciela saw me and waved her hand: "Come here, little sister, *hermanita*, come here!" Of course, I could not leave.

It was the month of May, the month dedicated to Mary, and it is almost impossible to describe the feeling of that moment in the waning light of the quivering candles; the tree dressed with paper flowers and garlands; a statue of the Virgin of Guadalupe, the gaudy colors washed out by the rain and the weather, except the hot pink of her tunic; pictures of saints, offerings, written messages, and a large photograph of the tree all clustered together. Graciela asks everyone what they can see in the photograph, and all of them can see the face of Christ. I looked, too, and saw that the bark shows something that could resemble a face, so I say to her, "Yes, I think I can see a face in profile." And she says, "Not quite in profile; it looks to the South, to the Latino countries of South America!"

Well, what can you say? That woman has the faith of Maria Magdalena, Marta, Saint James, Peter and Paul, and the Four Evangelistas and not a single thought of doubting Thomas!

That woman is the soul of the tree. She calls everyone brother and sister, she loves them all and tells them to come to the tree to pray, and she has made that spot on Seventh South a Catholic Latino shrine in the middle of Mormon Salt Lake City.

By the time we were through with the Rosary, the *Letania de Todos los Santos,* and the *oraciones* for the salvation of particular individuals, plus assorted songs of "Oh, Maria, Madre mia, oh consuelo, del mortal," I was totally exhausted by my long emotional day. Graciela reluctantly kissed me goodbye, and I drove home.

At home in my garden I lit an oil lamp and sat there to write, trying to put down on paper the emotions of that day, a day that had been very sad for me, but also glorious, full of remembrances of a meaningful life. I wrote for a long time, thinking that eventually all of us must experience sadness if we live long enough, because this is the way of the world, but in my case I have to be grateful because I have lived a full life, have known the love of many, and perhaps have still the chance of living a few more years as interesting as the past ones.

Who could ask for more? ❧

✦ 9-11 in italy

IN THE SUMMER OF 2001, my friend Willamarie, an artist, asked me if I wanted to join her and her class on a trip to Italy. She had organized a trip to the northwest coast, the Ligurian region, which includes Cinque Terra. These five coastal towns are accessible only by sea or by train through an underground tunnel. Willa is a very accomplished art teacher and had been taking students to that area for several years. By coincidence, I had recently painted a portrait of a friend of my daughter Maggie (and my friend, too), Perry Babalis, with her young son Phillip. Perry and her husband had asked me to use a photo of a town in Cinque Terra as the background. They had gone there for a vacation and had great memories of the place. It was fine for me because as a Mediterranean native I have a strong feeling for that whole area. Although I had never been there, I knew what the place would look like and the effect it would convey. While painting, I had developed a strong feeling of nostalgia for my beloved sea. This is hardly unusual for me, as I feel like that every time it comes to mind. So, when I realized Willa's destination was exactly that area, it was an offer I could not refuse.

I had to make it clear that I would go as an independent artist and not take her class but paint on my own. This is not because I think I could not learn something from her, as I am sure I could—she is a great artist and teacher and has a very good technique. It's because I don't want to "contaminate" my own painting, so to speak, which has always been entirely my own. I do not want "foreign" influences, outside of the unavoidable ones, those that enter your subconscious when you see art that impresses you, and the memory stays hidden there. Those memories reveal themselves without intent, unexpectedly, as has happened forever, for generations, because we all learn from each other and from the past.

Willa agreed to my request and even told me that another artist and friend would also join us in Italy, in the same independent way. So I began my preparations, getting all my

equipment together for the trip. When I travel I always paint with watercolors; they are the least complicated materials to transport and are the fastest and most spontaneous way to paint. I love watercolors.

On the first day of September 2001, a group of seven or eight women left the Salt Lake airport en route to Italy. After changing planes in New York, we flew over the Atlantic, and in the very early morning I had a bird's-eye view of my beloved Spain, just a passing glance, hello and goodbye. A while later, we landed in Milan—Milano to the Italians—a beautiful city, but we did not linger there. We did visit the cathedral, El Duomo, for a short while. Afterward, we walked through the streets, with their elegant shops, on our way to the station, where we caught the train to the Liggure and then to Santa Margarita. Finally, we took a taxi to Paraggi, a little hotel in a cove midway between Santa Margarita and Porto Fino.

That same afternoon, we went for a walk along the hillsides above the coast, and it was as if I were back in Mallorca. The beauty of the granite rocks and the Mediterranean pines hanging precariously over the blue and green of the sea seemed like a scene I had seen many times in the past.

The next morning we started to work, establishing our daily routine: we met early every morning in the hotel dining room for breakfast, got our equipment, and caught the bus to Santa Margarita, where we would ride the local train to various seaside locations. There was never a shortage of lovely sites to inspire us because Willamarie was familiar with the area. The only problem for me was that I saw too many places where I would have loved to spend not hours but days or weeks, breathing the familiar sea air and contemplating the views, absorbing them, and transferring their colors to my paper.

We went to Cinque Terra and spent time in Riomaggiore, a small town literally overhanging the sea. It is a fishing village with no harbor, the coast open, ragged, and unprotected. Even when the sea is calm the waves are lapping at the lower plaza and the streets. In the evenings, when the day's work is done, the fishermen of Riomaggiore pull their boats up a ramp to the square and nearby streets to keep them safe until their next foray into the dangerous waters. The town is very quaint, with crooked streets and passages and stairs

leading from the upper levels to the lower ones.

I found my place uncomfortably situated between some rocks near the entrance to one of those passages. People were almost stepping on my paints, and my palette was in danger of falling into the water, but it was the right place; it was where I had to be. So I endured the cramped legs and the constant interruptions of passersby—this is what you have to do when no other place will do. I spent about three hours there, and now it is a view I'll never forget. Painting gives you a memory that just casual looking will not. Even now I can see the forms and the colors of that place and can almost feel the cool breeze of the sea playing with my hair and touching my cheeks.

Pilar painting in Barcelona, 2006. Photo courtesy of Tom Erikson.

In the afternoon we took a long walk along La Via del Amore, a coastal path high above the sea that has tunnels cut in the rock and that unites the five towns of Cinque Terra: Riomaggiore, Manarola, Corniglia, Vernazza, and Monterosso. They all overhang the Mediterranean, touching the clouds, their trees piercing the skies. Here and there are patches of old grapevines and small fruit orchards, stone churches, and defense towers that protected the coast from the pirates and marauders that threatened for centuries, when the western European countries were repeatedly invaded by people from the East.

We went to Camoggli, another lovely small town with a harbor and a beach and a yellow church. We went to Portofino, and by boat to San Jenaro, an old abbey in a hidden cove you can reach only from the sea. The monks there must have seen very cold winters because this coast is not very far from the Italian Alps. Combined with the humidity of

the sea and the Gothic accommodations of the convent, it must have been hard to endure, despite the surrounding beauty and their strong faith.

Every evening, after the day's work was done, we would stop to have wine and dinner at some charming restaurant. There we would enjoy ourselves and let down our hair, saying outrageous, funny things, the way women do when not in the company of men. The days went fast, and soon it was our last night together in Paraggi. We had dinner at a very nice restaurant on the beach, where an Italian couple was celebrating their wedding. It was pleasant and very romantic; they had Italian music and were setting candles, *luminarias*, to float out to sea.

My daughter Monica and Tom, her partner, were in Sardinia, where Tom had had a photography show. They had called to tell me that if I postponed my return to the States, they would join me in Paraggi for a few days. I agreed to it. I loved the place and was in no hurry to leave, and, besides, I would get to spend time with them. So Willamarie and the rest left on Sunday to spend Monday shopping in Milano and make their trip back to New York on Tuesday, September 11, 2001. Our friend Kindra and her soon-to-be husband, John, also stayed in Paraggi for a few more days before continuing their trip in Europe.

On Monday, Kindra, John, and I went to Pisa and spent a wonderful day there walking around, crossing the old bridges, stopping in art shops, where I bought Italian brushes, and looking at the famous inclined tower, at the time off-limits and under repair to keep it from tilting any further. Pisa is a golden town with magnificent Renaissance buildings and bridges. It's a vision of the Italian past, another place to stay for weeks—and frustrating to visit for just one day. And the trip to Pisa by train is so pleasant, with views of the foothills of the Italian Alps to contemplate at leisure.

On the morning of Tuesday, September 11, while my friend Willamarie and her sister Ann were heading across the Atlantic toward New York, I decided to take the bus to Santa Margarita Liggure, a nearby town, to shop and linger in its streets and along its harbor. Santa Margarita is so lovely and reminded me of Palma, my home in Mallorca. The houses are painted in pastel colors, and your first impression is that the windows and balconies are adorned with sculpted ornamental friezes. But they are just painted in a way to

make it appear so, and it looks great, adding character to the town. The shops are small and interesting, with a variety of items in that inimitable, irresistible Italian style. I bought three pairs of shoes for myself, and presents for friends and for my children. The housetops have hanging gardens and pergolas covered with bougainvillea, and the silhouettes of the mountains surrounding the town and the harbor are dotted with medieval castles and churches on their crests.

It started to rain, so I went to a restaurant with a canopy and sat outdoors to have a cappuccino, looking at the softly falling rain and the tranquil waters of the harbor, and enjoying people-watching, the women with their purchases, the men with their attaché cases, people talking to each other in peace and harmony as if that day were just like any other day at the end of yet another summer in a place by the ancient sea. In this place that had been witness to many civilizations through the centuries, we were unaware that across the ocean, in a much bigger and younger city, an era was being ended by the actions of terrorist assassins. We did not know yet that events were occurring that would have repercussion across the world and would change our lives forever. I did not know then that these were the last moments of innocence, when we still could feel safe and confident; when we trusted that the world was progressing toward a better time; when we might all be able to understand each other and spend our time and energy improving the destinies of those less fortunate than we; when it might be possible to repair our ailing Earth and dedicate the strength of governments to finding ways to care for the air we breathe, the water we drink, the forests that keep our planet livable, and the animals that are our companions and share this place with us.

As it did not stop raining, I finally walked to the bus stop and took a bus to Paraggi. That road is very beautiful. In many areas the stone walls that border the sea are hollow, forming entrances to caves that might have been escape routes from inland castles—I have seen similar things in Mallorca. Perhaps now they are used to store boats or I don't know what. They are very old, their stones covered with moss, pine trees hanging above them, houses barely visible among the branches. How fortunate the people that live there are! The road turns and turns, winding around small coves of green water; waves caress the little

patches of white sand. Even what must be new houses look classic, with towers and balustrades overlooking the water. It looked like paradise that day in the rain.

When I arrived back at the hotel I went directly to my room, put away my purchases, spread my watercolor equipment on my bed and desk, and started to paint postcards to mail to my friends. I had done only two or three when my phone rang and my friend Kindra started speaking with great urgency: "Pilar, come down to the lobby, something horrible has just happened, come right away!"

When I got to the lobby a group of people, Italians and Americans, were gathered around the two televisions, entranced, watching transmissions from early morning in New York. There in Italy we watched what was just then happening in New York, the towers being hit and disintegrating in front of us. We watched the trajectories of the planes, unmistakably directed first at one tower, then the other. It was incomprehensible, unbelievable, but it was happening. The cameras were unforgiving, allowing us no hopeful illusion it all might be a grotesque mistake.

Aloud I said, "That must be the work of Osama bin Laden!" Everyone in the room turned to me to ask, "Who is Osama bin Laden?" Apparently, no one had heard that name before, or they did not remember it, and I had to explain. I don't know if they believed me, but soon after there was speculation that it could be he and his group, Al Qaeda. Like everyone else, we were glued to the TV, unable to stop watching the images repeated over and over again, unable to believe what was happening in front of our eyes. The Italians gave us their immediate sympathy, asking if there was a chance any of us had friends or relatives in the towers. None of us had anyone, but it did not matter; we were all affected, they could all have been our brothers. Seeing some of the people falling, escaping the fires by jumping to their deaths, was horrible; it was like Dante's inferno.

We watched the lobby TV for a long time, until I finally went upstairs to my room and turned on my own television, searching different channels for more information. I put away my paints, all desire to paint gone, and I lay in bed, obsessed with the terrible images. I thought of my friends, flying over the Atlantic, and I wondered where they would they go, since all U.S. airports were closed.

Pilar in Barcelona, 2006. From left to right, Tom, Monica, Pilar, Jose Luis, and Maggie. Photo courtesy of Tom Erikson.

The sun came out and, not knowing what else to do, I put on my bathing suit and went to the little beach across the road; it was deserted and peaceful, the waves calmly lapping the white sand. I went swimming and then floated on my back, with my hair and scalp feeling the calming coolness of the water, and looked at the blue sky and the pine trees by the shore. Nature was a contrast to what I had just witnessed, and made it more difficult to believe.

Monica and Tom were arriving the next day, and I could hardly wait for them to get there. I had arranged for them to have one of the rooms left unoccupied by my friends, just across the hall from mine. I needed them. I don't remember, but I probably had something to eat with Kindra and John; we all needed human contact and could not stop talking about the day's events. The night was restless but the morning arrived and with it Monica and Tom. That day we also had an e-mail from Ira, Willamarie's husband. He told us that Willa and her sister Ann, who were over the Atlantic Ocean during the horrible disaster in New York, had their flight diverted to St. John's, Newfoundland, Canada, where they were stuck with seventeen thousand other travelers. The local people were being as helpful and

hospitable as possible, trying to provide food and shelter for all of them. But, most importantly, they were safe, waiting to fly to the States as soon as possible.

I went with Monica and Tom to Cinque Terra and the other charming places I had visited with my friends. They were, of course, still just as charming, but our mood was subdued. We kept talking and speculating about the recent events and trying to decide what to do. Monica and Tom were flying to London from Genoa and did not change their plans, but I had a plane ticket from Milan to New York. I called Delta and changed it to depart two or three weeks later from Barcelona, where my daughter Maggie and her husband, Jose Luis, live. It was very nice to be with Monica and Tom. We share many interests, and despite everything, we still enjoyed our time together, but the atmosphere was downcast.

I went with them to Genoa, the place where my paternal grandmother, María Luisa Chicheri di Bellinzona, had been born. I had never known her because she died before I was born, but I liked knowing I had roots in that beautiful old city. We wandered around the streets, Monica and Tom looking for a hotel to spend the night. Their flight was the next day, but I was going to take the train along the coast of France and across the Pyrenees to Barcelona. We went to the harbor and walked around the medieval streets with their old buildings and Gothic churches. We stopped to eat in a small restaurant. Everything was normal; the problem was across the world, but the feeling was there. People realized we were Americans, and many of them stopped to give us their sympathy. Finally, at five o'clock in the evening, it was time for me to go to the station; I bought my ticket, they helped me board the train with my luggage, and we said goodbye. I was on my own.

It was going to be a long trip, with the train stopping in many small towns, sometimes for an hour or more. At those times I got off and walked in the area, enjoying early evening with the Italians, having some delicious ice cream. While it was still daylight it was pleasant, but when the dark came it was different. Perhaps it was just the way I was feeling after the recent shock, but it was sort of spooky. Twice I had to change to another train, and I had to go downstairs, underground, to cross to the other side of the rail. The stairs were stone and rather dark, and I was carrying my backpack with my painting stuff, my suitcase, and my purse. If the other train was not yet there I had to wait, sometimes alone. I also had

the feeling that I might make a mistake, as there was not much information available. I suppose that because it was sort of a local train people knew what they were doing and did not need to ask many questions.

It was a long night. There were other passengers—not too many—and I could not figure out what language they were speaking when they were speaking, which was not often. The lights were dim, lugubrious, no one was in charge, and I had no idea where I was. I was trying to read the names of the small stations we stopped in, but the names were not visible until the train started out of the station. For a long time that was all right, because I knew we were still far away from the Spanish border and the town, Port Bou, where I had to change from the train to the bus if I wanted to reach my destination.

As dawn approached, my fellow passengers started to feel as restless as I; I suppose they were having the same problem. Then I got help from an unexpected source: art history. I started to recognize the names of the stations because they were places where Matisse and other famous painters of the early 1900s had created some of their masterpieces—Cannes, Couliore, and so on. I knew where I was, and that Port Bou was approaching. As it turned out, I worried for nothing because just before we got there a porter appeared from nowhere and announced our arrival. It is an important point because is a major border crossing into Spain.

I left the train with all my luggage—miraculously, nothing was missing—and entered the small Port Bou station. It was full of people but most of the information windows were still closed, though notices said help would be coming later. There was much Spanish being spoken, which made feel at home although I was not yet on Spanish soil. But when I went outdoors—then I was in Spain. Soon the station was alive; ticket window opened, one could exchange currency, coffee and breakfast were served, and a short time later I was on a bus to Barcelona.

I had called my daughter about my coming but hadn't given her the time of my arrival, as I had no idea when it would be. So, once again I took charge of my luggage, got a taxi, and went to her apartment on the Paseo de San Juan. She and her husband, Jose Luis, were very happy to see me, and to see that I had arrived in one piece. I guess sometimes

they don't have as much faith in my competence as they should. It was good to be there, with them and in Spain, but it was not like other times. We were all still in shock. They both work, so when I was alone I visited my favorite places in Barcelona. On my way back each day I would stop at some charming shops to buy fresh vegetables, fish, and bread, and then would cook something for our supper; it is so much more pleasant to cook when it is not just for yourself. On the weekend, we visited the property they had just bought on the outskirts of Barcelona; Maggie was afraid to show me the place because she feared I would think it was a crazy idea, but I thought it was a wonderful buy. It is up in the mountains, on the other side of Tibidabo. Their garden is very steep, terraced three times, and the house is on the very top, with a sweeping view of several mountain ranges—some near, some far away, all covered with green forests that faced west. Because it is a national forest, no new building will be permitted. To reach the place, there is a steep and curvy road used only by the local owners, and, at the bottom, a pretty train station where one can board and be in Barcelona in only ten minutes.

Maggie had worried about my opinion because the house was a wreck, a disaster. But she had a vision, and I immediately joined her in it; this is how we are in our family: the present does not scare us because we know what to do to change it into a great future. Maggie's house is marvelous now and it will continue to be more and more so because Maggie has a vision.

As much as I enjoyed staying with them, I had to come home. My home is my old house in Salt Lake City's Avenues. When bad things happen I need to be there—I need to be here. It is reassuring to be surrounded by what is and what has been my life, to know that in spite of terrible events my home is still here, unchanged. So I left Barcelona with regret, flying to Atlanta on a Delta plane that normally carries more than two hundred people. This time it was crossing the Atlantic for the benefit of twenty-three travelers. The trip was uneventful and safe and it felt good to be back. But life has changed; six years later we still don't know what to do to repair the damage and recover what we lost on that fateful day, 9/11.

❧ epilogue

URING THE LAST TWO MONTHS, typing my old stories and writing some new ones, I have been, necessarily, reflecting on my past, already rather a long one. It has been for me sometimes a hard and sad remembrance, and sometimes an amusing one. And I have also been wondering if I were living now what I lived before, would my feelings and my reactions be the same? I think that the events of the past have produced the person I am now but, perhaps, if I had been the person I am now, my past would have evolved differently.

I have come to the conclusion that my life can be neatly divided into three separate parts. The first is my early life, my childhood in Spain with my father and mother, my sisters, my maternal grandmother, and all the other significant people who at that time surrounded me. There was our cook, Catalina, whom I loved so much; my mother's old nurse and her daughter, Tonina; Pepa la Carpintera; and so many others. There was our old house in the Calle de Santa Clara, and my grandmother's country home, Son Vida. And then there was the Spanish Civil War, which destroyed that life and caused my father's death, our escape to Portugal, and later our return to Mallorca to gather the pieces and try to make a life in a different world. There was school and my friends, my teenage years and my youth, and the beauty of my island—all the things I left behind when I met my husband and came to America. I did not leave all that with indifference. Though it was my will and I did it because I wanted to, it broke my heart to leave that first life behind.

My second life started in America with Walter, and then a new family and new friends, who became very important to me. I embraced Utah and its astonishing landscape of mountains and lakes, and the American experience. I have never totally integrated, for across so many years I have always missed Spain. I am happy here and everyone has always

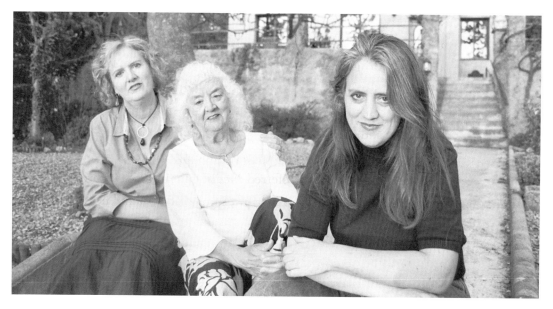

Pilar with her daughters, Monica (left) and Maggie (right), Barcelona, 2006. Photo courtesy of Tom Erikson.

made me welcome, but inside I know I am not totally the same as the others, and they can feel it, too. Not worse, not better, just not the same.

I had my husband, my children, my house, and a happy life. And later, when my art could not be suppressed any longer, it became one of the most important parts of that life. But during all those years, because I was a woman, a wife, and a mother, I took care of everyone's needs over my own. That was as it should be, and I did not want it any other way, but then my children left home and my husband's health progressively deteriorated, requiring more and more of my time for him. I was happy to take care of him during the eight or nine years of his decline. I was still working on my art, but in stolen moments and with many interruptions, and often with guilty feelings—even though he was encouraging me to spend my time painting. When he died I was left sad and lonely, and for a while I felt lost, missing what was gone forever, wondering how I was going to survive on my own, without anyone to care for and say hello to in the morning. My second life ended then.

For weeks I could not concentrate, but I had to face immediate problems. I had to sort boxes and boxes of papers and make some sense of them, change insurance policies, have my house painted to repair the tornado damage, and start preparing for a one-person show at the Kimball Art Center in Park City. Also at that time I became really sick with a mysterious ailment that my doctor could not diagnose. Finally a dermatologist sent a biopsy to the University Hospital and discovered I had Celiac disease, a congenital illness that can sometimes stay hidden until stress or trauma brings it out. Consequently, I cannot eat gluten anymore, ever, so it was goodbye to my preferred Mediterranean foods of bread and olive oil, pasta, and *empanadillas*. It was difficult at first, but I got used to it and became healthier and stronger again. Spring arrived, I cleaned my garden, and I was walking regularly in City Creek Canyon with my dog, Kiva. My third life had started.

So now I am living a new experience that I did not desire but that could not be avoided. In this third life I am entirely on my own, what I do is only what I choose to do at the moment, and I am free to make mistakes, to work ten hours straight if I want to, and to be responsible only to Kiva, my only boss. This is a freedom I have never experienced before in my entire life, and I like it. I am independent and I can feel it in my blood and bones, and I am full of energy and the confidence that there are more accomplishments ahead for me and more things to discover, if I decide to do so.

I feel empowered as never before; actually, it is almost ridiculous that I feel this way, but I do. I am my own person with my own name, Pilar Pobil. I resent it if someone introduces me with my husband's name, Smith. That is not my name. In Spain, married women keep their surname; it is part of my identity. I am not disloyal to my late husband, for he wanted it that way, too. He always wanted my art to be signed Pilar Pobil, because that is who I am. When my mail arrives, I know what is really for me by the name on the envelope, and I look at that first. The other mail consists of the necessary boring things such as business and bills. I am definitively Pilar Pobil for the rest of my life.

I don't sleep long hours; in fact, I have to make an effort to sleep enough to stay healthy. I have the feeling I need to use all my time in the best way possible to accomplish all I want to do, whether it is work or recreation, which I consider equally important.

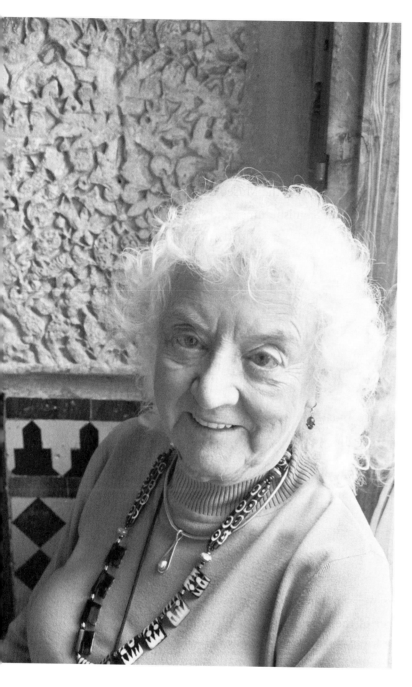

My children are no longer "just" my children; they are my friends. I don't tell them what to do, or even offer much advice unless they ask for it. They are, like me, independent, and this is yet another freedom for me because their mistakes will be their own. I love them entirely as they are, and I know they love me, too.

I am lucky to have many other friends, the best anyone could wish for, and I try to be a good friend to them. Life goes on, and I feel optimistic that I am still learning. I want to take advantage of the years I might still have in front of me, whether few or many, and do the best I can because, after all, that is the only thing one can do.

I am enjoying my third life! 🐦

Pilar at the Alhambra, Granada, Spain, 2006. Photo courtesy of Tom Erikson.

✾ art in pilar's garden

THROUGHOUT MY LIFE, art has been my obsession and my delight. When I was very young and was taken on trips to Madrid with my relatives, I would visit the Museo del Prado every morning, staying until they closed for the main afternoon Spanish dinner and siesta. I would wander around the salas, rooms filled with the world's masterpieces, collected throughout the centuries by the Spanish kings and emperors, remnants of the past grandeur of my native country. I never got tired or bored, as there was always more to discover. It was impossible to assimilate all the art or to fully appreciate how far the artists had gone in the pursuit of myth, of beauty, and of history, recording the events, the wars, the victories, the customs, the traditions, and the dreams of generations of peoples all around our planet. Wherever I went, it was always the same; I could never get enough. I also visited old churches and castles, and the art galleries where contemporary artists displayed their work. So, of course, shortly after I arrived in Salt Lake, I started to do the same. My husband, Walter, also loved art and music, so a good part of our leisure time was spent in artistic activities. There were not many art galleries here then, but Utah society was very appreciative of the performing arts, such as classical music and ballet, and the visual arts. Walter's family had several painters among them

We went often to the Art Barn, and soon after to the University of Utah Museum of Fine Arts, which was then in its infancy, being lovingly raised by its first director, Frank Sanguinetti, a man I am proud to say was my friend. Other galleries, such as the Tivoli and the Phillips Gallery, started to pop up around town. My brother-in-law and his wife had a studio in Emigration Canyon, and many Sundays we went there for dinners or parties with art aficionados. Walter became a board member of the Utah Arts Council and, later, chairman of the board. During all those long years, I became familiar with the Salt Lake art

Entryway of Pilar's house. Photo courtesy of Tasha Lingos.

scene, and it appeared to me that usually the same people attended these events (I am referring mainly to the visual art events).

I started to think about what could be done to entice other people to discover the arts, those who were perhaps intimidated by more formal events in museums and galleries. I had noticed that many people enjoyed garden tours; in fact, my garden had been included in several of them, and I had seen that while looking at the flowers many of the attendees were also looking through the windows of my studio and my home and were very curious about my paintings and sculptures. It was then that the idea for "Art in the Garden" was born.

I talked to some artist friends and they were all for it, especially since it would be held not in their houses, but in mine (I suspect that was a big factor!). But that was all right with me because I wanted to be in charge and have the final say. The process is pretty democratic and we all share ideas and discuss whose work goes well in a garden show; we get along very well. Three artists have been in almost all the shows: Willamarie, Polly, and I (of course, no one can avoid me). The other artists come and go.

A friend, Katie, a very talented cook, offered to prepare the refreshments. She did a fabulous job, and now another friend, Jorge, is catering it.

Part of the show's history is that we have never advertised it. It is, after all, in my house, and I don't want the whole world to come. I want those who truly like art, whether they can afford to buy it or not. I hope they come to admire it in an atmosphere of spring

beauty, of conviviality and friendship, of generosity of spirit and love for what makes life worth living.

The event soon became more and more well known, very successful, so much so that over the years other groups started their own, which is great, but apparently they were unable to think of a name other than the simple one I had used from the very beginning, "Art in the Garden." As other "Art in the Gardens" started to sprout around Salt Lake City, they created quite a confusion, which kept my telephone ringing constantly with people asking if my show was being held elsewhere. So I changed the name to "Art in Pilar's Garden."

In March 2006 I went on a trip to Spain, and when I got back, the garden was just awaking from its winter sleep. Winters are hard in Utah; it takes time to clean, to trim, and to prepare the soil for spring planting. When the weather permits, I work from morning until early evening, and I enjoy it very much, imagining how beautiful the garden will look later, when the flowers bloom. And they certainly do look great; they don't disappoint me. By the time June arrives, the garden is ready.

This year we were seven artists, and between us we covered several mediums and different subjects and styles: painting, sculpture, and stained glass. One of the artists came all the way from Italy for our show.

And everything was, as expected, in full bloom, especially my rose bushes, some of them very old and huge. The garden is on the north side of the house, and it is shady and cool, with big old trees and a grape arbor that shelters a good part of the patio. Because I like the sound of water, every year I build several fountains with unplanned designs. We have the show over three days, in the evenings, from 5 P.M. to 9 P.M. By Thursday, I have my whole place looking its best (I also open my house and studio to the visitors), with flowers and lighting for the art display. To have an outdoor art show is always a challenge because everything must be done at the last minute (you can't have art exposed to the sun for very long, wind can be a problem, and don't even mention rain—that's the worst!). The art starts to arrive by 1 P.M. My friend Willamarie and I are great experts and can hang the show very fast because of so much practice. We know the best places in the garden for display, and

View from the living room. Photo courtesy of Tasha Lingos.

we make sure that each one of the artists has a fair share of them. We hang paintings from the wood fences, glass from the rafters, sculptures in the flowerbeds. We put easels everywhere, at the same time allowing space for the people to circulate. By that time, the caterers are setting the tables with good food and refreshments, and we try not to collide with each other. As 5 P.M. approaches, we artists disappear for a well-deserved shower and to try to make ourselves presentable and relaxed, as if we had just been sitting around for hours. And people start arriving promptly at 5 o'clock. Often, musicians or poets will show up, uninvited but welcome. So we sometimes have live music and readings, further enriching the experience of the evening.

It pleases me that many who come had not previously paid much attention to art, and they tell me that now they have learned to appreciate it and assiduously go on the city art walks every month. I was very touched by a young boy two years ago; he was about 13, and he told me that he had heard talk about art many times before, and never paid attention, but that day, in my house and in my garden, he had finally understood, and now he knew what it was all about. I have people who can barely afford it but want to buy a painting. I make a special deal for them, and allow them to pay small monthly amounts, because I believe that anyone who sincerely loves a work of art deserves to own it. I trust them and let them take the painting so they can enjoy it, and not a single one has forgotten to pay in full!

People thank me for allowing them to come into my house and see what it is like to live surrounded by art, to have the opportunity to meet artists in a friendly and casual situa-

tion. Some tell me that, before they came, their houses were painted in beige and other dull tones, but now they are no longer afraid of more brilliant colors. They probably liked them before but were afraid for fear it was in bad taste. Now they are free to let themselves go and enjoy what makes them happy. I also receive many letters of thanks and appreciation, and all of this makes the work and preparations, and, yes, expenses, worthwhile for me.

I have come to the conclusion that, in general, the world is a pretty messy place and not all of us can do much to change it, even if we would like to. But if I can use whatever little individual power I might have to show a few people that there are beautiful things surrounding us, accessible to us, just waiting to be appreciated and admired, and this contributes to making them a little happier, I will have done my part. And so, once again, on the last evening of Art in Pilar's Garden, in 2006, our friends linger, unwilling to part, to end the charming interlude in our life, while the twilight makes the shadows deeper and mysterious. Those are magical moments with friends gathered together on a summer night.

And this has gone on for the same three days in June for twelve consecutive years. It is always hard work, but it is rewarding, and we hope it will happen again. ✒

Pilar's studio, 2001. Photo courtesy of Tom Erikson.

THE SPANISH WOMAN

by Shawn Dallas Stradley

Pomegranate strength

It happened right there
in front of all the society guests,
 the virile flowers,
 the voluptuous paintings
 and the quiet green of evening.
She was even married,
but this did not matter to my young-man heart.

Cornflower beauty

It was in her garden,
 no one knew
 no one noticed
 no one suspected.
The peace of her Victorian home
 resting in the avenued streets
with strong tides of color
rising and blooming throughout.
España,
 her native home recreated,
 not the rocky mountains
 of my native west.
Her life is art of true intent,
 no pretense.

Lavender vulnerability

Paintings of iris,
 clematis and sunflowers,
 sensuous women,
 silent cathedral masses,
 and bright shrimping boats
 prepared to set sail,
repose in the garden,
as do quiet guests
and brightly painted chairs
in silent green alcoves
along walks of stone and brick
 edged with moss
on cool summers eve.

Chartreuse simplicity

This place
 far removed from my dusty life,
into vibrant expressions of emotion and joy
that tumble from voluptuous canvasses
under wisteria trellises,
is like walking through
 breathing in
 living
 one of her potent paintings

Sunflower formality

Turning,
 I see a woman dressed as a summer memory.
 My Duchess of Denver,
 dressed in yellow pants and jacket,
 a straw hat rimmed with bright flowers,
 handing out invitations
 in the Colorado sun
 to an afternoon cocktail party.
 The only other woman I have known
 whose very life is art and poetry.

Rose serenity

Wine and song,
green and light
rise and flow through the garden,
como relatos en Español
 and stories in English,
 of diamonds,
 distant travels,
 ideas and art
 softly mix and float across the misty air.
Intellectuals pontificate on cerebral theories
 of no consequence
 amid the grandeur of the peace.

Pumpkin innocence

Some speak of the chaos
of this colorful collection,
chairs with flowers,
 growing, as it were, in the garden,
and flowers flowing into the house.

For me,
 no chaos,
 only unity,
 completeness,
 wholeness,
 perfection of being.

 Sea intimacy

Ha, how can I call her old?
Simply because she has spent more years
 awake than I?
I remember the rose garden of the queen
 and the moonlit walk
 con la Señorita Maria.
Now, I walk with the queen
 in her rose garden,
and return three mysterious nights
 to bathe in tranquil, jeweled evenings.

 Midnight harmony

I, the awkward young poet,
wander freely and invited
among garden rooms.
She, the queen,
with vibrant eyes paints stories,
 taking time with each young man
 explaining the paintings that take their fancy
 como el toro negro del medio dîa
 with reality indistinguishable
 beneath the hot Spanish sun
 or
 las tres modelas sensuosas
 lime,
 lemon,
 tangerine.

 Fuschia clarity

And now the guests are gone,
the paintings taken in from the garden.
Soft raindrops silently begin to fall.
Y yo,
 sôlo,
en el jardîn de color y pasiôn
in love
with the young Spanish woman.